Creative Careers
in Museums

Creative Careers in Museums

JAN E. BURDICK

ALLWORTH PRESS
NEW YORK

12 11 10 09 08 5 4 3 2 1

Published by Allworth Press
An imprint of Allworth Communications, Inc.
10 East 23rd Street, New York, NY 10010

Cover design by Derek Bacchus
Interior design by The Roberts Group
Page composition/typography by Integra Software Services, Pvt., Ltd.,
Puducherry, India
Cover photo by Nathan Umstead

Library of Congress Cataloging-in-Publication Data:

Burdick, Jan E.
 Creative careers in museums / Jan E. Burdick.
 p. cm.
 Includes bibliographic references and index.
 ISBN-13: 978-1-58115-498-6 (pbk. : alk. paper)
 ISBN-10: 1-58115-498-4 (pbk. : alk. Paper)
 1. Museums—Vocational guidance—United States. 2. Job hunting—United States—Handbooks, manuals, etc. I. Title.

AM11.B87 2008
069.023'73—dc22

 2008007593

Printed in the United States of America

DEDICATION

*"Museums are dull boring places that no one wants to go
to, but parents and teachers insist on dragging us there.
The only good thing about a museum is
when you can shop."*

—AUTHOR'S DAUGHTER, AGE 13

To Erika
for her challenge, her inspiration, and her willingness
to change her mind.

To Dennis
for his boundless love and support, and
superior editing skills.

To Mary and Robert
for encouraging me to take the road less traveled.

CONTENTS

ACKNOWLEDGMENTS

A key issue in the museum field today is leadership—as voiced by Ford W. Bell, the president of the American Association of Museums—"not only how to lead, but who should do it."[1] From their simple beginnings, museums have become complex institutions serving many purposes and audiences; as a result, they require a broad range of expertise from the people who work in them. To successfully serve our multifaceted society, museums must look not only to experts trained in the field but also to the myriad talents of those in the larger community. To this end, Ford W. Bell poses the question: "How will we attract the best and brightest young people into the museum field?"

This book is dedicated to that endeavor—helping people find their way into the museum field and encouraging a new wave of expertise, enthusiasm, and perspectives. The stories herein document the career paths of many people who have done so already as a way of inspiring those who follow.

A project like this is only possible with the collective wisdom and guidance of many sources—most notably, the people who took time to speak with me about their careers. They offered thoughtful advice and insights on the many aspects of their work. In addition to those profiled in this book, I'd like to thank: Jodie Ahern, Minneapolis Institute of Arts; Andrew Andoniadis, Andoniadis Retail Services; Debra Ardemendo, Museum of the City of New York; Candace Barrett; Jake Barton, Local Projects; Jeanne Benas, National Museum of American History; John Beaver and Leonda Levchuk, National Museum of the American Indian; Alyssa Borek, Alison Reiser, and Chris Sheppard, Bronx Zoo; George Buss, Harsco Science Center; Charles Day, Wave Hill; Eileen Goldspiel, American Association of Museums; Kate Javens; Chad Jones, Bonsai Artransport; Janice Klein, Mitchel Museum of the American Indian; Davison Koenig and Don Luria, Arizona State Museum; Eric Mauriello, Operand; James L. McCreight, Museum Trustee Association; Joe Mikuliak, Philadelphia Museum of Art; M. J. Morse, Museum of Science, Boston; Diana Pardue and George Tselos, Statue of Liberty National Monument and Ellis Island; Marilyn Reppun, Mission Houses

Museum; Mya Sadler, Museum Store Association; George Shakespear, New York Botanical Garden; Murray Tarnapoll, Queens Museum of Art; Sally Williams, Brooklyn Museum; Ann Wright-Parsons, Anthropology Museum, Northern Illinois University; Ryan Wyatt, Hayden Planetarium, American Museum of Natural History.

Special thanks go out to my colleagues at ESI Design for their inspiration and years of collaborative, creative work; to Allison Day of the Brooklyn Museum for her insights on museum careers; and to Sarah Henry of the Museum of the City of New York for her inspiring crossover to the museum world. I'd like to express my appreciation to Nicole Potter-Talling and Brauna Rosen for bringing this project to me. Thanks also to Eric S. Brown, Holly English, Mary Moriarty, and the Authors Guild for legal and technical advice. And I'm deeply grateful to Alan Burdick and Clay Gish for their generous help editing and shaping this work.

I am indebted to the many people who provided encouragement and celebrations at milestone moments, especially my brother, Stephen Burdick. And I am grateful to my family for their extraordinary patience, love, and support.

And best wishes go to you, the reader, in your search for new horizons. Museums are extraordinary places; may you discover, as I have, that the folks who work in them are a warm and generous people.

INTRODUCTION

Museum work is an ensemble activity.

—Elaine Heumann Gurian[2]

On a Thursday night, the Beaux-Arts Court in the Brooklyn Museum has been transformed for a magical evening. The floor is lit from below with subtle red lighting. The tables are exquisitely decorated with flowers and floating candles. The guests, dressed in their black-tie best, begin to arrive and are greeted at the door by a young woman, Jennifer Williford, who checks their names on her reservation list and cheerfully directs them to the appetizers. Jennifer's evening will be long but rewarding; this event is the culmination of months of hard work. She is the Special Events Manager, responsible for orchestrating this annual gala fund-raising event for the Brooklyn Museum. For months, she has organized, planned, cajoled, fretted—and not in vain. The guests are visibly impressed and the Director is pleased. On Monday morning she'll receive many congratulations for a job well done. In the meantime, she'll make sure that all goes smoothly tonight right through to when the band leaves and the room is cleared. On Saturday evening, a wedding will be held in this same space. Her planning lists for that event are ready on her desk.

Meanwhile, across the Atlantic Ocean, Richard Fazzini, curator emeritus at the Brooklyn Museum, toils in the heat and the dust at the ancient Egyptian site of the Temple Precinct of the Goddess Mut. Working in close coordination with Egypt's Supreme Council of Antiquities, he directs a team of conservators, archaeologists, and other specialists as they excavate, preserve, and restore this important religious site. They've recently finished the restoration of a small chapel near the entrance of the Precinct and have restored the granite sphinx to guard duty just inside.

Alisa Martin, the Brooklyn Museum's Manager of Marketing and Visitor Services, is meeting with the design firm hired to fashion a new graphic identity for the museum. To prepare, she interviewed many of her colleagues to understand how they use the current design and what they'd like to see in the new one. Naturally, no two people agree. In the coming

months, Alisa's job will be to balance and mediate the varying opinions, craft a consensus, and gently steer the team to a new branding solution tailored to the multifaceted needs of the museum.

Three colleagues, with distinctly different jobs, work for the same museum. Each of them brings unique skills and prior experience; all of them bring passion and dedication to their work. They represent but a glimpse of the wide array of careers in the museum world. With these three as a starting point, imagine the career possibilities in the myriad of museums across the country.

The American Association of Museums estimates that there are approximately 17,500 museums in the United States; approximately 865 million people visit them each year.[3] That's about three times the population of the United States, which means some people are going to museums quite frequently. Museums range in size from the very large—with a staff of thousands—to the very small—with a staff of one. In the United States today, there are about 200,000 people working in museums in various capacities, not including those who volunteer their time.

Who are all these people? What do they do, and how did they come to work in a museum? What skills do they need to do their jobs? The answers vary widely. People with all kinds of interests, experiences, lifestyles, and education work in museums. They teach, they direct, they perform, they organize, they collect, they conserve, they display, and they protect museum collections for the education and enjoyment of society.

This book is an exploration of the spectrum of jobs available in the museum field. It will start with the broadest definition of a "museum" and will consider art museums, natural history museums, children's museums, science museums, botanical gardens, zoos, aquariums, historical sites, and more. Then, it will expand the definition of "working for a museum" still further and look at the constellation of jobs in places that do consulting work for museums, like architecture firms, art moving companies, exhibit-design firms, music- and video-production companies, and fund-raising firms.

Above all, this book is a collection of stories told by people about their jobs—what they do, how they came to be there, and what they love about their work. Every job is unique to its museum and to the person filling it. Some people, like Kirk Johnson, know from an early age that they want to work in a museum. Kirk's undergraduate, graduate, and postgraduate work were all focused on landing a job in a science museum; he is now

the Vice President of Research and Collections and Chief Curator at the Denver Museum of Nature and Science. But many more people, myself included, came to their museum-related careers via meandering paths, so most of the stories in this book chart trajectories shaped by circumstance, growth, and change.

For eighteen years I worked as a project manager at an exhibit design firm in New York City helping our clients—mostly museums—design, shape, and build their exhibitions. Early in my career there, I was impressed by the team of people I worked with and their diverse work backgrounds and education. Some had studied theater, history, law, philosophy, education, or ethnomusicology. Others had expertise in writing, drafting, marketing, video production, or cartography. With my background in both dance and computer science, I felt right at home. Each of us brought unique perspectives to our work designing museum exhibits, just as museum visitors bring their individual perspectives to the exhibits they've come to see.

When I began interviewing people for this book, I quickly found that most had started their career in one field of study and gravitated, whether by lucky chance or by intention, through one or more professions until they arrived at their museum job. James Hackney, a graduate from Yale Divinity School, is now a partner at a fund-raising firm specializing in museum work. Joan Collignon worked for many years in a public advocate's offices and now heads the docent program at the Oakland Museum of California. John Spavins, after graduating from MIT, worked for several years designing NASA rockets and now is the head of exhibits at the Boston Children's Museum. Greg Stevens began his career in theater design and now designs professional education programs for the American Association of Museums. All of these people can describe how their previous experience, seemingly unrelated, has been important in the work they do for and with museums.

This book is written for the reader who is looking to take the next step on his or her career path, asking such questions as, "What kind of jobs are available in museums?" and "How can I take the skills I have and transition them to a museum career?" It is intended as an inspirational starting point to finding your way to a museum career. You may be a student just out of school, unsure where to go next. You may be at a midpoint in your career and want to make a lateral move to a new field. Or maybe you are retired and looking for an "encore" career. My hope is that you will find

examples of your own skills and interests in these stories and be inspired to explore a career move into the museum world.

The first section will look at what museums are—what they have been historically, how they have evolved in the United States today, and the important role they serve in our ever-changing culture.

The second section is a collection of interviews with people who work in museums or for companies providing services to museums. You'll learn what they do, how they got there, and how they think about the museum field. Each career path is idiosyncratic—none can be identically duplicated. But the breadth of education, skills, and opportunities these people have utilized to get where they are offers perspectives on how to map your own transition into a museum career.

The third section explores the steps necessary in finding a job—where to look for leads, how to put together a résumé, and tips for doing well on an interview. Finding a job takes a lot of thoughtful work—from figuring out what you want to do to mapping a trajectory to get there. This takes time, so start researching and ruminating early.

The fourth section offers helpful resources for finding a job in the museum world: books, associations, and Web sites—lots of Web sites. Trolling through the vast amount of information on the Internet is time consuming, but there are a lot of resources available at your fingertips. Learn how to use the Internet to your best advantage.

Working in the museum field is a rewarding career in whatever capacity you choose. As you'll discover in these pages, there are many exciting options to choose from.

PART I

WHAT IS A MUSEUM?

... an inviting structure, held in place by inferences and implications, ideas and concepts, suggestions of the possible.

—DAVID CARR[4]

Museums come in all sizes and flavors. They range from the very large—such as the Smithsonian, housed in eighteen buildings in Washington, D.C., and other cities—to the quite small, like the Museum of Jurassic Technology, which is housed in a small storefront in Culver City, California. There are well-funded museums, operating primarily off the generous contributions of philanthropists, and the not so well-funded, many of which close each year. Some museums, like the American Museum of Natural History in New York City, cover broad topic areas, while other museums are dedicated to specific subjects, like the Lace Museum in California or the Sandpaper Museum in Minnesota. Most museums contain a unique collection of objects, artifacts, plants, or animals, but some museums have important collections comprised simply of ideas, stories, or records, like the Ellis Island Museum of Immigration in New York Harbor.

Academic museums are associated with colleges and universities and are primarily focused on study and research. There are fanciful museums that exist just for fun: the Cockroach Museum, the Tooth Fairy Museum, or the Cookie Jar Museum. Some museums highlight the dreams and aspirations of humankind, like the Ford Museum in Michigan, with its collection of historical buildings assembled from around the country. Others, like the Holocaust Museum in Washington, D.C., are dedicated to illuminating the depths of the human condition in the hopes of preventing the recurrence of such tragedies. A few museums simply explore the macabre, like the Museum of Death in California, or the obscure, like the Barbed Wire Museum in Kansas. Museums may be housed in specially designed, architecturally distinct buildings, like the California Academy of Science's beautiful new Steinhart Aquarium, or may find their home in rented office space or someone's living room.

What is the common thread? The American Association of Museums defines the common denominator as an institution that makes a "unique contribution to the public by collecting, preserving, and interpreting the things of this world."[5] In addition to preserving and displaying objects and ideas, many museums have taken on the additional role—actually an ancient role—of serving as centers for discussion, as places for classes, lectures, meeting, parties, town hall forums, performances, where the community can gather to discuss and reflect upon important issues.

one

A HISTORY OF MUSEUMS

[The museum] ... is derived from various other, older
social organizations. It is in fact a modern
hybrid, bred with mingled characteristics of the
cathedral, the royal palace, the theater, the school, the
library, and according to some critics,
the department store.

—ALBERT TEN EYCK GARDNER, CURATOR,
METROPOLITAN MUSEUM OF ART[6]

One way to understand what museums are today is to look at what they have been historically. The word "museum" comes from the ancient Greek *mouseion*, meaning "temple of the Muses." In Greek mythology, the Muses were the nine lovely daughters of Zeus and Mnemosyne and popularly considered the goddesses of art, science, inspiration, and learning. Their expertise embraced history, theater, comedy, poetry, astronomy, dance, and music. "Mouseai" festivals were held in their honor, and participants from all over Greece came to perform and revel at these events. Before reciting their work, poets, actors, and storytellers customarily invoked the protection of the Muses and asked for inspiration. Homer's *The Odyssey*, written about 700 b.c., addresses the Muses in the opening lines—"Tell me, O Muse, of that ingenious hero who traveled far and

3

wide"—and tells of the travels and adventures of Odysseus. Most schools of that time dedicated temples or shrines to the Muses.

The first recorded museum was the Museum of Alexandria, established in the third century B.C. as a center of learning similar to what we would today call a university.[7] It had an immense library, which housed the papyrus rolls collected by Alexander the Great. The school also had an observatory, several laboratories, lecture halls, botanical gardens, and collections of objects and statues. A staff of prominent researchers and teachers lived and worked there, including the noted mathematician Euclid, who wrote his *Elements of Geometry* while there, and Archimedes, the inventor of an ingenious water pump.

COLLECTIONS AND ACQUISITIONS—AN ANCIENT CONCEPT

The idea of collecting things, a central theme of many museums, has been around far longer than the ancient Greeks, perhaps as long as there have been people to collect things. Presumably, early nomadic peoples collected items for religious purposes or as status symbols but had limited ability to carry much with them. As larger civilizations developed and people settled, building methods improved and brought the ability to amass and preserve larger collections. Significant collections of objects have been found in the remains of ancient cultures around the world—Mongolian burial sites, Egyptian pyramids, and Mayan temples. When the ancient Roman armies returned from war, they brought with them statues and paintings acquired during their conquests and proudly displayed them in public places and in private homes. These became symbols of pomp and social status, and eventually it was de rigueur for every wealthy household in Rome to have a collection of statues or other artwork, thus leading Cicero in his treatise *Paradoxa* to warn against the "corrupting effects of art."[8]

About 500 B.C., trade routes began to develop independently in Asia, India, and the Mediterranean area of Europe and eventually merged into a network of routes known as the Silk Road. These caravan routes flourished for nearly two thousand years, facilitating the exchange of ideas, languages, foods, goods, and religions across the continents. Exotic items of jade, lacquered wood, iron, and silk from the Far East made their way westward into the collections of the wealthy European rulers; at the same time gold, precious stones, and glass traveled east. In eighth-century

Japan, Emperor Shomu built a great temple and treasury building called the Shoso-in to house his collection of precious jewels, musical instruments, glass, silver, and silks. The Shoso-in was considered the eastern terminus of the Silk Road and is probably the oldest museum in the world still standing today.[9]

EXHIBITING AND INTERPRETING

During the Middle Ages in Europe, the Catholic Church was the primary producer and collector of artwork, effectively providing public "museums" where the faithful could be awed by art and architecture.[10] As the Renaissance blossomed in Europe, so did the secular arts and scientific thinking. It became fashionable for ruling houses to commission and collect paintings and statues and then set aside a room or wing of their palatial homes for viewing by nobility and their friends. The means of displaying the collections varied widely with personal taste. In 1582, the Medici family renovated the upper floor of their Uffizi Palace with long corridors and large windows to accommodate their collection. In the Palazzo Ducale in Mantua, Italy, artwork was displayed everywhere—throughout the living quarters of the palace as well as the riding school, the courtyards, the kennels, and the storerooms.[11]

In sixteenth-century Europe, "cabinets of curiosity" became popular. At the time, philosophers assumed there was a finite amount of knowledge in the world, and these cabinets were the collector's effort to obtain one of everything in the world and arrange them in relationship to one another. Cabinets ranged in size from small enclosed spaces, sometimes even a single portable box, to great rooms or wings of the palace. Each object was arrayed, carefully labeled, in special drawers and slots. Sometimes a member of the household staff was hired specifically for this task, becoming, in a sense, the precursor of the museum professional. As travel became more widespread and the known world expanded, new and rare artifacts made their way into these cabinets, including some of dubious origins, like mermaid skeletons and unicorn horns. The collectors' passion for describing the objects sometimes crossed over into the imaginary. Ulisse Aldrovandi, Professor of Philosophy and Natural History at the University of Bologna, accumulated an extensive collection of natural history specimens, which he accompanied with notes and illustrations. A catalogue for his cabinet published in 1642 includes a little-known "fact" about stingrays—"they love music, the dance and witty remarks."[12]

MUSEUMS OPEN TO THE PUBLIC

As collecting became more widespread in seventeenth- and eighteenth-century Europe, the average collector no longer came from royal or noble families. Now the merely well-to-do felt compelled to accumulate interesting and extensive collections, especially of plants, animals, rocks, and minerals. In England, John Tradescant and his father, who was a gardener by trade, accumulated a significant collection of rarities that was acquired by Elias Ashmole. Ashmole eventually left the collection to Oxford University on the condition that they construct a building to house it. The Ashmolean Museum opened in 1683 as a public museum—that is, a collection owned by an institution and viewable by the public—charging the nominal admission price of a sixpence.[13] Throughout Europe, collections formally owned by royal families were opened for public viewing. Maria Ludovica, the last of Florence's Medici family, turned over her family's collection to the State Treasury in 1737.[14] The royal collection at the Louvre in Paris was opened to the public thanks to the French Revolution.

By the early nineteenth century, colonial influence had founded museums and museum societies in most parts of the world. In Jakarta, the Batavia Society of Arts and Science became the Central Museum of Indonesian Culture and then part of the National Museum. The Asiatic Society of Bengal was founded in 1784, later to become the Indian Museum of Calcutta. The Argentine Museum of Natural Sciences was founded in Buenos Aires, and a zoological collection was founded in Cape Town, South Africa. And in 1773, in the soon-to-be United States, the Charleston Library of South Carolina announced its intention to form a museum.[15]

EARLY U.S. MUSEUMS

Historically, American museums have placed more focus on education than their counterparts in Europe and around the world. Early on, the American collections were made up of local shells, rocks, minerals, and flora and fauna that were unfamiliar to the new settlers. Private clubs or societies with aspirations for scientific study were typically responsible for their inception. In South Carolina, members of the Charleston Library Society pooled their own collections, advertised in the papers for other acquisitions, and in 1773 opened the first museum in the United States. They soon appointed four curators to care for the growing collection.[16]

In 1785, Charles Willson Peale, an avid naturalist and painter, opened the Peale Museum in a wing of his home. This museum included his natural

history collection, interspersed among portraits of distinguished Americans, largely painted by Peale or other family members. The Peale Museum soon grew to be more than a personal collection. On the encouragement of Peale's good friend President Jefferson, Meriwether Lewis and William Clark donated many of the natural history specimens and Native American artifacts—collected on their West Coast expedition—to the Peale Museum, being "the nearest thing to a National Museum then in existence."[17] Not until 1826, with a bequest from an English scientist, James Smithson, did Congress establish a national museum—the Smithsonian Institution. Initially a small museum, library, and art gallery, the Smithsonian today comprises more than eighteen museums in several cities.

Peale and other museum owners saw their exhibitions as scholarly endeavors. P. T. Barnum, on the other hand, took the idea of a museum to a whole new level of commercialism. In 1841, he bought a museum collection from the Scudder family, added performing acts, wax figures, panoramic settings, and mermaid skeletons, and reopened it as Barnum's American Museum. Although his exhibits were sometimes hoaxes, his museum was truly aimed at mass consumption in a way no other previous museums had been. He encouraged dialogue and skeptical debate among his patrons, drawn from the increasingly heterogeneous population of New York City. In his time, wealthier collectors regarded him as a charlatan, but today he is considered a revolutionary pioneer in his understanding of the entertainment value of museums.[18]

CHANGES IN MUSEUM GOVERNANCE AND SPECIALIZATION OF STAFF

After the Civil War, industrialization brought radical changes to American society. New technologies fostered new industries, which in turn generated great wealth for leaders of those industries. As their disposable income grew, these captains of industry collected and donated art to a growing number of art museums, including the Boston Museum of Fine Arts, the Metropolitan Museum of Art in New York City, the Art Institute of Chicago, and the Detroit Institute of the Arts. But, benefactors don't like to relinquish major collections without some say in their continued care and the future of the museum. This brought about an evolution in the way museums were governed. Business leaders and benefactors became trustees of museums, eventually forming a governing board. The museum's director and staff looked to the board to guide and fund their long-range goals.[19]

As the number of museums increased, jobs within the museum field became more specialized. Art museums hired curators, or keepers, with specific expertise in caring for the collections. Natural history museums hired scientists to classify and arrange their exhibits. Conservation became an important field of study as museums began to realize their role in protecting their collections against deterioration. By the late 1800s, sentiment grew for providing public education to the working class. Museums embraced public service as part of their mission, and thus education and interpretation became areas of expertise within the museum field. Museums hired staff to welcome newcomers and explain the significance of their collections, soon coining the term "docent."[20] In 1880, the Norwich Museum and Library in Connecticut invited school classes to the museum, thus beginning the time-honored tradition of the museum field trip.[21]

By the early 1900s, sparked by Charles Darwin's theory of evolution, natural history museums sent expeditions across the United States and around the globe in search of dinosaur remains. Paleontologists and other scientists on staff at the American Museum of Natural History in New York embarked on numerous expeditions and soon returned with ships and railway cars full of fossils destined to be cleaned, classified, studied, and preserved in storage. But the public clamored to see the fruits of these efforts. The museum quickly spotted the public relations opportunity and set up full-scale replicas of Tyrannosaurus Rex and other extinct creatures.[22] Soon other museums followed suit and the country's infatuation with dinosaurs was in full swing, as was the museum field's attention to public relations.

Museum collection policies were not confined to animals already extinct. In an effort to collect and preserve the world's vanishing species, hunting expeditions shot thousands of big-game animals and brought them back to American museums for mounting and display. Painters created elaborate dioramas—art forms in themselves—to set the backdrop for these exhibits. As the emerging field of anthropology focused attention on the dwindling Native American populations in the United States and Canada, museums seeking to preserve and document these cultures acquired artifacts in a variety of ways. While their motives may have been well intended, their means were not always so. Sometimes museums bought household or ceremonial objects from their original owners and fairly compensated them for the items. But often objects and human remains were stolen from homes or gravesites. In extreme cases, living specimens—actual people—were brought to live in museums. In 1897, Admiral Peary "collected" six

inhabitants of Greenland for the American Museum of Natural History. They were housed in the basement, where four died of tuberculosis; the skeleton of one was then placed on exhibit in the museum.[23]

AN EMERGING PROFESSION

The early 1900s was a booming time for the United States. Business was flourishing; cities were growing; immigration was at its peak. Americans were enchanted with the art and history of their own country and felt it was important to impart this knowledge to the wave of new immigrants arriving daily. Restored historic homes, such as Thomas Jefferson's home, Monticello in Virginia, became a popular way to preserve the architecture of the colonial era and satisfy the growing nostalgia for the "old days." In Williamsburg, Virginia, John D. Rockefeller, Jr., purchased and restored a whole neighborhood of buildings, recreated the cobblestone streets, and opened the country's first themed attraction. This restored village marked a shift in thinking about a museum's contents: The buildings were more integral to the collection than the objects. Henry Ford took the thought a step further. He purchased historically significant buildings around the country—including many of Thomas Edison's laboratory buildings and the Wright Brothers' bicycle shop—and moved them to a newly invented "town," which opened in 1929 as Greenfield Village in Dearborn, Michigan.[24]

By the mid-1920s, museum work was becoming a profession with increasing specialization and a code of behavior. The American Association of Museums, which formed in 1906 as the first national professional museum organization, set up permanent offices in Washington, D.C. In 1922, Harvard University started the first serious museum training program where future museum professionals could study museum philosophy, history, and management. A number of museums started apprenticeship programs for on-the-job training.

Museums began to study their own facilities and wondered how their visitors reacted to the exhibits and buildings. In 1925, a Yale University psychologist described an affliction known as "museum fatigue" characterized by general achiness and the desire to leave the museum. The director of the Philadelphia Museum conducted extensive research on the visitors to his museum to discover how long they spent looking at a piece of art. He discovered that visitors spent an average of 2.8 seconds viewing an artwork, and they tended to move to the right through an exhibit, leaving through the first exit they encountered.[25] This fundamental piece of information laid the groundwork for future exhibit planners.

MUSEUMS REFLECTING SOCIETY

Throughout the twentieth century, American museums reflected the many challenges of an evolving society. During World War II, museum exhibits portrayed the prevalent patriotism of the country—letters from soldiers overseas, classes on how to grow a victory garden, and notably the sudden hiding away of Asian art collections due to anti-Japanese sentiments. The McCarthy Era sparked suspicion and controversy over art and national security. Museums were encouraged to censor works by artists with possible communist connections. In the 1950s, the Soviets launched the Sputnik satellite and the United States raced to the moon. Suddenly, there was a huge demand for public information about science and technology. Universities and federal government agencies funded several new science museums and planetariums hoping to inspire the next generation of scientists. The advent of broadcast television set new standards for what visitors expected to see in museums. In 1951, the Museum of Archaeology and Anthropology at the University of Pennsylvania utilized this new medium by broadcasting a game show called *What in the World?* where guest curators brought in artifacts and asked audience members to guess what they were.[26]

Then came the cultural revolution of the 1960s—the antiwar protests, the women's liberation movement, and the civil rights movement, all questioning the status quo and inciting society to envision the world in new ways. Museums were challenged to expand where and how they presented their exhibits and most importantly who should guide the presentation of an exhibit. In 1967, the Smithsonian opened a branch museum in the Anacostia neighborhood of Washington, D.C., which focused on the achievements of African Americans.[27] The museum was well received because it was located within a low-income black community, sought input from members of the community, and tackled social issues particularly relevant to the locals. In 1969, the Metropolitan Museum of Art in New York followed suit but with very different results. The museum commissioned the well-intentioned "Harlem on My Mind: The Cultural Capital of Black America," presenting an extensive photo exhibition of African Americans in the twentieth century but with no curatorial input from the black community and no black artists represented in the show. Furious, protesters picketed the museum, and the Met closed the exhibit.

Advances in educational theory also shaped the way museums presented material. Since the 1800s most museum exhibits consisted of neatly labeled, orderly rows of paintings or exhibit cases. By the 1930s,

once the majority of the U.S. population could read, curators added more labels with background information. But exhibits were still primarily presented as rows of "do-not-touch" artifacts or artwork, effectively a horizontal filing system. In the 1960s, the educational theory of "learning by doing" put forth earlier in the century by noted educational philosopher John Dewey, fell on fertile soil. The Boston Children's Museum opened a groundbreaking series of exhibits that let kids take apart, crawl into, and see inside of oversized replicas of a flower, a baseball, or a toilet.[28] The California Science Center sponsored an exhibit designed by the furniture designers Ray and Charles Eames called "Mathematica," where visitors could make bubbles, test the laws of probability, and explore the beauty of mathematics. A truly revolutionary science museum opened in an abandoned airplane hanger in San Francisco. The Exploratorium dispensed with all the formal trappings of a museum and built exhibits from everyday objects. It was full of interactive, hands-on exhibits: cranks, pulleys, optical illusions, all the things that make science fun and intriguing. The exhibits required designers and educators to think "out of the box," or in this situation "out of the museum case."

SHAPING THE CULTURAL LANDSCAPE

The 1970s and 1980s were marked by a dramatic expansion of American museums, as community groups, educators, and civic institutions all got into the act of building or supporting museums. Nearly three thousand new museums were built in the space of two decades.[29] The American Association of Museums (AAM) now defined museums as covering a sweeping array of topics, including anthropology, art history, natural history, aquariums, arboreta, art centers, botanical gardens, children's museums, historic sites, nature centers, planetariums, science and technology centers, and zoos. The AAM established an accreditation program for museums, which set up standards for collections management, governance, and education within the museum community. By 1980, attendance to museums reached more than 500 million visitors a year.[30] More museums and more visitors meant that museums needed more staff, in many cases with specialized training. The university community responded by expanding the number of advanced degrees or mid-career training programs offered in the museum field.

Museums were considered an integral part of many urban development projects. Frequently, the presence of a museum sparked the cultural renewal of a city's center community. When city planners in Baltimore

considered how to revitalize their downtown—even before they built the new ballpark—their first step was to relocate the Maryland Science Center to the inner harbor and build the National Aquarium.[31]

Museum architects explored new designs, materials, and use of natural light. They designed iconic new buildings inspired by the museum's mission and content. All the same, these buildings had to meet an expanding number of functional requirements—a large gathering area at the entrance for ticketing, indoor escalators to move large crowds through the museum, and bus drop-offs and lunchrooms for school groups. The biggest impact to the architectural design was the need to accommodate alternate means of revenue. By the second half of the twentieth century, museums could no longer depend entirely on benefactors, government grants, and entrance fees to fund their operational needs. They had to look to other forms of income. Museum shops became an important part of the museum's design and function, often with a separate entrance and longer hours than the museum itself. Museum architects now designed gallery spaces to accommodate weddings and catered events and incorporated restaurants into the museum setting.

All of these innovations added to the levels of expertise expected of museums and their staff. Marketing, business development, retail management, and fund-raising became important aspects of museum work. In some areas it was no longer feasible to look for this expertise within the knowledge base of the staff, so museums relied on outside firms with specific education and training. In some cases even traditional museum functions, once carried out solely by museum staff, were now assisted by the work of consultants and experts from other industries, thus expanding the definition of "working for a museum" well beyond the four walls of a museum.

MUSEUMS AS A CATALYST FOR CHANGE

Our increasingly multicultural society continues to have implications for museums and the people who work for them. The American population has steadily become more diverse—racially, religiously, and economically—and museums have worked to represent history and culture from a more inclusive perspective. But it has not always been easy, nor will it ever be. Exhibits that are thought-provoking to some are offensive to others, and themes that are historically truthful can also be painful.

In 1993, for example, the National Air and Space Museum proposed an exhibit about the Enola Gay, the plane that dropped the atomic bomb on Hiroshima, that included the subsequent effect on the Japanese

people. The proposal caused such a national controversy, with accusation of it being un-American, that the Smithsonian was forced to change the exhibit, focusing instead on the restoration and technology of the aircraft itself.[32] In 1990 the federal government passed the Native American Graves Protection and Repatriation Act (NAGPRA) requiring museums to give back sacred objects and human remains to the tribes from which they came. And on September 11, 2001, when the World Trade Centers were attacked and destroyed, museums and the American people immediately began to collect e-mails, oral histories, photos, and artifacts from that disaster. Americans found comfort and safety in museums, as places of solace and community renewal. But the effort to memorialize the event may take years to resolve, as families and the New York community debate with city planners and architects on what type of museum will best help us remember that day.

Now, in the first decade of the twenty-first century, American museums strive to be many things to many people. We want them to collect and document our many cultural heritages. We want them to be research centers for scientific study. We want them to inspire, intrigue, and educate us, and we expect that they will do the same for our children and many generations thereafter. We expect them to fairly represent many viewpoints.

IN THEIR FULLEST CAPACITY museums are the place where we meet, debate, and discuss the issues pertinent to our communities. They are our campfire, our town square. As individuals living in a complex society we may not all agree on all issues, but museums give us the forum to keep talking about them.

WHAT ARE MUSEUMS AND WHY DO WE HAVE THEM?

*Museums ... provide the scaffolding on which
our imaginations can soar.*

—GERALDINE BROOKS[33]

Museums are the public institutions to which we entrust our valuables. They store our artifacts, our artwork, the mementoes of our daily lives and the world around us. They remind us of our history, our mistakes, and our aspirations. They encourage us to play, discover, wonder, and imagine. Today, museums in the United States have evolved a long way from the Temple of the Muses and the Museum at Alexandria. So too, the tasks involved in running a museum have expanded far beyond simply collecting things. No two museums are alike in function and museum scholars offer a variety of opinions on how to define them.

The International Council of Museums (ICOM), headquartered in Paris, describes a museum as:

> A non-profitmaking, permanent institution in the service
> of society and of its development, and open to the public,
> which acquires, conserves, researches, communicates and

exhibits, for purposes of study, education and enjoyment, material evidence of people and their environment.

The Institute of Museum and Library Services (IMLS), an agency of the U.S. government, defines a museum as:

> A public or private nonprofit agency or institution organized on a permanent basis for essentially educational or aesthetic purposes, which, utilizing a professional staff, owns or utilizes tangible objects, cares for them, and exhibits them to the public on a regular basis.

In establishing a code of ethics for museum professionals, the American Association of Museums (AAM) defines the mission of museums and the scope of their collections:

> Their missions include collecting and preserving, as well as exhibiting and educating with materials not only owned but also borrowed and fabricated for these ends. Their numbers include both governmental and private museums of anthropology, art history and natural history, aquariums, arboreta, art centers, botanical gardens, children's museums, historic sites, nature centers, planetariums, science and technology centers, and zoos. The museum universe in the United States includes both collecting and noncollecting institutions. Although diverse in their missions, they have in common their nonprofit form of organization and a commitment of service to the public. Their collections and/or the objects they borrow or fabricate are the basis for research, exhibits, and programs that invite public participation.

Edward Alexander, a noted historian and leader in the museum field, looks at museums from a slightly different perspective—the purpose they serve in our society. He suggests that museums as a group serve a number of functions: collections, research, conservation, exhibition, interpretation, and as cultural centers. And inherent in all of these functions is the role of education. Any one museum cannot serve all these purposes at once—at least not effectively. An individual museum will concentrate on several, but not all, of these roles.[34]

COLLECTIONS

The museum's collection role is often underestimated by the average visitor. A common misconception about museums is that they are glorified "attics"—a place where people donate miscellaneous stuff and where it is stored. In fact, museum staff take very seriously their task of keeping the collections in line with the museum's mission. They "accession" or acquire objects that are relevant to the goals of the museum, either through purchase, propagation, or excavation. They "de-accession" objects not appropriate for the collection, either by selling them, donating them, or returning them to their original owners. The collections staff has the responsibility of maintaining the relevance of their collection—updating scientific data as it becomes available, acquiring new, more relevant artworks and/or returning historical artifacts—and their jobs are as varied as the collections themselves. Later, we'll hear from Kirk Johnson about collecting fossils from around the world for the Denver Museum of Nature & Science and from Terry Snowball of the National Museum of the American Indian about returning artifacts from the Smithsonian's collection to Native American tribes.

RESEARCH

A museum's role within the research community varies widely and is largely dependent on the type of collection it has. Typically, science-based museums—including natural history museums, zoos, aquariums, planetariums, and botanical gardens—consider research to be a primary part of their mission. Their research staff studies the museum's collection and shares the information with colleagues at other research institutions. Their research is then used as the basis for exhibits and other programs presented to visitors at the museum. Anna Nowogrodzki will tell us about her work in a science lab at the New York Botanical Garden.

To a lesser extent, art museums may have research staff who study, for example, the painting techniques of the artists whose work is in their collections or the weaving techniques used in a particular tapestry. Sometimes the distinction between the museum's collection role and research role is blurry and staff functions overlap. History museums consider historical research so integral to their work that they may not have a separate research department; research is simply a part of what everyone does.

CONSERVATION

Caring for the collection is a museum function closely related to acquisition and research. Conserving the collection means properly storing all the objects in the collection so that they remain in good condition, utilizing proper lighting and humidity controls. It also means properly *restoring* items in the collection—cleaning, refurbishing, and rebuilding as needed. David deMuzio, a conservator at the Philadelphia Museum of Art, can give examples of some of the intricacies of furniture preservation. If the collection consists of living animals or plants, these need to be fed, watered, cleaned, or replanted, activities that all must be scheduled and tracked—diets planned, medical care scheduled, and mating cycles recorded.

The record-keeping or documentation of a collection is just as important as the conservation of the objects. The museum staff needs to know the whereabouts of each object at any given time—is it in storage, on display, on loan? They want to know the previous owners of the object, its value, who wore it, when it was made, or where it was found. They may want to have pictures or oral histories about the artifact when they prepare exhibits or publications. All the insurance records and the legal paperwork must be carefully recorded to know under what conditions, if any, the object can be sold or de-accessioned from the collection. The upkeep of the records is so important that without it, some collections are rendered almost useless.

EXHIBITION AND INTERPRETATION

For the most part, we expect more from a museum than just acquiring, preserving, and studying a collection. We expect museums to display representative parts of the collection in exhibits and tell us about the objects or information being exhibited. We expect these exhibits to be well designed, enlightening, engaging—even entertaining. In other words, we want the museum to "exhibit" the collection and "interpret" it for us in a way that a non-expert can understand and enjoy it. As noted museum author Jane R. Glaser says in her book *Museums: A Place to Work*, exhibits "are one of the most visible products of museums, a bridge between the museum, its ideas, its collections, its research, and its public."

Staff who specialize in exhibition and interpretation work hard to fulfill this aspiration. Gone (almost) are the days of museums simply filled with rows and rows of dusty cabinets. In today's museums you'll

find animated films, hands-on activities, and multimedia exhibits. Greg Hardison utilizes his unique background as an actor to interpret Kentucky history for visitors to the Kentucky Historical Society in Frankfort.

EDUCATION

Educational programs in museums are a natural extension of their exhibition and interpretation roles. Educational staff plan programs and run classes as a means of telling visitors about the exhibits. They may give tours, host lecture series, or run workshops to intrigue or inform the public about their museum. Educational programs often extend beyond the walls of a museum, to schools or other public venues, to reach those people who might not otherwise come to a museum. This emphasis on education is one of the hallmarks of American museums. Jennifer Rothman will tell us about her work in the Children's and Public Education department of the New York Botanical Garden.

CULTURAL CENTERS

Museums are dedicated to serving the communities they are in. Not only do they strive to provide exhibits pertinent to the interests of their community members, they also serve as centers for people to gather to discuss and reflect upon the important issues in their communities. Museums provide meeting halls, town hall forums, rooms for parties and celebrations, and performances. A local museum is a place where a community's stories are told, and hence a place where its members gather to share, wonder, debate, and reflect. Robert Archibald, author of *The New Town Square*, likens museums to the Hopi figurine of the storyteller who transmits history and communicates culture. He asserts that museums today have taken on the broad mission of helping us understand the ever-evolving world around us by offering us a place to explore, question, and discuss events pertinent to our communities—in effect becoming our town square.[35]

BROADLY DEFINED, museums are repositories of objects, animals, plants, and ideas. They hold in trust the ideas and things valued by our society. They display them for us—to discover, find significance in, and to ponder. By inspiring us to explore, they teach. By raising difficult issues, they foster interaction and encourage us to find solutions.

three

TYPES OF MUSEUMS

*A "museum" in the American sense of the word
means a place of amusement wherein there shall be
a theater, some wax figures, a giant and a dwarf or
two, a jumble of pictures, a few live snakes, and a stock
of dubitable curiosities.*

—ENGLISH VISITOR TO THE WESTERN MUSEUM
OF CINCINNATI, CIRCA 1820[36]

Museums come in all shapes, sizes, and levels of complexity. They have different budgets, staff sizes, and missions. They reside in big cities and small towns. They are conservative, or cutting edge, or plain quirky. No two are quite alike. The following is a general description of the categories of museums we find in the world around us.

ACADEMIC MUSEUMS

Colleges and universities often have museum collections. Sometimes these relate to the university's area of expertise and are used for research and study by the students, like the Brigham Young University Earth Science Museum. Others are collections carefully acquired over many years by a founder or major benefactor who then bequeaths the collection to the institution, like the collection of British swords donated to the Brown

University library and exhibited in the Annmary Brown Memorial. Some, like the museum at the Fashion Institute of Technology in New York City, are used as a venue for faculty and students to showcase their work. They all welcome public visitors.

ART MUSEUMS

Art museums collect and display all kinds of art—paintings, sculpture, textiles, photographs, ceramics, glass, jewelry, and furniture. Generally art museums are dedicated to preserving and displaying the art, allowing visitors to enjoy the works in a contemplative environment—letting them enjoy the artist's ideas and skill with very little interference. There are many different types of art museums, distinguished by the breadth of their collection:

- ❖ *Encyclopedic art museums* have comprehensive collections that cover many time periods and styles. A good example is the Metropolitan Museum of Art in New York City, whose collection spans more than five thousand years from ancient art through current fashion.

- ❖ *Contemporary art museums,* such as the Museum of Contemporary Art in Los Angeles or the Modern Art Museum of Fort Worth, focus their collections and exhibits on artwork by recent artists.

- ❖ *Decorative arts museums,* like the Smithsonian's Cooper-Hewitt National Design Museum in New York City, have collections of objects that are ornamental or functional, such as furniture, silverware, textiles, and wallpaper.

- ❖ *Ethnic art museums* highlight works by artists from a particular ethnic or cultural group, such as the Smithsonian's National Museum of African Art in Washington, D.C., or the Asian Art Museum in San Francisco.

- ❖ *Folk art museums* are dedicated to a particular style of art and may include exhibits from any of a variety of cultures. For instance, the Museum of Craft and Folk Art in San Francisco may feature exhibits of folk art by Japanese internment prisoners, African-American quilt-makers, or Scandinavian modernists.

- ❖ *Art museums dedicated to specific artists,* such as the Georgia O'Keefe museum in Santa Fe, New Mexico, or the Norman

Rockwell Museum in Stockbridge, Massachusetts. These museums primarily exhibit art by their namesake but may also include works the artist influenced, or was influenced by.

BOTANICAL GARDENS, ZOOS, AND AQUARIUMS

Botanical gardens, zoos, and aquariums are all considered museums in the broadest definition, in that they collect, maintain, and care for collections of living animals or plants, rather than art or artifacts. They care not only for the health and well-being of individual animals or plants but for the long-term preservation of the species through breeding and propagation programs.

❖ *Aquariums* house collections of fish, animals, and plants that live in water. Aquariums may specialize in plants and animals of a particular area, such as the Monterey Bay Aquarium, which focuses on the sea life in the local environs, or they may include specimens from many different parts of the world, such as the Mystic Aquarium in Connecticut.

❖ *Arboretums* specialize in trees and woody plants, usually ones native to the area. They are usually large tracts of undeveloped land with very few buildings or other construction. Interpretive programs consist of information at a small interpretive center, augmented by guided tours by staff or docents or by self-guided options such as maps and audio tours, as at the Bernheim Arboretum and Research Forest in Clermont, Kentucky.

❖ *Botanical gardens* are collections of plants. Specifically, they are collections of labeled plants, arrayed in greenhouses or on the grounds of a large park or estate, such as the Missouri Botanical Gardens in St. Louis.

❖ An *herbarium* is a collection of dried plants preserved largely for research purposes. Herbaria are usually located within a botanical garden, such as the herbarium at the New York Botanical Garden.

❖ *Zoological gardens*, or zoos, are collections of animals. From the visitor's perspective, zoos are places where animals are displayed, as humanely as possible, for the public's enjoyment. In fact, behind the scenes, there is an enormous amount of research going on at zoos.

CHILDREN'S MUSEUMS

Children's museums are relatively recent arrivals to the museum world. Sometimes called children's discovery centers, they are usually geared toward kids twelve and under. Children's museums have been instrumental in the creation of activities that truly engage the visitors and have had an enormous impact on influencing how the rest of the museum world thinks about its exhibits. Early pioneers—the Brooklyn Children's Museum and the Children's Museum of Boston—have taken the idea of "hands-on learning" and translated that into interactive exhibits for various age levels.

CULTURAL MUSEUMS

Cultural museums celebrate the history, art, and culture of a particular ethnic group. Particularly focused on community outreach and education, they offer a wide array of programs. An interesting example is the Smithsonian's National Museum of the American Indian in Washington, D.C., which, in fact, represents the cultures of many Native American tribes and nations across North, Central, and South America—not only their history, but the current lives and contributions of native peoples today.

GENERAL MUSEUM

General museums include a little bit of everything. The Newark Museum in New Jersey has an African art gallery, a contemporary art collection, a collection of Tibetan art, a sculpture garden, a planetarium, a historic house, and a small zoo. With such a broad collections policy, they use their exhibits as the springboard for the many and varied educational programs that are a hallmark of their mission.

HISTORY MUSEUMS

Historic museums focus on conveying the history behind a place or set of objects. The value of their collections lies in the context of the objects—who they were owned by, how they were used, or what they did. Some historic museums have very few objects in their collection and focus on the events that occurred there or the people who lived there, such as the Topaz Japanese Internment Camps in Delta, Utah. Some are re-creations of life in a particular time period—such as the Sturbridge Village in Massachusetts, with costumed staff and docents recreating typical 1830s New England life. Sometimes the collection is actually the buildings themselves, such as the Old Barracks Museum in Trenton, New Jersey.

NOVELTY MUSEUMS

By some measures, novelty museums are not museums at all because of their lack of scholarly research, or record-keeping, or professionally trained staff. But it is hard to deny that they are fun and almost always have interesting collections of stuff. Some examples include: the Nut Museum in Old Lyme, Connecticut; the Lunch Box Museum in Columbus, Georgia; and the Barbie Hall of Fame in Palo Alto, California. There is something for everyone.

SCIENCE MUSEUMS

Science museums usually have an extensive research component to their mission, and they work collaboratively with researchers in the larger academic community. They also focus on explaining their findings or collections to visitors—what they are, how they work, and why they are important.

❖ *Industrial arts museums* have exhibits about machines and tools, explaining how they work, why they were made, and the changes they brought about in a particular industry—for instance, pocket watches, zippers, sewing machines, printing presses, bridge cables, steam engines, or rockets. The Smithsonian's Arts and Industry Museum in Washington, D.C., was started with such a collection, donated from the Philadelphia World's Fair in 1876.

❖ *Industry museums*, sometimes call *company museums*, are founded by companies that are leaders in a particular field. These museums feature exhibits about the process of making their product, such as the glassblowing demonstrations at the Corning Museum of Glass in upstate New York.

❖ *Natural history museums* present exhibits based on the natural sciences, covering a broad range of topics—from archaeology and anthropology to geology, paleontology, and all the way to zoology. Some of the larger museums like the American Museum of Natural History in New York City may cover many of these topics, while smaller museums concentrate on just a few.

❖ *Science centers* are less likely to focus on collections and more likely to put their efforts into education. Institutions like the Museum of Science in Boston, Massachusetts, specialize in exhibits that explain the "how" and "why."

❖ *Planetariums* are almost always located within, or associated with, a science or natural history museum like the Hayden Planetarium at the American Museum of Natural History. These large domed rooms present star shows illustrating the night sky.

PARK VISITOR'S CENTERS

With the advent of the automobile in the early part of the twentieth century, national and state parks proliferated across the nation, and visitor's centers became a common way to educate visitors about features of the park. Very similar in function to museums, the visitor's centers at each of the national parks provide interpretive information on plants and animals, geologic formations, the lives of the people, or events that happened there.

TOPICAL MUSEUMS

Topical museums include any kind of museum that is dedicated to a specific subject and are geared to visitors enthusiastic about the topic. Hundreds of these museums dot the United States: train museums, logging museums, sports museums, whaling museums. The Museum of Television and Radio is a good example, with its collection of more than 50,000 television and radio shows in its archives.

CAREERS IN MUSEUMS... AND BEYOND

Museums offer us an opportunity to be informed and inspired, to be enriched culturally, intellectually, emotionally. Without them we would be infinitely poorer as individuals and as a nation.

—MARJORIE SCHWARZER[37]

Given the wide variety of museums, career options within them are numerous. At first glance, the array seems obvious: art museums need art curators; science museums hire staff with science degrees; zoos need veterinarians; historical museums look for experts in various areas of history. All museums want people who are good at explaining things and enjoy working with visitors. So far, this is pretty simple.

Look a little deeper, though, and one finds that each museum employs many types of skills. For instance, an art museum also needs:

❖ educators who can design programs for kids and adults

❖ photographers to document each object in the collection

❖ writers and editors to publish a bimonthly publication

❖ registrars to keep track of the whereabouts of all the objects in the collection

❖ security personnel, who keep an eye on what's happening and set policies regarding fire emergency and evacuations

❖ event planners to organize receptions, parties, concerts, and gala events

❖ development planners to apply for grants, request donations, and raise the funds needed to keep the institution in business

❖ financial personnel to pay the bills

Every museum employs all kinds of people behind the scenes to keep it running smoothly. Some work full-time, others part-time. Some wear more than one hat, doing several jobs at once. Some came to their job with a museum studies degree; others transferred skills from another industry and knew very little about museums when they started. Although there are certainly standards and general requirements for museum work, each museum tailors the job descriptions to the talents of the individuals on their staff. Like any kind of business, museums hire staff with a variety of areas of expertise, backgrounds, and years of experience. These dedicated people take care of most of the jobs needed to open the doors everyday, curate the collection, educate visitors, and in general operate and grow the museum.

BEYOND THE MUSEUM

But no matter how dedicated or talented the staff, they can't do everything. So museums also hire consultants or contractors to supplement the staff's efforts. The need for "outside" staff may simply be the result of a backlog of work, requiring extra hands to help the department catch up. So the museum might hire freelancers with many of the same skills as its staff, such as writing and editing for the annual report, to help out when the in-house staff is too busy on other projects. Or the museum may hire a consulting firm with expertise beyond the scope of the internal staff. Such consultants provide services that the museum needs only infrequently, like planning an architectural renovation or launching a new Web site. The consultant's staff will work with a museum for a defined period of time, bringing their expertise to the project, always working in close collaboration with the museum's in-house staff.

Alternatively, a museum may hire a consulting firm to provide services that it needs regularly but not on a full-time basis. For instance, large art

museums may have full-time art handlers, but small art museums often find it cost-effective to hire an outside company as the need arises. Sometimes the tasks are highly technical, such as film editing or audio recording, and best accomplished by people trained specifically in those fields. Sometimes the task just requires an outside eye, someone who doesn't work every day at the museum and can bring a different perspective to the task or decision at hand.

In short, the museum world is serviced by a whole constellation of companies. One way to look for a job "in" the museum world is to see what's available "outside" of museums. Broadening your career search in this way opens up a rich vein of job possibilities and the opportunity to work with many museums in the course of one career.

CAREER CATEGORIES

Museum jobs can be grouped in several broad categories. Building on the museum functions discussed in the last chapter, we can begin to construct a spectrum of career possibilities. For museums to effectively serve as cultural centers, they need to reach out to visitors, provide services outside of the scope of the collections, and be well-managed institutions. In order to stay relevant to the evolving society around them, museums must plan for growth and change. To meet all these needs, museums require experts in:

- ❖ collections and research

- ❖ conservation and documentation

- ❖ exhibition and interpretation

- ❖ education, outreach, and visitor's services

- ❖ administration and support

- ❖ long-range planning

On the following pages you'll find descriptions of museum jobs listed within these six categories, but it is important to note that the work done by people in these jobs is rarely contained neatly within these or any categories. The work is fluid—no one does just one thing. The work is cooperative; people frequently assist with tasks not within their job description. Each museum's staffing structure is unique and driven by the overall goals of the institution. These categories and descriptions are just guidelines for the many possibilities within the museum field.

COLLECTIONS AND RESEARCH

Curator

A curator is responsible for the oversight of a particular collection, whether it be ceramics, rare prints, mollusks, or historic cars. At one time referred to as the "keeper," the curator is the most knowledgeable person in the museum about that collection; a large museum with many collections has many curators. The curator knows about each piece, its significance in history or in relation to other pieces, and determines what new objects should be added to (accessioned) or removed from (de-accessioned) the collection. Depending on the type of collection, the curator's responsibilities vary significantly—a fish curator has a very different job than an art curator. The curator's responsibilities are not limited to the acquisition and study of the collection but frequently include the care and sometimes the exhibition of the collection. Curators arrive at their museum job with extensive expertise in a subject and usually several years working in a museum.

Oral Historian

Oral historians compile collections of audio and video recordings—first-person narratives of people who have shaped or participated in the course of history in some way—preserving the living voices of history. An oral historian is the interviewer, asking questions that elicit the stories and jog memories. He or she may also handle many of the technical aspects of the interview, and therefore has to be savvy about audio-visual recording and editing equipment. An oral historian may come to his or her job from a degree in history or from an AV background. Good people skills are probably the most crucial aspect of an oral historian's expertise.

Researcher

The type of work a researcher does depends on the type of museum he or she is working in and the specific department within the museum. Historic museums hire researchers to find information about the history of an object or artifact. Historical sites may want information about the clothing, architectural details, attitudes, or agricultural practices of a certain group of people in a certain time period. Art museums have researchers who track down information about when and where a piece of art was made. Development departments utilize researchers to summarize the interests of a potential donor in order to tailor a funding request to that individual. A research position can be an entry-level position and is an ideal way to start working in a museum.

Scientist/Lab Technician

Most science museums have a significant research component to the work they do and so have scientists on staff to conduct and oversee the research. Depending on the museum's area of focus, there may be archaeologists, paleontologists, astronomers, or any number of scientists employed at a science museum. Museums whose work is associated with living plants and animals may have arborists, botanists, or zoologists on staff. But other types of museums also require scientific research. Art museums may have a chemist on staff to analyze paint samples in order to determine the age or authenticity of an artwork. Botanical gardens conduct research on genomics or the evolution of plants and need lab technicians to assist with this research. The position of a scientist at any museum usually requires an advanced degree in a specific area of study, but starting as an assistant or as a lab technician is a good way to get a foot in the door of a museum science career.

CONSERVATION AND DOCUMENTATION

Archivist

The museum's archives store all the records and materials related to their collection, either original records or materials produced by the museum in conjunction with its work. The archivist is responsible for letters, photos, manuscripts, or other original documents maintained as part of the collection. In addition, during the course of implementing an exhibit or program, each department creates a series of records—meeting notes, contacts, schedules, and planning documents, and ultimately brochures, photos, or videos of the final event. Once the project is complete, staff members turn their files over to the museum's archives. The archivist catalogues and files them so they can be retrieved at a later date by other staff wanting to do similar projects. Archivists usually have an advanced degree and internship experience, although for some very small museum collections, it is not unheard of for a volunteer with good organizational skills to take over the role as archivist.

Conservator

The conservator is responsible for the care of the objects in a collection. Usually this does not refer to live collections of animals or plants, which would be cared for by a veterinarian or botanist. The conservator makes sure the objects in the collection are properly cleaned, stored, repaired, and restored. He or she knows the proper temperature, humidity, and lighting conditions that are best for long-term preservation of different

kinds of objects and generally has a solid understanding of what chemicals can be used on what materials to safely clean and restore them. The conservator may specialize in a type of material—such as the care of glass, metals, textiles, paper, or furs and hides. A conservator has graduate training in a specific area of conservation, which usually includes some knowledge of chemistry.

Librarian

Most museums keep a library of books and articles pertinent to the collection. Sometimes this library is open to the public and sometimes it is only available to the staff or researchers. The librarian is responsible for the oversight of the library's collection, determining what materials are included in the library and who has access to them. The training required for this position usually includes a Master's of Library Science, and the job skills are transferable from similar positions in most other institutions.

Media Manager

Increasingly, museums are making parts of their collections available online. This online database helps the researchers by making the collection easily accessible with minimal travel. It also protects the collection by providing digital replicas of information for study rather than the object or specimen itself. The media manager will oversee the photography, image scanning, data entry, file naming, and access criteria for the database. He or she is usually familiar with the collection itself, as well as technical knowledge of the database, Web access, and media system.

Movers, Packers, and Couriers

Museums occasionally have to move parts of their collections, when they buy, sell, borrow, or lend objects and artifacts. Movers, packers, and couriers are responsible for the care of the objects and artifacts during transport. Sometimes the objects are very tiny and fragile, such as a collection of hand-decorated eggs. Other times, they are very big, like a historic house being moved to a new location. In all cases, the item is extremely precious and expensive. There is no allowance for broken pottery, or scratched-up paintings, or dead fish at the end of the move. So packers and shippers are trained in the materials and techniques for packing and shipping. Couriers travel with the object, escorting it to its new destination. They come to their jobs with a proven history of being organized, conscientious, and, most of all, careful!

Photographer

The museum's photographer documents the collection by photographing each object and the details of each object. These photographs are used by the registrar for identification and documentation of the piece; they are used by the conservator in preparation for restoring a piece; they are used by the PR department for publicity purposes; and they are used by the education and curatorial department for interpretive purposes. A museum photographer is hired based on his or her portfolio of work, rather than extensive experience in museum studies, and needs to be fluent in both digital and film photography.

Registrar and Collections Manager

The registrar keeps track of every item in the museum's collection. He or she knows where each item is at all times—in an exhibition, on loan, in storage. The registrar makes sure that all the information about an object is accurate and up to date—who made it, when it was made, when the museum purchased it, who it was purchased from, how much it cost, what exhibitions it has been in, and so on. The registrar also is responsible for all paperwork associated with lending the piece—insurance forms, shipping and packing arrangements, customs procedures, photographic copyrights, and permissions. All this information is stored on a computer database maintained by the registrar, so that all the information about the piece is accessible to those who need it. A registrar usually has a museum studies degree with specific training in registration.

The collections manager's job is very similar to the registrar's, and in some museums they are interchangeable. Natural history museums and history museums usually hire collections managers, sometimes instead of curators. Like the curator, they are responsible for the collection, but the collections manager is also an expert is categorizing and numbering objects and specimens in the collection—rocks, insects, bone fragments, historical letters, etc. He or she will work in collaboration with historians and research scientists and in small museums may take on the tasks of the registrar. A collections management position usually requires a museum studies degree with specific knowledge about the collection.

Veterinarian and Animal Keeper

Veterinarians and animal keepers take care of the animals housed in zoos. The keepers attend to the day-to-day feeding and cleaning of the animals in consultation with animals' curators. Veterinarians take care of animals

that are sick or injured. A keeper is usually an entry-level position and a good way to be considered for this job is to start by volunteering at your local zoo. A veterinarian position requires an advanced degree and usually several years of experience.

EXHIBITION AND INTERPRETATION

Actor

Increasingly, theater and performance arts are being incorporated in museums as a means of conveying information and sparking discussion among visitors. Museum theater can run the gamut from multi-actor pieces on a proscenium stage to storytellers and puppeteers circulating among the visitors to large reenactments interpreting milestones in history. Actors and actresses use their performance training as a method to interpret the exhibits and educational information presented in museums and to "bring it alive."

Docent, Tour Guide, and Docent Coordinator

Museums depend on a cadre of volunteers to provide many of their services. Some volunteers interact with the public on a day-to-day basis, giving tours, answering questions, and helping to interpret the exhibits. Still others work behind the scenes, helping with special events, fundraising, program planning, or just keeping things fixed. Often there are many more volunteers in a museum than there are paid staff. Museums welcome docent volunteers with any level of skill or expertise. The job of the docent coordinator is to recruit and train all the volunteers in the museum and ensure that they are well suited to their "jobs." The docent coordinator has to be an excellent people person, knowledgeable about the museum's subject matter and good at motivating and engaging the volunteers in the work of the museum.

Exhibit Designers and Fabricators

Museums are full of exhibits. Loosely defined, exhibits are what people see, do, learn from, or are inspired by at the museum. Sometimes exhibits can be crawled on, pulled on, touched, listened to, or altered by the visitors. Sometimes visitors push buttons, turn knobs. Sometimes exhibits are to be looked at, admired, thought about, and wondered at. The exhibit designer works with the curatorial staff or education department to understand their vision for the exhibit and then determines what the exhibit

should be and how it should be built. Sometimes a museum has an in-house exhibit design staff, but just as frequently an outside firm is hired for its expertise in regard to the project. The more complicated the exhibit, the more people it takes to design it. A highly interactive exhibit needs a team of specialists including:

❖ interactive designers who determine what the activity is and what visitors will see, do, and learn from it

❖ illustrators to visualize and communicate the ideas of the design team

❖ computer software specialists who design the software and media components

❖ drafters who draw up how the exhibit will be built

❖ graphics designers who design the signage and graphics around the exhibit and any graphics used on the computer screen

❖ acoustic designers, if there are a lot of audio components in close proximity to one another

❖ lighting designers to set the mood of the exhibit or incorporate lighting effects into the interactive portion of the activity.

Once exhibits are designed, they must be built, typically by a team of people. Some museums do this in-house, others hire exhibit construction firms or fabricators who might have on staff:

❖ carpenters, welders, or artisans to build the physical elements—walls, casework, models, or replicas for the exhibit

❖ AV producers to produce the audio-visual materials

❖ systems integrators to configure and install all the computer and audio-visual equipment

❖ installers who set everything up in the exhibit hall and, in the case of traveling exhibits, move to new locations.

Writer

Writing is central to the work of many departments in a museum. During exhibit design phases, writers communicate the concepts and educational objectives for the exhibit to other team members and write the text

for the labels and graphics panels and the scripts for films, audio tours, or plays. Writers are essential in the publications department to write text for brochures and other publications, in the education department to write curriculum guides, and in the development department to write grant proposals, solicitation letters, or any other kind of written communication that the museum may need. Writing can be an entry-level position, working under the guidance of more senior experts, but good writing skills are very important in almost any job in a museum.

EDUCATION, OUTREACH, AND VISITOR'S SERVICES

Audience Researcher

One of the things that museums need to know is what visitors think of the museum. Are they impressed? Did they learn something? And most importantly, are they inspired to come back? Audience research surveys, or visitor studies, use various methods to poll visitors to understand their likes and dislikes about an exhibit or museum. The museum's education department uses this information to tailor its programs, and the exhibit design team uses it to plan future exhibits. Audience research helps museums ensure that they meet the needs and expectations of the people they serve.

Educator, Teacher, and Education Director

At one time, education of the public was a very minor aspect of museum work, but today, a large part of a museum's mission is to reach out to visitors and help them understand and appreciate the collection. This is done in a variety of ways, including classes, workshops, demonstrations, tours, special events, brochures, audio and video programs, school programs, and so on. The education director is responsible for planning and implementing all these efforts and coordinating them with the exhibits scheduled by the curatorial department. The education director usually has a degree in education and several years experience working in a museum or similar nonprofit institution. Teachers may be hired based on their teaching credentials, or they may be volunteers with a particular capacity for working well with people.

Events Coordinator

Museums host all kinds of events. They have parties to raise money and parties to celebrate new openings. They rent their galleries out for weddings and other private events. The events coordinator schedules and oversees

all these events working with the chairperson or the bride to coordinate invitations, catering, decorations, and hundreds of other details. The events coordinator's skills are in management and coordination of people.

Public Relations Director

The public relations director manages the flow of information from the museum to the public via the news media, special events, press interviews, and advertisements. The PR director works with the other departments within the museum, especially the fund-raising and development office, to coordinate all brochures and information packets going out to the public. In general, the PR director is responsible for the museum's public image as perceived by the community it serves and usually comes to the field from a background in public relations, communications, or sometimes journalism.

Publications Director and Editor

A museum publishes newsletters, brochures, press materials, Web site articles, and sometimes books. If the number of publications is large enough, the museum establishes a separate publications department to produce all these materials, headed by a publications director. The publication director, in association with a staff of editors, writes or revises all the materials the museum publishes. Sometimes one of editors assumes responsibility for writing the exhibit labels and text for the exhibit catalogues. Editors may come to a museum position from any number of other fields or straight out of school as long as they have good writing and editorial skills.

Web Site Manager

A museum's Web site is an important component of the marketing and outreach efforts. Visitors check the museum's Web site before they leave home to see what hours the museum is open, how to get there, and what to expect when they arrive. This may be the point that visitors decide whether to come at all. The Web site needs to be interesting, accurate, and reflect the style and aesthetics of the museum. It also needs to be kept up to date. The Web site developer designs the look of the pages, collects the information, and sets up the initial Web site. Once the site is up and running, he or she may then hand it off to a Web site manager, who doesn't need the same level technical expertise but will be responsible for maintaining the information on the site—new exhibits, classes, whatever information changes on a regular basis.

ADMINISTRATION AND SUPPORT

Business Manager and Financial Officer

The business manager at a museum is similar to a business manager at any other institution. He or she is responsible for determining budgets, paying bills, proper administration of endowments and contracts, and oversight of revenue-producing activities, such as income from admissions, membership, or the retail shop. The business manager usually has a background in business, rather than a museum studies degree.

Development Officer

The development department is responsible for all the ways that the museum raises money—from membership, to special events, to public and corporate campaigns. The development officer is responsible for planning all the fund-raising efforts of the museum in conjunction with the events manager. He or she will estimate the amount of money each project will raise and evaluate the projected income against the costs. Development officers come to their museum job with a background in fundraising, PR, or marketing in a related nonprofit setting. He or she oversees a staff that includes writers, researchers, and financial planners.

Director

The director provides the leadership for the museum and oversees the work of all the departments, so that the institution works as a coordinated body. Along with the board of trustees, the director sets policies for the museum and is responsible for its financial success. Guided by the curatorial and education departments, the director makes decisions about what objects the museum collects and how and when they will be displayed. As the "voice" of the museum, the director is the person most likely to represent the museum at public events. The director comes to his or her position usually after many years in the museum field and often with a museum studies degree.

Retail Shop Manager

Most museums have a shop where visitors spend a significant portion of their visit. The shop must serve the entire range of visitors that come to the museum and provide interesting merchandise for the upscale art collector as well as the legions of school groups on class trips. The shop

manager determines what is sold in the museum shop, keeping the product selection in line with the museum's themes and mission. He or she hires and manages the staff, keeps track of all inventory, and oversees all the financial and operational functions. Museums generally look for shop managers with a background in business or with other retail management experience.

Security Staff

A museum's security staff is responsible for ensuring the safety of all the objects, plants, or animals in its collection. They are responsible for the safety of the building and all the people on the premises, including both staff members and visitors. The security chief establishes policies and plans for all security procedures, emergency plans, crowd control, and package surveillance to protect the building, collections, visitors, and staff against damage or injury. He or she usually has a degree and experience in law enforcement and oversees a staff of security guards stationed throughout the building or grounds.

Superintendent, Facilities Manager, and Operations Manager

The superintendent is responsible for the museum's building and grounds. He or she makes sure that the facility and its operational elements (heating, cooling, phone service, etc.) are in good working order, proactively services and repairs everything, and plans long-range upgrades (e.g., a new roof, upgraded wiring for Internet service). The superintendent also works with individual departments to ensure that they have the proper space and work surfaces to do their job. For instance, if the conservator is restoring a particularly large canvas, the superintendent makes sure she has a large enough work surface in a properly ventilated room.

Technology Specialist

As the use of computers and other specialized technology becomes more prevalent in museums, so too does the need for qualified staff to install and troubleshoot the equipment. Increasingly, museums include technology specialists on their staff who can maintain the computers, networks, scanners, and audio-visual equipment utilized on the administrative side of the museum, as well as on the exhibit floor. As in any other industry, these staff are hired based on their experience and level of expertise with the equipment.

LONG-RANGE PLANNING

Architect

With only a few exceptions, museums exist in or around buildings—buildings built especially to be museums or buildings retrofitted to become museums. A museum architect works with the director or the board of trustees to define the aspirations and functional requirements of the space and then designs the building, wing, or restoration project. The process goes through many iterations and phases including presentation to city council groups. The architect must have an architecture degree and may possibly have additional degrees or areas of expertise, such as engineering, energy-efficient design, or historic preservation.

Board of Trustees

An important part of the leadership of a museum includes the board of trustees. They work on a voluntary basis assisting the director and senior staff. A governing board has a management role in that they hire the director and are responsible for the financial health of the museum. An advisory board has less authority and acts in an advisory capacity to the museum. In either case, members of the board dedicate many hours of their time serving as trustees and represent the community's best interests in any long-range planning for the museum.

Landscape Architect

Landscape design is the design of the outdoor space around the building—although sometimes the outdoor space *is* the museum, such as the sculpture park at the Storm King Arts Center. Landscape designers are concerned with the structure of the outside terrain—not only the trees and plantings but how best to arrange the buildings and outdoor spaces for public use. They'll look at how to situate the building relative to the topography of the land and the solar orientation. They'll plan the parking lots and walkways to accommodate pedestrian, wheelchair, and vehicular traffic. Landscape designers try to reflect the aesthetics of the museum in the outdoor space around it and connect the museum to the surrounding community or environment. Like architects, landscape architects are needed only infrequently in the life cycle of most museums, so they usually work for consultancy firms and are required to have a degree in landscape architecture.

Strategic Planner

When a museum is looking to undertake a major expansion or wants to make a significant change in its mission, it often enlists the help of experts in the field to help it define its direction, figure out how much it will cost, and how to accomplish the plan. Usually this is best accomplished by a consultancy firm with experience doing this work with other museums. These firms bring experience in community planning, fundraising, and management training to help the museum achieve their goals. The owners and partners of these firms have extensive museum experience, but many of the staff will have more general skills.

AND THESE ARE JUST a few. There are variations, permutations, and specializations on all of these. In the next section of the book, we'll meet some of the people working inside and outside of museums and hear what they have to say about their jobs. In many cases they've moved from some other field into their museum job. How did they get there? What skills or opportunities helped them make the jump into the museum job? What are the challenges and rewards they experience in their work?

PART II
MUSEUM CAREERS

A collection consists of much more than the objects within it. A collection usually reveals something significant about the collector, his or her ideals, and even society at large.
—MARJORIE SCHWARZER[38]

T he best way to learn about museum jobs is to hear directly from individuals who work in them, finding out what they do and how they got there. In this section, we'll hear from people in a variety of jobs; they'll tell us how they arrived at their museum career and the skills and background they find essential to their work. These folks work in institutions large and small across the country. Some knew early on what they wanted to do for a living. Others took circuitous routes to get where they are, starting out on completely different career tracks and then moving into their museum jobs—gradually or suddenly, intentionally or by a stroke of luck.

On the following pages you'll find a selection of interviews with people who work in and around museums. In general, they are grouped into categories defined by the type of work being done:

- ❖ Gathering the Collection: Collections and Research

- ❖ Caring for the Collection: Conservation and Documentation

- ❖ Putting on a Display: Exhibiting and Interpreting

- ❖ Engaging in Conversation: Education, Outreach, and Visitor's Services

- ❖ Running a Tight Ship: Administration and Support

- ❖ Looking to the Future: Long-Range Planning

But it is important to note that none of these jobs are so specifically prescribed that they don't overlap with other functions and departments within their institution. No job fits neatly within any one category, and many jobs span quite a few. In general, museum folks are dedicated not only to their work but to the larger mission of their institution. Let's see what they have to say.

five

GATHERING THE COLLECTION: COLLECTIONS AND RESEARCH

Museum collections vary widely, as do the jobs that pertain to the acquisition and research of the collection. Some collections are object based, involving artwork, fossils, or historical artifacts. Some collections, like zoos and botanical gardens, contain representative samples of living animal or plant species. Others are collections of intangible items like memories, ideas, or electronic data. Whether a collection consists of preserved specimens, or works of art created with great expertise, or animals saved from extinction, somebody—often a team of people—was responsible for assembling it.

Who finds and assembles the collections in a museum? What kind of research and study is conducted on those collections? And when is it appropriate for a museum to no longer keep artifacts in its collection? We'll hear from several people responsible for collecting and studying their museum's collections:

❖ **Kirk Johnson,** who travels the world collecting fossils for the Denver Museum of Nature and Science

❖ **David Powell,** an animal curator in the mammal department of the Bronx Zoo

❖ **Shipherd Reed,** who collects oral histories for the Miner's Story Project at the Flandrau Science Center in Tucson, Arizona

❖ **Anna Nowogrodzki,** a lab technician at the New York Botanical Gardens, studies the genetics of flowering plants

❖ **Terry Snowball,** who works at the National Museum of the American Indian repatriating artifacts and remains back to native communities

" ... finding fossils. ... the joy of finding something no one has ever seen before."

KIRK JOHNSON

Vice President of Research and Collections and Chief Curator
Denver Museum of Nature and Science, Denver, CO
www.dmns.org

It is an unusual day when you find Dr. Kirk Johnson in his office. His extensive travel schedule keeps him moving around the globe in search of a thin layer of fossils that mark a very specific point in geological history. But when you catch a few minutes of his time, his easy-going and affable manner belies his over-busy schedule, and he speaks with enthusiasm about his work at the Denver Museum of Nature and Science.

OUR MUSEUM IS SURPRISINGLY large for where it is located. Depending on how you measure, it's the fourth largest natural history museum in the country with the Smithsonian, the American Museum, and the Field Museum in front of us. Denver is the twenty-fifth largest city in the country, so the museum is relatively large given the size of our market. It's been around forever. This museum was founded in 1900, which, considering the fact that Denver itself was founded in 1858, is pretty remarkable. The building has been enlarged ten different times in the last 108 years, so it's a big onion basically.

A lot of natural history museums are coping with the challenge that they need to be more audience focused, and in doing so they are becoming less collections and research focused. We're trying to push ahead on those two fronts simultaneously. We fundamentally believe that if you don't have experts in the house, then you don't really have the credibility you

need to present the scientific information to the world. A lot of science centers don't have scientists on staff, and so they don't actually produce new knowledge. What we do here is try to strike a balance between presenting scientific information to the public and preserving the collection for the scientific staff to study, which in turn ensures that what we present to the public is accurate.

One of the most unique aspects of the museum is our tremendous volunteer corps. There are sixteen hundred active volunteers. On any given year we'll accrue approximately 140,000 hours of volunteer time, which is the equivalent of seventy full-time employees. The volunteers do everything—some take tickets, some organize lecture series, and a lot of them get involved with the process of science and science interpretation. So when I make a discovery in the field I might have twenty to thirty people working with me on the science end of it and a hundred people working on the interpretive end of it—and they're all volunteers.

I'M A SCIENTIST WITH a strong interest in the interface of art and science. I think that's because paleontology, which is my field, is deeply imagination based. As a paleontologist, you're always finding fragments of things and then imagining the whole from the fragments.

I've been here for sixteen years and my role has evolved over time. Now I have two job titles. I'm Vice President of Research and Collections and Chief Curator. In my role as VP of Research and Collections; I oversee the museum's six areas of scientific study: geology, paleontology, zoology, anthropology, health sciences, and space sciences. I also oversee our conservation department, which takes care of our collection; our registration department that documents our legal ownership; and our library and archives, which record the big metadata that goes into the collection. Finally, I oversee our adult programs department, which coordinates a variety of courses, lectures, and classes; and our education collections department, which maintains collections for use in our education classrooms and with interactive exhibits.

I'm very much a world traveler—about 50 percent of my time. As a scientist, that is an important part of my job. I've never met anyone else who has gone to every continent as part of his or her job description, except maybe the *National Geographic* people. I've spent a lot of time in Asia, Mongolia, China, Japan, India, Australia, and New Zealand and a fair amount of time in Antarctica, Patagonia, Greenland, the Canadian Arctic, and Alaska. I've traveled the whole spine of the Rockies. I've

spent a little bit of time in Europe and in Egypt. That level of travel and interaction with different cultures is great. There's never one day that is the same as another, and there's never a boring day.

MY SPECIALTY IS WHAT happened to plants when the dinosaurs went extinct. That time period is called the K-T boundary, the Cretaceous-Tertiary boundary—an event that happened 65.5 million years ago when this big asteroid struck Mexico. It kind of adversely affected the planet for a while. The problem is that to study the K-T boundary you have to find exposures of rock that are at the surface today that were exposed surfaces exactly 65.5 million years ago. You're looking for a strata of sedimentary rock that is about a centimeter thick. That is a real challenge—like looking for a needle in a haystack. But it's pretty fun when you find it. I've traveled the world looking for that. The best examples are in North America. One of the great successes we found was a K-T boundary layer thirty-eight miles east of the museum.

The interesting thing about the K-T boundary is that because it was caused by an asteroid impact, it's effectively the only worldwide time maker in the geologic record that has a precision of less than a year. So what we do—once we find that layer—we collect fossils from below that layer and from above it. We compare the fossils and begin to pose questions about how things changed with that event, like "When was the first tropical rain forest?" It turns out that most of the modern biomes that we have—tundras, prairies, grasslands, grass-based savannahs, and tropical rain forests—have all come into existence after the extinction of the dinosaurs. The world as you know it may in part be shaped by the random impact of an asteroid—or maybe not. We pose those questions and then collect data. And the questions always change. As a scientist you are driven to do what you do by curiosity, and you don't necessarily ever discover what you set out to discover—you almost always discover something else. You are following a path that is not predetermined. If you knew the path ahead of time it wouldn't be discovery.

We collect dinosaur fossils whenever they become available—especially if the sites are local. We've spent a huge amount of time collecting in the Denver area in the last decade because Denver is growing and there is a lot of construction. When there's construction, there's excavation for construction, and when there is excavation for construction they find things. We grow our collection tied to the economy because housing creates excavation. We try to get into the excavation site before they

build the building. That's a big part of my work, though I can tell you the building excavators *really* don't want to hear from me!

I do a lot of consulting on the side too. One of my areas of specialization is the reconstruction of ancient landscapes. If you image the scenery behind a dinosaur, how you construct that landscape is pretty interesting. And a picture is really worth a thousand words. I've collaborated with probably fifteen different artists in making these ancient landscapes. Some of the really successful ones are when you juxtapose a local landscape with what it looked like 70 million years ago. Intellectually, people might know that the middle of Colorado was covered by seas in the Cretaceous Period, but to actually see an image with reptiles flying over the sea, and say, "This is Denver 70 million years ago," that's a much more compelling hook.

IF YOU HAD ASKED me what I wanted to do when I was a kid, I would have said I wanted to be a museum director. As a little kid—four, five years old—I got into collecting rocks and fossils and arrowheads. They were like treasures. I liked stuff I could find and collect. When I was about twelve, I met an artist who was a volunteer at the Burke Museum in Seattle, and we struck up a friendship. As a consequence, I came to know that museum and the people who worked there. When it came time to go to college, I was interested in geology, paleontology, and art. I chose a college that had a really cool museum. When I went for my college interview I met the guy at the museum. He said, "If you come here we'll give you a job, for sure." So I started working at that museum on my first day of college and worked there the whole time I was in school. After I got my undergraduate degree, I went on to graduate school and did collections-based research. I eventually got a job here at this museum as an assistant curator and have worked my way up from there.

A lot of scientists work in museums because they want a place to do their science—that's their end goal. And that's part of my end goal, but I also know that museums are places that have always been very evocative for me. When you say the word "museum," people immediately have an image of what that means. It might be an art museum, a history museum, or a science museum, but it conjures up an image and an experience of imagination—they are ready to be transported. It's been a long-term goal of mine to work in a museum.

The best part of my work is public speaking and finding fossils. One involves engaging a crowd and seeing what they know and then amazing them with something they don't know. The other is the joy of finding something no one has ever seen before.

I'D SAY THERE'S a real trend in the museum world in terms of staffing. As the jobs in a museum become more specialized, museums are out-sourcing a lot of what they do—using more consultants. When I first got here, we had a fifty-person exhibit staff that included taxidermists, sculptors, painters, diorama cleaners. Now we have an exhibit staff of eleven, and when we build a big exhibit we'll contact an exhibit design firm.

One of the biggest challenges we face as a society is to figure out how we are going to live on this planet. Everything has to be viewed in context of how many people there are in the world. When my mom was born there were 2 billion people on earth. When I was born, we hit 4 billion. Now the population of the world is 6.5 billion people. In a single life, the population of the earth has tripled. The other two issues that will force a lot of our decisions in the future are energy and climate. All three of these issues—human population, energy, and climate—live in the purview of the natural history museum. And museums are the places where we are obligated to engage people in these conversations.

The world has changed dramatically in the last two hundred years—some of the most dramatic changes humanity has ever faced in our 700,000 years of existence. In geologic time, this event is almost as abrupt as an asteroid hitting the earth. It's a very interesting time to be alive.

"I like working with a dynamic collection that is breeding. It is definitely seasonal business—sometimes it's snow-leopard season, sometimes it's wild dog season—sometimes it's giraffe season."

DAVID POWELL

Assistant Curator
Mammal Department, Bronx Zoo, Bronx, NY
www.bronxzoo.com

One of the primary responsibilities of a curator is to determine a collections plan for the museum—deciding which pieces of art a museum should purchase or planning research expeditions to collect new specimens. In David Powell's case, he oversees a collection of live animals at the Bronx Zoo, so "growing" the collection includes carefully monitoring a breeding program in collaboration with other zoos around the country.

I'M AN ASSISTANT CURATOR in the Mammal Department at the Bronx Zoo. Generally, in zoos, a curator is responsible for the oversight of a particular part of the collection of animals. Most zoos have several curators, each responsible for a particular taxonomic group—a curator of mammals, a curator of ornithology, a curator of herpetology, and so on. Here at the Bronx Zoo, we have the largest mammal department of any of the zoos in North America, so we have three mammal curators. I'm one of them. My area of expertise lies in carnivores and ungulates—hoofed animals.

Each curator directs the overall care of their part of the collection. We decide what species to exhibit and how to design the exhibits—we aren't trained in architecture or exhibit construction, but we give the designers the requirements so that we can ensure proper care of the species on and off exhibit.

For the collection itself, the curator is responsible for developing a collections plan that determines what animals we'll have, what animals we'll bring in, what we'll send out, what we'll breed, and what we'll just maintain for exhibit purposes. For certain species, like tigers, the zoo participates in a collective management program called an SSP—Species Survival Plan. For each SSP species there is a species coordinator and a stud book keeper who maintain what is called a "stud book"—a pedigree, a breeding registry of all the living and deceased animals. Then, specialists take all that data, look at the genetics and demographics, and make pairings of animals. The SSP coordinator sends out these pairings to the zoo. So I may get a recommendation to bring in a male from Philadelphia or send my female to Philadelphia or things like that. For those species, the curator usually is the primary contact.

These days, the vast majority of animals that we bring into the collection come from other zoos. This is particularly true with the mammal collections. It's very rare that we'd import an animal from the wild. Some of the other taxonomic groups—bird, reptiles, and amphibians—may import from the wild. Generally the regulations for moving mammals in and out of the country are much more stringent. So we tend to work most of our mammal transactions through AZA-accredited zoos.

The Association of Zoos and Aquariums (AZA) is the body in the United States that provides accreditation to zoos in this country. We only deal with zoos that have been accredited by the AZA. Different zoos are different, but here we try to only deal with accredited zoos—certainly in sending our animals out. Occasionally for some species, we will take an animal from a non accredited institution. For instance, a rehabilitator may have an injured hawk or waterfowl that needs to be placed.

Because we're such a big zoo, and historically we breed a large percentage of our collection, it's more likely that we'll supply other zoos with animals. All told, we'll probably bring in or send out about one hundred animals a year. The majority of that one hundred will be groups of rodents or small animals. Some animals are sent out on exhibit loan, with the stipulation that they cannot be bred. Some animals are sent out on breeding loan. In a breeding loan, part of that agreement is deciding who owns the offspring. Typically, one institution will take the first, third, and fifth offspring, and the other will take the second, fourth, and sixth; something like that.

I'VE ALWAYS KNOWN that I wanted to work with animals. And I knew pretty early on that I didn't want to work with the insides of animals, so I never followed the veterinary track.

I started working at Zoo Atlanta—that's where I'm from—when I was fifteen or sixteen. I was working mostly with visitor services at that point. I started college as a marine scientist. After my freshman year of college, I did an internship at the zoo as a keeper in the mammal department and my interests began to shift on land. I was always really interested in animals and their behavior and ecology, whether it was marine or terrestrial animals.

When I finished college I knew I wanted to find a curator job, or research position, or a field conservation job. But I needed an advanced degree for any of those. So I went to graduate school and got my Ph.D. I still pretty much knew I wanted to be associated with zoos and work with animals, but I also learned over time that I liked managing people. My training is in animal behavior, with a minor in psychology. I have an interest in how organizations work, how to motivate people and get teams to work together. I've always been interested in understanding the dynamics of animal societies and human societies. So this is a great job for me because there is a large personal component.

HERE AT THE BRONX ZOO, we require a PhD for our curators. An animal curator in a smaller zoo would need a lot more practical skills—how to restrain a gazelle, or how to tie the right kind of knots, things like that. There are plenty of curators at zoos in the United States who do not have advanced degrees but who are seasoned animal people. They've learned their job by working as a keeper and moving up the ranks over a number of years. In a smaller zoo their keeper skills may get called on more frequently than mine would.

A few places have separate collections managers in addition to curators. In that case, the curator is responsible for all the administrative stuff—hiring and training, and oversight of the collection, setting policy for the department, budget management, and strategic planning. If there's a collections manager, they are responsible for overseeing the daily care of the collection. That way, the curator can focus on the higher level needs of the department—so we aren't pulled out of our office for a tamarind that is losing weight. The collections manager will direct that—work with the keepers to get that animal from its enclosure to the veterinary hospital. The curator is always in a management role. We develop the collection plan and give it to the collection manager. Then it's their job to implement the collection plan. So the curator provides the input but the collections manager oversees the execution of the plan.

THE GROUP OF ANIMALS that has occupied a lot of my attention has been our African wild dogs. This is a species that I've always wanted to work with. It just so happened about the time I started here, two and a half years ago, the zoo had planned to open an exhibit for them. So we acquired a pack of dogs from a breeding center in South Africa that is set up to protect some of the endangered species in that part of the world. Now we have over thirty individuals in our pack. It's the largest population in North America.

These dogs are an *intensely* social species. There is a lot to learn about them and our pack has been anything but predictable. They are a species we touch base with on a daily basis. It's a complicated society—there is dominance in the pack, there's submission, there's alliances, there's sneakiness, there's maternal care, there's paternal care, uncles, aunts. It's incredible to see that society unfolding and evolving. We've produced a number of litters, so we get to see the variety of life stages and have been able to document their growth and development. We've put surveillance cameras in the den boxes, so we've been able to see what even field research haven't been able to see as far as what the female is like in the den—how much time she spends there, how much time she actively nurses the puppies. We've made some unique contributions to the body of research on this species.

So that part of my job really generates a lot of positive energy for me. In general, I like working with a dynamic collection that is breeding. It is definitely seasonal business—sometimes it's snow-leopard season, sometimes it's wild dog season—sometimes it's giraffe season. That's what's rewarding. There's always something to look forward to.

**"The storytellers have shaped the stories—fashioned
them into their most effective format, and that,
in and of itself, is interesting."**

SHIPHERD REED

Project Coordinator: Miner's Story Project
Flandrau Science Center, University of Arizona, Tucson, AZ
www.minersstory.org

*Shipherd Reed is a people person. He is easy to talk to and a good listener—skills
he puts to use collecting oral histories from miners and their families. These oral
histories are the "artifacts" in a growing collection of stories about the history of
the mining industry in the southwest United States.*

THE MINER'S STORY PROJECT is an oral history project designed to collect
oral histories from men and women who worked in the mining industry
in the southwest United States. The project is a collaboration between
the University of Arizona and the University of Arizona Mineral Museum,
which is part of the University of Arizona Science Center. Eventually, the
interviews will be available on searchable kiosks at the Science Center.

Mining played a huge role in the economic development of Arizona
and New Mexico. Before air conditioning, people didn't have a lot of
interest in coming here because it was so hot in the summer. But the
mining brought people. It paid good money and gave birth to the towns
where miners and their families lived. Every time I talk to someone in
Tucson or elsewhere, even if they have nothing to do with mines or have
never visited one, they're related to someone who worked in the mines—
a grandfather, father, or uncle—or they know people connected to the
mining industry. It's a huge part of the heritage here.

I AM THE PROJECT COORDINATOR. I didn't really comprehended all
that I would be responsible for when I started this job, but happily, the
project has grown since I came aboard. What I imagined I'd be doing—and
it's my favorite part of the job—is going out to these old mining towns and
talking to men and women who worked in the mines—predominantly
men, in the case of the older miners—but also the families. I've talked to
a lot of women who were born and raised in these towns and seen a lot of
history. I interview them and record their stories. Then I edit and compile

all those interviews. I also collect photographs if people have them. I'll scan the photos and store them with the digital recording. Some of the stories I'll edit and put up on the Web site.

We do a lot of outreach, so I do presentations all over the place. I'll take our trailer to events like the Tucson Gem and Mineral Show and set up a booth where people can sit down and listen to stories and learn about the project. It's good for publicity but sometimes we end up signing up more people than we can catch up with. We've received a lot of positive publicity—KJZZ in Phoenix has picked up some of our stories. They broadcast them, so more people have heard about the project, so more people contact us.

I'm also working with the woman who is putting together a copper exhibit here at the Science Center. Part of that exhibit will be photographs and stories from the Miner's Story Project. So I've been helping to design that and figure out how to use the content as engagingly as possible.

I have so much on my plate I'm not able to keep up with everything. The way to remedy that is by writing a new grant proposal, which has also fallen to me. One of the reasons I'm so swamped is the project is successful. At the moment, I'm hopelessly backlogged.

WHEN I STARTED, I certainly never dreamed that I'd be working on something ultimately destined for a museum. I went to film school at Columbia University. I moved to Los Angeles and worked in the film industry for a while. In 1999, I went to the Sundance Film Festival with a friend's film. While I was there, I attended a seminar about digital film making and discovered that you could shoot relatively high-quality video and edit it on your home computer. So I turned my attention to that and became a freelance cameraman and editor in Los Angeles. I learned a lot about digital media and digital media management.

Then, I met my wife-to-be in Tucson and ended up moving here, not knowing what I was going to do. I was a little apprehensive about how my skills would fit in here, but I found the listing for this job. I'd worked on documentaries before—both shooting and editing. I'd conducted lots of documentary interviews so it seemed like that would be a good fit. Also, they wanted someone who understood digital media, and I did. In addition, my mother's family is from Colorado and I've always been fascinated by the history of the western United States. I was very excited to read about the job, and I applied not knowing what the applicant base was like. I got it and I'm so glad I did. It's not where I would have ever speculated I'd be at this point, but it's really been fascinating and rewarding.

PEOPLE SKILLS COME naturally to me. I've always been curious about the world and I'm able to talk to a wide variety of people. I guess it's just my temperament. I am able to put people at ease after I meet them and start talking to them. That has been a big asset in doing interviews.

Collecting interviews is a fascinating process. I go to a new town and start out by making a number of contacts—usually at the town hall, the local history museum or historical society, and the local newspaper. I contact people, explain what I'm doing, and try to get coverage in the local newspaper. That usually brings in a few people. But people don't really know who you are. Saying I'm from the University of Arizona gives me some credibility, but I have to wait until the networking process gradually begins to work its way through the community.

The networking process is interesting. People are at first a little leery—What are you doing here?—What do you want?—there's not an immediate sense of trust. But I've found that after I've done a few interviews, I'm able to earn that trust. Then, they'll suggest friends I should talk to, and they'll pass along the word. These are small communities and the word gets out. Everybody who participates gets their own copy of the interview—people really appreciate that. I've received some touching phone calls and letters from children of some of the men I've interviewed who have since passed away. The families are deeply grateful to have that story of their father's career in mining.

THERE ARE A FEW PEOPLE that I've encountered that not only have had interesting lives but also have an innate gift for storytelling—it's a thrilling experience to find those people. Often they may push or pull the truth to a degree, but you can tell that those stories have been told and re-told numerous times. The storytellers have shaped the stories—fashioned them into their most effective format, and that, in and of itself, is interesting. That gets into the folklore aspect of mining and mining culture. Miners are very proud and much of their work was very physical, so there is a fair amount of machismo. Those stories are met with great glee by other miners, and by myself as well. I'm less concerned about whether the story is slightly apocryphal; I'm more interested in whether it is a good story and very well told.

Sometimes I'll contact someone and they will have heard about me, so they say, "OK, but I don't think I really have much to tell you. I've never done that much in my life." It turns out they've done amazing things. They come to understand in the course of the interview that their experiences are

unique, that they have interesting stories to share and a perspective on life and history that other people don't have. It's very rewarding to see people come to that realization. Almost everybody has something unique and interesting to offer—it's just another good reminder in life.

Ultimately this is a rewarding occupation because you feel that you are making a difference and enriching people's lives.

"When people ask what I do, I say I pipette all day."

ANNA NOWOGRODZKI

Lab Technician
The New York Botanical Garden, Bronx, NY
www.nybg.org

Anna Nowogrodzki works at The New York Botanical Garden studying the evolutionary history of plants. She made an interesting career move from an editor at a publishing company, to a lab technician in a genomics lab.

I'M A LAB TECHNICIAN at The New York Botanical Garden. I work in the Plant Genomics lab—one of several labs here at the garden. Specifically in my lab, we're studying ginkgos and cycads and other plants related to them. These are plants that evolved before flowering plants—they are the earliest plants to evolve seeds that are still alive today. They're called "gymnosperms." In my lab we're studying how seeds evolved by looking at the genes in ginkgos and cycads and comparing them to genes in other plants. We isolate DNA and RNA from seeds in different developmental stages—when the seeds first start developing through when they are almost done developing. Once the DNA and RNA have been isolated, we sequence them. Then we see if the cycad and ginkgo genes match genes from other plants that have already been sequenced. We also look at where the genes are expressed in the plant for instance, in the outer coating of the seed. Knowing where it is expressed tells you more about what the gene does. At the moment, I'm isolating RNA from ginkgo seeds that were collected last summer in the garden. There are other projects going on in the lab, one studying a toxic compound called BMAA, which is found in cycads. BMAA is controversially implicated in a neurological disease called Guam's dementia, similar to Alzheimer's.

I HAVE A B.A. in ecology, and I worked in various labs during summers throughout high school and college. Several of them were labs studying plants and one studied the evolution of invertebrates. After I graduated, I moved to New York City and got a job at a publishing company editing elementary school science workbooks. I worked there for a while, but I kept my eye out for a job doing more hands-on science. I saw this job on the New York Botanical Garden's Web site and applied for it. I had a fair amount of experience working with molecular genetic experiments. That was what made me think that this job might be a good fit for me. Part of my motivation for taking this job is I've always loved plants and knew I'd be exposed to lots of different possible careers studying plants.

LAB EXPERIENCE IS VERY transferable, at least within related subjects. Working in one lab will give you a pretty good foundation for working in another. You really use a lot of the same techniques and equipment—for instance, machines for measuring the concentration of nucleic acids, or for amplifying DNA, or for running gels. Anyone who works with DNA works with tons of gels, separating DNA by size. The tools used in labs are pretty universal—like pipettes. Lab technicians everywhere use them for measuring liquid in small amounts from one container to the next. When people ask what I do—I say I pipette all day. It's important to have a general understanding of the experiments you're running, even if you're not the person directing them, like an understanding of the biochemistry that is going on. For instance, if you have DNA, you shouldn't shake it up a lot because you will break the strands into little pieces.

In general, the working environment in a publishing company is very different from working in a science lab, but I learned skills in publishing that are quite useful here. In the publishing job, I was interacting with a lot of people and managing a small staff. I'm not a manager now, but having that experience taught me the importance of good communication, which does help me in the lab. We have visiting scientists and grad students who are only here part of the time. It can be confusing since we all share equipment and supplies, so I try to make sure that new and visiting people know where to find things and help them if they have questions. I also train some of the high school and college students who volunteer or intern here. I like the questions they ask, because it always makes me think. In a few years, I expect I'll go on to graduate school and may someday be in a situation where I'm managing a staff again, so I expect those skills will be useful in the future.

ONE OF THE ASPECTS of my job I really like is just being at a garden. I live in the middle of New York City and I work at a huge beautiful garden. It's wonderful. The cycads that I study are tropical plants, so here in New York we have to grow them in the greenhouse. That's where I go to collect samples. Whenever I walk into the greenhouse I feel so happy. It's full of such an amazing diversity of plants and reminds me of why I decided to study biology. What's more amazing than living things and what's more interesting than studying life?

Another thing I like about my job is getting to hear other scientists and graduate students give talks about their research. Visiting scientists come to use our labs and our herbarium, and I hear about their research in all different parts of the world. It helps me to think about what I might want to do next and what I'd like to study.

"Repatriation provides a latitude of reconciliation."

TERRY SNOWBALL

Prairie Band Potowatomi/WI Ho-Chunk
Cultural Protocols Coordinator
National Museum of the American Indian, Suitland, MD
www.AmericanIndian.si.edu

In 1989, Congress passed legislation creating a new Smithsonian museum, the National Museum of the American Indian. The same legislation required the Smithsonian to inventory its entire collection of Native American artifacts and begin the process of repatriating sacred objects and human remains back to the tribes that claimed them. In 1990 the Native American Graves Protection and Repatriation Act mandated similar legislation for all museums in the United States. Terry Snowball works with native communities repatriating artifacts from the Smithsonian's collection, and he works with the Smithsonian ensuring that the artifacts they keep in their collection are handled with cultural integrity.

A SIGNIFICANT PART OF OUR MISSION at the National Museum of the American Indian is to represent the indigenous peoples of the western hemisphere and recognize Native Americans in a contemporary situation, not just from a historical perspective. That is part of the charge of this museum—re-educating people as to who native people are. The museum

was established in 1989 when 800,000 cultural artifacts, which included a small collection of human remains, were transferred to the Smithsonian from the George Heye collection. In 1994 we opened the George Gustav Heye Center in Manhattan. It was the first stroke "to hit the canvas" in presenting a paradigm of community collaboration where those perspectives were primary to the concept of exhibit development. In 2004, our new museum opened on the mall in Washington following the same model—each exhibit area looking at issues from the perspective of the entire western hemisphere, with the representation of groups from North, Central, and South America.

My official title is Cultural Protocols Coordinator, which is the name that the repatriation department transformed itself into. The Cultural Protocols Unit establishes and maintains the protocols and procedures for returning objects and responds to potential incidents where guidelines for displaying objects held in the NMAI's collection may require community feedback or consultation—making sure that objects held in the collection are handled in a culturally appropriate way. For instance, in our collection we have medicine bundles that were used in religious ceremonies within the tribe. In their traditional context, not everyone was allowed to touch or even see them, so it is culturally inappropriate to put these bundles on public display in a museum today without proper forms of consent.

REPATRIATION IS THE CORNERSTONE of the NMAI. We work proactively to return artifacts and human remains to tribes—when it comes to the human remains we don't just wait for the tribes to come to us. There are several imperatives associated with repatriating items and human remains. One is determining who an item should be returned to. This is not an easy question, especially with older remains. Simply knowing where something was found is not a specific attribution to any one tribe. Many of these communities migrated at various points in their history, and ultimately one or more tribes may be representative of that return. The challenge is to arrive at consensus.

Another imperative—we're a government agency and we work within the context of tribal sovereignty so these communities are accorded due process of the law via the establishment of our government-to-government relationships. Primarily we work with federally recognized tribes, but there are, in fact, other groups—state-recognized tribes, and amalgamations of peoples still trying to assert their own sovereignties. We have to establish who in that community can represent the group as their government

representative and make sure their community has given them this authority. This is not always easy for them. It's a delicate process of how we work through these things and most of the time it requires advocacy or representation through those federally recognized tribes.

Many of the artifacts we hold at the Smithsonian's NMAI are objects that often defined a tribe's societal, plenary, hierarchical, and egalitarian structures. Ownership of a clan hat or a dagger, for instance, indicated an individual's status or role in the tribe. Today, these objects represent a continuum that is vital to these communities as they rebuild their hierarchies and orders and reconstruct their rituals. It is bittersweet to recognize that if it weren't for George Heye's activities in collecting these items, it is quite possible these things wouldn't be available for return.

The way an object reenters the tribe is as important as the return itself. One of the objects in the Heye collection was a bear hat that belonged to the Tlingit tribe in southeast Alaska. The gentleman claiming the hat came down to New York with his wife, who was a member of the opposing clan within his tribe. Clan dynamics dictate that you do not marry into your own clan, but marry a member of another clan. He was able to have the hat presented to him in our exhibit area—a public venue—by his wife who was from the opposing clan. The validation of that return was very significant to that community in terms of who presented it and how many people witnessed it.

THE RETURN OF HUMAN remains brings with it another set of challenges—metaphysical and spiritual risks that one takes on. These ancestors journeyed in this world and then went into the ground to continue another form of journey into the next world. Disrupting that journey is risky and even the stewardship of those remains has personal implications. As a native person myself, I cross certain lines and taboos within my community and my culture by doing the work I do. My family questions whether I should be doing this. Dealing with human remains has very serious implications in terms of affecting my spiritual wellness, and as a result I return home for my ceremonies in order to deal with the consequence of such stewardships.

On one occasion, the museum was returning a mummified infant back to southern Colorado. One of the imperatives of this return was to have those remains in the ground before sundown. Normally on a trip like this I would pick up the remains just before going to the airport. But, given the time constraints, I actually had to take the remains with me the night before and check into a hotel. That was a very big responsibility. You have

to come to terms with the fact that what is really taking place here is for the benefit of the particular individual whose spiritual journey has been disrupted. You hope they know that, and you take care to ensure that no harm comes to them in the interim. We landed in Shiprock, NM, and went directly to the burial site. The tribe had their municipal people there with equipment for digging the grave. They were also there to witness the return, but they maintained a safe distance as if to say they didn't want to be too involved. Dealing with human remains is spiritually very risky. There are various different kinds of powers that these remains still have. Some tribes have the perspective of "you dug them up, you deal with them." They may not have the resources to transport and escort the remains, or they don't want to deal with the spiritual implications. Here at the museum, we have facilities where people can cleanse or purify themselves either before or after their interaction with these collections.

I COME FROM A RURAL community in central Wisconsin. I'm a member of the Dream Dance religion and frequently go home to attend ceremonies. I attended school in Santa Fe at the Institute of American Indian Arts. Initially I wanted to be an artist and I still have those aspirations in me. I was studying two-dimensional arts—painting and drawing. Some of my roommates were involved in the museum studies program there. They would tell me about the trips they'd made to different museums and talked about how native culture was being presented. I got really interested after the NMAI was founded and was excited to come on board. We have a good internship program here that accommodates native and non-native people alike. I started in the summer of 1996 as an intern in the collections management department in our original storage facility up in the Bronx. It was a good introduction to the museum in its infancy.

I've been here eleven years now. One of the rewarding things for me is the number of people who come back and say how glad they are to see me still here. Within this big organization I like to think that I help provide a sense of continuity and also hope that I have maintained a good reputation out there in Indian Country.

IN OUR WORK WE have to be very understanding about our interactions with tribal people—their politics, their religion, and the state of their nation. We are dealing with a number of histories here. Today these communities are dealing with a lot of issues—in retrospect they continue

to deal with unemployment and poverty, underfunded social programs, alcohol and drug abuse (the newest emerging plague today is crystal methamphetamine use), suicide, and land claim issues to name a few. Repatriation is just a small part of what they have to deal with. We have to be mindful, we have to be patient, and we have to be understanding.

There is a lot of collateral damage out there. Now my family understands why I'm doing this work, in spite of the cultural risk involved. There is a greater purpose than my own interests. It's about the broader respect of humanity. I feel that by honoring these ancestors, I honor my own ancestors. Repatriation provides a latitude of reconciliation.

CARING FOR THE COLLECTION: CONSERVATION AND DOCUMENTATION

Putting together a collection is just the beginning. Once acquired, it must be cared for: animals and plants tended, artwork restored and stored properly, data kept up to date. Each item in a collection must be properly documented, identified, catalogued, and tracked, so it can easily be accessed. Whenever an object is loaned from one museum to another, both institutions keep careful track of the packing, transfer, and insurance of the item.

Who manages and cares for collections? What does it take to keep a collection in shape? We'll hear from several people responsible for caring for and maintaining their museum's collections:

❖ **David deMuzio,** a furniture conservator at the Philadelphia Museum of Art, carefully restores the furniture and woodwork in the collection

❖ **Bart Shepherd** is a fish curator, responsible for the care of the animals at the Steinhart Aquarium in San Francisco

❖ **Rebecca Buck,** the chief registrar at the Newark Museum, makes sure that accurate records are kept on all the items in the collection

❖ **Scott Pittman** owns an art moving company that packs and transports art for museums around the country

❖ **Irving Solero,** a photographer, documents the collection at the museum at the Fashion Institute of Technology

❖ **Néstor D. Pérez-Molière,** a bioinformatics manager at the New York Botanical Garden, organizes and translates the herbarium's collection of plant specimens into an electronic database

" ... sleuthing and discovery is the most rewarding part of the job. It's the marriage of history, craft, and science."

DAVID DEMUZIO

The Elaine S. Harrington Senior Conservator of Furniture and Woodwork
Philadelphia Museum of Art, Philadelphia, PA
www.philamuseum.org

David deMuzio started his career as an architect. But one day, quite suddenly, he had a change of heart and decided he was in entirely the wrong field. He followed his instincts and his love of woodworking to a position as a furniture conservator at the Phildelphia Museum of Art.

I WORK IN THE FURNITURE CONSERVATION DEPARTMENT of the Philadelphia Museum of Art. I have a lengthy title—The Elaine S. Harrington Senior Conservator of Furniture and Woodwork. That is a fancy way of saying that a kind woman died and bequeathed money to endow my position. I am responsible for the care of all the furniture and woodwork in the museum's collections, which encompasses more than two thousand pieces of furniture, the architectural woodwork in twenty-five period rooms, and Mount Pleasant and Cedar Grove—two eighteenth-century houses in Fairmount Park that are administered by the museum.

IN A GENERAL WAY, conservators in museums are responsible for the preservation of the collections. More specifically, that means the study and treatment of works of art—conserving old finishes, restoring or

replacing missing elements, cleaning and fixing them—but it also means carefully studying the objects to determine how and when they were made. Whenever possible, we try to preserve the original material and use methods and treatments that are reversible. For instance, if I'm repairing a chair, I'll use a type of traditional glue that can be removed in warm water and alcohol. That way, if the chair needs to be repaired again in the future, it can easily be taken apart without compromising the object. My focus is on joined wooden objects—mostly furniture and woodwork. My subspecialty is the conservation of intarsia or marquetry. That's when you cover the surface of a piece of furniture with decorative inlay or a pictorial composition made of little bits of wood.

Part of conservation is to make sure things are stored correctly—I spend a lot of time in our storage facilities. I also supervise gallery maintenance—making sure the pieces are properly dusted and cleaned when they are on exhibit. I advocate for the preservation of the collection to other departments here at the museum. For instance, when the event planners want to host a function with tables and catered food in the gallery, I'll meet with them to explain the problems and risks to the collection—food might get spilled, chairs can bump into things. I'm always on the defensive for the collection. Sometimes I'll send out reminders to the staff not to bring flowers from their garden into the museum because of the bugs they carry. The variegated carpet beetle and clothes moths are a huge problem. In their larvae stage they will eat just about any kind of natural material—wool, hair, upholstery. There are lots of things that people aren't necessarily aware of—so we kindly remind them.

I also do a lot of traveling. We just finished an exhibition of Latin American art, with about two hundred and fifty loan objects coming from Mexico, South America, and Spain. It was very challenging to get all the things here. Many pieces had to have their fragile decorative painted and gilded surfaces consolidated and stabilized before being custom packed to get here safely. We loan over three hundred objects a year from our collection to other institutions all over the world. Because of the high insurance values, each piece is accompanied by a courier from the museum staff—curators, conservators, art handlers, registrars, whoever is available. So I often go to Europe twice a year on business.

Only about half of my time is spent at the workbench treating furniture. The other half is spent supervising staff, going to meetings, lecturing, traveling, writing grants, dealing with storage issues, and so on. I wear many different hats, which keeps work interesting for me.

I GREW UP AROUND woodworking shops. My grandfather came from Italy where his father and brothers were ornamental sheet metal workers, but I knew him mostly when he was retired and puttering in his home workshop. My father was trained as an engineer. He also likes to spend time in his workshop. That's probably what started my interest in working with wood.

My undergraduate work was in architecture, with a minor in furniture making and design. After I graduated, I worked very briefly as an architect, but I knew quickly I wasn't going to pursue it as a career. I had a much stronger interest in woodworking. I love architecture and I love the design process, but I found the scope and size of architectural work too daunting—you never have control of the whole project. The nice thing about furniture is that the scale of the object allows you to be in control of all aspects and processes. That's what really appealed to me. Out of school I started as a draftsman at an architecture firm. The bread-and-butter work of that firm was drafting architectural details for chain stores. One day, I was finishing the details and specifications for these bathroom fixtures, and thought "I don't want to do this." It was an epiphany. I'd only been there about six months, but I quit.

I tried working as a furniture maker for a while. Furniture making is a very romantic idea. A lot of guys try it, but they starve and then move on. I was one of them. I got a job in a wooden boat shop doing interior joinery work. One day I just happened to look in the back of *Smithsonian* magazine and saw a notice that they were starting a graduate program to train furniture conservators. I applied and got in, and that's where I got my conservation training. I stayed at the boat shop while I went to school, then worked briefly in a commercial antique restoration shop in Baltimore. I heard there was a job at the Philadelphia Museum of Art as the liaison between the conservation and construction departments—I was hired because I had an architecture background. As luck would have it, the guy running the furniture conservation department decided to leave. And I was in the right place at the right time.

AT OUR MUSEUM, we basically have three conservators in every specialty—paintings, works of art on paper, sculpture and decorative arts, furniture and woodwork, and costume and textiles. We currently have twelve conservators, three scientists, a full-time photographer, and an array of post-grads, interns, and technicians. There are thirty-five people, both full and part-time, that work in this department. It is unusual for a museum to have a conservation department of this size and scope.

It's a $1.5 million operation each year, just caring for the artwork in our collection. Not many museums can afford that.

There is a lot of science involved in art conservation. We are fortunate at the museum to have two chemists on staff. They collaborate with the conservators and curators to help better understand artist materials and techniques. In order to study materials at a molecular and elemental level we can take a very small sample from an artwork, about the size of a pin head, and use various methods of analysis to identify and characterize the materials used. We can look at the layers of accumulated varnish on a piece of furniture by mounting a finish sample in cross section and viewing it under ultraviolet light. This helps us understand the finish history and may determine which layers are original so we have a better understanding of what the object may have looked like when it was new. This is useful information to have before beginning work on the finish of a piece of furniture. It is very rare that we would strip off an old finish. We prefer to preserve the old finish as it is part of the history of use of a piece of furniture.

THOSE OF US IN the conservation field, you might say we are all compulsive to varying degrees. Paper conservators and painting conservators have to have a great ability to focus on a task for day after day after day. If you are cleaning or in-painting a picture, you can work all day and cover only a square inch of the surface. It takes a certain kind of person to focus in on the smallest detail and work consistently and calmly. You don't have to be a good painter to be a good paintings conservator. Most paint conservators couldn't paint a very nice picture. The skill sets are different. However, in furniture, you do rely much more heavily on knowledge of the traditional craft. In the course of your work you may have to carve and cut joinery, so you need to have good traditional woodworking skills.

I often talk to college and high school students when they come to the museum on career day, so I think about how to say it succinctly. The salient points are 1) you should be interested in history, 2) you should have good hand skills, 3) you should have some facility for science, and 4) you should be willing to go through a lot of training. Most conservators have a graduate degree. They will have studied art history, material science, and methods of conservation. One of the things I don't say so directly, but is an important point—you'll probably be working for a nonprofit institution, which means you'll not be making a lot of money.

FURNITURE IS OFTEN MADE in sets—several pieces that are made to go together. But over time, the sets or suites of furniture are dispersed.

Different people in a family will each get a piece and they'll descend down different branches. It's really fun when we can reunite the whole set.

We had an early-nineteenth-century painted chair in the collection. We got a call from a dealer in New York that had just acquired a similar chair at auction that he was pretty sure was from the same set. He wanted to know if they could come look at ours. We got ours out of storage; it had ugly modern upholstery on it, which I carefully removed. In the process, I found a signature on it. It's very unusual to find a maker's signature on furniture. Our curator did some archival research—some sleuthing. She turned up where the chairs had lived, how many were in the set, who made them, who painted them and who commissioned them. She eventually found the current location of all the chairs—one was in New York, one was in Chicago, one in Delaware, one in Baltimore, and several were still in the collector's family outside of Philadelphia. We organized a study day and brought all the chairs together here. We lined them all up and invited in the dealers, scholars, curators, conservators, owners, and others with an interest in these chairs. We found that one of the chairs had its original upholstery, so that's how we discovered the kind of fabric that had been on them originally. We went in with the Metropolitan Museum, Art Institute of Chicago, and Winterthur Museum and had the wool moreen custom woven for the chairs so we can accurately restore the upholstery. What started out as a routine inquiry by a dealer turned into a huge research project involving several institutions. It was like reuniting a family.

That kind of sleuthing and discovery is the most rewarding part of the job. It's the marriage of history, craft, and science.

"Some days we call ourselves 'fish janitors.'"

BART SHEPHERD

Curator, Steinhart Aquarium
California Academy of Sciences, San Francisco, CA
www.calacademy.org

In addition to developing acquisition and breeding plans for their collections, curators of live animals must make sure their collections are cared for every day. Bart Shepherd directs a staff of aquatic biologists who tend to the daily needs of the fish and animals at the Steinhart Aquarium. Several times a week, he dons his own scuba gear and dives in for an up-close look at one of his favorite collections—the coral reef habitats.

THE STEINHART AQUARIUM is one of the oldest aquariums in the country. It was started in 1923 by Ignatz Steinhart, who donated some money to the city to found an aquarium in memory of his brother, Sigmund. It's managed and run by the California Academy of Sciences, which is a mini West Coast "Smithsonian." The Academy is mostly a natural history museum with lots of systematic biologists and people who do taxonomy and study the interrelationship between living things. The research departments all have their own focuses and they send people all over the world to collect specimens. But the aquarium is really the public side of that. We're the living aspect of the Academy. For eighty-four years, we have displayed and kept animals from all around the world. It's been a great pioneer in the aquarium world in terms of going and getting and learning how to take care of new animals. We are the oldest continually operating municipal aquarium in the country.

At the moment, the whole Academy, including the aquarium, is under construction. We are redesigning and rebuilding our facility in Golden Gate Park, so at the moment we're in temporary quarters downtown. The new facility should be ready for us in 2008.

I'M ONE OF TWO CURATORS here at the aquarium. I oversee a staff of ten aquatic biologists who are the hands-on people taking care of the exhibits. They are responsible for the day-to-day maintenance of the displays, including changing the water, cleaning the sand, pulling out algae, and wiping down the windows and walls. Some days we call ourselves "fish janitors." But there is also an animal health component of the job—making sure their diet is appropriate, checking for disease. I coordinate any health issues with our laboratory and veterinary staff. Usually we're the ones who notice disease first because we're looking at the tanks every day.

I oversee the acquisition of new animals—getting new species in, putting them through a proper quarantine period, treating them for parasites, acclimating them, and getting them into the permanent display. I do long-range planning for the collections—looking at the animals we have now and planning for the ones we want to have in the future.

One of my particular interests is coral reef habitats, so I'm pretty involved in the care of the big prototype tank here—we have to get in with our scuba equipment about twice a week to give it a good cleaning. We check on the filtration equipment and bring down pieces of shrimp to feed the sea anemones. We've turned that whole cleaning and care activity into a public program, because visitors love seeing a scuba diver in the water. You could

just be sitting on the bottom doing nothing and everybody loves it. So we do that as a scheduled event for visitors to watch. The safety person at the top of the tank tends the air hoses and talks to visitors, pointing out what we're doing in the tank and answering any questions. In the new facility, we'll set up a volunteer program, inviting divers in the community to help with regular cleaning. At the moment, I've got no shortage of staff members, including myself, wanting to get in the tank and swim around. It's a big relief some days to leave my desk full of papers and get into the water.

I'VE ALWAYS BEEN interested in fish. When I was about six my parents' friends were getting rid of this groovy 1970s coffee table aquarium with a glass top. They gave the whole thing to us—gravel, filters, fish, everything. That started me off. Taking care of that aquarium was a project my mom and I did together.

I grew up on the Chesapeake Bay and was always interested in going to the beach, playing in the salt marsh, catching fiddler crabs, and things like that. Then I was fortunate enough to do some traveling with my parents in the Caribbean. That exposed me for the first time to clear water where you could actually see stuff when you swam in it. My interest in fish-keeping really expanded. I kept a whole variety of things in aquariums—freshwater fish, saltwater fish, all kinds of animals.

So when I went to college I thought, "Great. This is what I want to do." I signed up for freshman biology and promptly got a D. I figured that was the end of that—so much for my marine biology degree. I switched to art history and graduated with a bachelor's degree in art and art history. But after college I was right back into working with fish. I'd been keeping home aquariums all through college—reading up on them. I was very interested in coral reefs at that time. I got a job at the Virginia Marine Science Museum and worked there for about a year.

Then I did some traveling and that really solidified my career choice. I participated in an internship with the Pacific Whale Foundation—an Earth Watch program. It was great. I was really inspired by the work they were doing. We did two dives every day surveying the reefs on Maui. We'd count fish and coral populations. We'd look at species and diversity and percent cover. I was hooked. But I knew I wasn't going to go very far in the profession without having a real biology degree. I needed to go back to school.

So I left the Virginia Aquarium and moved to Poughkeepsie, New York. I got a job at Vassar College working with a professor studying various aspects of aquatic maneuverability in water and how different organisms,

not just fish—worms, salamanders, and all kinds of things—how they move through water. It was a project funded by the Navy to study unusual aquatic propulsion systems. While I was there I completed my graduate degree in biology. Then I moved to San Francisco. I had some friends who lived here—I didn't have a job, but there was an aquarium out here. I figured, "I'll see what happens." I started by volunteering, within six months I got hired on a temporary basis. Then three months later I was hired on as a permanent staff member. I've been here since February 1997 and I've just sort of worked my way up from there.

My interest in fish and aquariums has kept me circling back to this career. And having my scuba certification has been a skill I utilize on a regular basis—one of the tools I use to do my job.

Good writing and public speaking skills are pretty important in my job. We do a lot of interpretive programs for the public and sometimes I'm asked to help with those. There are lots of opportunities to speak to groups outside the aquarium. There's a pretty extensive scientific community that holds conferences and lectures related to aquatic studies. I've spoken to all of the local aquarium societies at one time or another.

And interesting enough, my art background has come into play in this job. Part of working with the public includes planning and setting up displays, so it's helpful to have a good eye for presenting things visually. Something that is really unique about the staff here is that several of us have strong visual arts or photography backgrounds. It really helps. You can come here with all the scientific knowledge in the world but that doesn't mean you're going to set up nice displays.

As we are re-envisioning our whole museum, it's been really stimulating for me to be involved in the design process. It's neat to go back to the creative side. Combining that with the scientific work I do keeps both halves of my brain active.

> "... as registrars, we have an amazingly diverse
> set of tasks."

REBECCA BUCK

Chief Registrar
Newark Museum, Newark, NJ
www.newarkmuseum.org

Rebecca Buck's varied interests and superb organizational skills make her well suited for her position as Chief Registrar at the Newark Museum. She oversees a diverse collection of objects, from modern works of art to ancient artifacts to science specimens, keeping track of where they are, where they came from, and where they are going.

THE NEWARK MUSEUM is a comprehensive, general museum, founded in 1909 by John Cotton Dana. He was one of the great museum philosophers and educators of the twentieth century, and consequently we have a great educational program and do a lot of collaborative work with our surrounding community. We're a medium-size museum with about 115 full-time staff and another two hundred part-time staff. We have about 200,000 pieces in our collection, including science specimens and art from around the world. The Tibetan ceramics are especially important and well known. We also have an educational loan collection—about 15,000 pieces—that goes out to schools and other local institutions. We have a planetarium and a mini-zoo with about three hundred living creatures. The registrar's department is responsible for whereabouts and condition of all the pieces in the museum, except the zoo. That's one collection that we're not responsible for.

THE BEST WAY to describe the work of a registrar is to talk broadly of risk management and collections management. It sounds dry but it's really a lot of fun. It includes the basic documentation—photographing and cataloging of every object in a museum's collection whether permanent or on loan. It includes tracking each object—knowing where it is at all times—and making sure it is stored and exhibited properly. It means making sure that all the legal paperwork is in place when an object is loaned or given to the museum. And if you put all those things together, it is a tremendously broad spectrum of tasks. Registrars do everything from developing contracts to standing on loading docks and riding on planes and trucks with an object, to outfitting storage areas, to working on packing specifications, to developing computer databases. It's an incredibly broad position. In addition to me there are four other registrars in my department, as well as a preparator, a database manager, a librarian, an archivist, and a traveling exhibition manager. As Chief Registrar, my day is probably like anyone one else's in a managerial position. I am primarily an administrator who keeps the work assignments evenly distributed among my staff.

I'm also responsible for developing internal policies for the acquisition and care of our collection. In order to be accredited by the American Association of Museums, we have to have a collections management policy. This document details both the practical and ethical policies regarding accessioning and de-accessioning objects and access to the collection. When the museum is considering acquiring a new piece, registrars must give advice on whether we have the storage space for the piece, what conditions it needs to be kept under, and what the conservation costs of the piece will be. That's all critical information about an acquisition.

There is crossover between the roles of a registrar and a collections manager, and each museum is structured a little differently. For instance, the person in my position at the Dallas Museum of Art is called Director of Collections Management, and that person oversees all the registrars at that museum. In Newark my position is called Chief Registrar, and I oversee the collections management, the registration, the coordination of conservation, rights and reproduction, photography, traveling exhibitions, library, and archives. In general, there is an implication that registrars do more of the paperwork, tracking, documentation, and legal administration, and that collection managers do more hands-on work with the collection, but it's pretty fluid.

I CAME TO THIS JOB by default. I was an English major with a concentration in religion. Then I got a master's degree in education. But after I got my master's degree, I had trouble finding a job and ended up pounding the pavement in Spokane, Washington, after my car broke down there. I ended up with a job with the Smithsonian Folk-Life Festival. I was a quilter and knew a bit about the history of textiles, so they hired me as a quilting coordinator. For a while, I worked part-time for the festival and part-time researching quilts at a local museum. Then the museum hired me full-time as an assistant curator.

I was in Spokane for eight years and I fell in love with the museum profession. I went back to school to take some museum courses. I enjoyed basic collection work more than I enjoyed curatorial tasks, so I found a job as a registrar and stayed with registration from then on. I've worked at the Hood Museum of Art at Dartmouth College, then at the University of Pennsylvania Museum of Archeology and Anthropology, and now I'm at the Newark Museum.

I LOVE TO RESEARCH. I love to write. And I love working with all types of different objects. When I was taking museum courses in Spokane, I knew

I didn't want to be a curator. A curator is usually a specialist on a particular topic, whereas a registrar is more of a generalist covering many topics. It's a different way of looking at the world.

I like the parts of the work that are systematic and have to do with hands-on collection work. As a registrar you learn systems and procedures that apply to many objects. You deal with the history and context of each piece, and its physical care. Each museum is somewhat idiosyncratic, but knowing the systems and procedures at one museum makes it possible to step into a content area that you might not be fluent in at another museum. One of the most frightening days of my career was the day I arrived at Dartmouth College thinking I would be working with the anthropology collection and found I was the art registrar! But I did fine. Knowing the systems and procedures gives you enough of a background to pick up the knowledge you need to care for a collection that might not be part of your core interest or academic background. I like the Newark Museum because the content is so broad, and as registrars, we have an amazingly diverse set of tasks.

"The crate ... itself was beautiful. All of it was very precise, and all archival. When you finish a good packing job, you want pictures."

SCOTT PITTMAN

Founder and Operations Manager, Bonsai Fine Arts, Inc.
Glen Burnie, MD
www.bonsai-finearts.com

Scott Pittman owns and runs an art moving company. He and his team at Bonsai Fine Arts, Inc., help museums move their artwork from one location to another—when a piece is purchased, when it goes out on loan, when it goes on temporary exhibit. Prior to moving a piece of art, they custom build packing crates so intricate they are art forms themselves.

I'M A FOUNDING PARTNER in an art moving company, Bonsai Fine Arts, Inc. We crate and pack all kinds of fine art and fragile objects for museums, dealers, and private owners. Lap Tran and I founded this company. We have a partner company, Bonsai Artransport, that does the transportation of the artwork.

When Bonsai started, our idea was simply to provide technical support for museums—packing, crating, installation, and moving services as well as exhibition fabrication. With budgets diminishing, many museums have lost their crew of art handlers, so we provide a team of experienced art handlers—most of whom worked at museums before they came to work for us.

But we've done a lot more than just crates and installations. For instance, we designed and installed a ventilation system for this big carriage house storage space for the Evergreen House. I encourage museums that are trying to come up with ways to manage their collections to give us broad parameters, and then we come up with ideas—making use of space that is not being used, or improving an old climate system. We're really good at creative problem solving like that. At this point we're doing 70 percent crating and 30 percent other specialized things.

One of the biggest pieces of my job is simply talking. Talking is the business side of the work. It's really important to keep a dialogue with registrars, collections managers, curators, and for smaller museums, the directors, to stay in touch with their upcoming projects. Sometimes, I talk with them and the ideas just come out. Once we've done a few jobs for them, they know they can trust us. They just explain a problem and I'll come up with a plan.

I STARTED AT the University of Maryland in 1980 in pre-architecture, but the professors were not so encouraging, so I embraced the art department and ended up getting a degree in fine arts and a degree in economics with all those prerequisites I took for architecture. When I graduated, I was waiting tables and thought I needed some experience in my field. A friend of mine worked at an art trucking company and recommended me. Three weeks later I was on a truck to California. I loved the travel part so much, I thought, I would do this for free. It can be fun, interesting work. There can be some very intense moments, which I like. You are introduced to lots of different worlds—the world of the high-end collector, the museum world, the gallery world, and antique business. You're traveling around on a truck, picking up artwork and delivering it and setting up exhibitions. You really get to see the country.

Another reason I liked that job was that it seemed like there was always a shortage of good art handlers. There were lots of people who *wanted* to do the job, but a good percentage of those people would be unreliable, wouldn't show up, would break things, or wreck the truck.

I discovered that, if you were good and didn't make mistakes, you were in high demand. I could go spend my summers in Alaska working and traveling. And anytime I wanted to come back to the East Coast, I could just call up the owners of one of these art moving companies and get a job doing art handling.

In Alaska I was in the seafood industry—off-loading boats and processing the salmon. The money was good and I saved up enough to go on a long trip to Southeast Asia. I began to see a pattern. I could always have a job back in art service companies, but the money that was going to take me to interesting places was in Alaska. So part of the year I'd work down here, then I'd go to Alaska in the summer to work. And then I'd travel. I went to Mexico, Indonesia, all through Southeast Asia, Vietnam, Thailand, and then back in Europe.

That might be another reason that people stay in the art handling business. It's somewhat flexible. You don't have a regular nine-to-five life—unless you are an administrator. Most of the artists that have become art handlers, they would prefer to do two to three weeks of intense work, make a lot of money, then take off and work on their art.

Traveling was a big part of my life. Although I liked the art handling I wasn't seeing that as a good vehicle for going abroad. I decided that if I got my master's in bilingual education, I could teach English to speakers of other languages. That would be just the ticket to living wherever. So that's what I did. I came back East, got my degree at night while I was working for an art handling company.

Then in 1998, I took a job in Korea teaching at an English academy. I moved there with my wife and one-year-old baby. We lived there for about two years and then traveled for a while afterwards. But, I kept getting e-mails from the art moving company back in the states. "We're growing and we need you, if you want to come back." Finally we did come back—in the summer of 2001—and I took a job training art handlers. I had a background in art handling but also a background in education. I put together a training program.

Finally, I went out on my own and started this company with Lap. We had a lot of contacts in the art world, and we knew who were the good art handlers and truckers. We started the company at the end of 2002. Now we have about six full-time people and another six to eight part-time people.

THERE IS THIS DEBATE in the art handling community, whether it's better to hire an artist who already has some knowledge and appreciation

of what they are doing, or hire truck drivers and teach them the value of the art. I'm in the first camp. People who have an innate appreciation will do a better job—though there are plenty of individual cases. Most of the people that work here are artists and musicians. That also lends itself to a very interesting work environment.

We do a lot of design and construction of crates and packing systems. That kind of work is similar to what set designers or prop builders do in the theater. So I recruit in the theater world—Baltimore is a big theater town. Right now, we're doing some mount-making for cars. There's a guy who is a sculptor and he does welding for the movies. He's working on a horror movie down the street right now. When we have welding jobs, he steps in with his equipment and helps.

Some jobs require a high level of sensitivity. Sometimes a piece is already damaged or compromised in some way, and it has to be moved to another location. Nobody wants to touch it for fear of causing more damage. Conservators will look at it and talk about it and write books about it. They'll hem and haw for years before touching it. But once you decide what has to be done, somebody has to take that first step. That's a very sensitive moment. So in those tense moments, you really want somebody who's got the sensitivity to read the situation and know when it is time to act. That's where we build our trust with our clients. Our reputation depends on it.

THE SKILLS I USE the most?—people skills, athletic skills, and organizational skills. I would say to be a great art handler you have to have stamina and coordination. You have got to be on your toes all the time, not only talking to the client, but handling the valuables—they'll know it right away if you're a klutz. Art handling can be very hard work. It often involves getting up at three or four in the morning, operating an $80,000 truck, and loading hundreds of extremely valuable and fragile things. You get in the truck and drive to a place you don't know where it is or what kind of conditions you'll encounter—and you'd better not be late! You have to maneuver these trucks into sometimes impossible spaces.

Now you're going into somebody's house—a lot of times, a multimillionaire's house. So you've got to be clean. You can't have any grease or dirt on your hands or clothes. You've got to go in and convince them that you're the man that they want to take their $3.5 million painting off the wall. Usually the whole job has been set up by someone else, so this is the first time you're meeting the client. There's a stress factor

right there. Then you may have to wrap up something that is particularly delicate—with lots of pieces. You've got to have a plan and have all your materials together. And monitor the whole process carefully. And label everything. Sometimes you'll go in, and there are twenty-five sculptures and four of them break down into fifty pieces. If you don't label them so you can unpack them properly, you can really be in trouble. I've seen all of this happen. And that's just the first stop of the day. You may be picking up several other pieces that day. Everything has to be very carefully organized. It can be a stressful job.

One of the more valuable things we've moved was the Borghesi clock. It's a beautiful grandfather clock, created by an eighteenth-century Italian inventor. It has no hands—but the decorative mechanism turns. The glass, which is original, has gold leaf lines on it so you can tell the time. It tells time like our clocks but it's a different whole design from what we have come to use. We had to take it apart. The works, the mechanism, and the bonnet with the original glass—those were all crated separately. There were inner boxes that would go into trays, that would slide on top of calculated foam designs. The crate for the body itself was beautiful. All of it was very precise, and all archival. When you finish a good packing job, you want pictures.

It's interesting work. Every job is it's own story. It makes the sales job easy, because you're just talking about stuff you are proud of.

"I translate the information from the curator into photographic images that both document the piece and show it off in its best light."

IRVING SOLERO

Museum Photographer
The Museum at the Fashion Institute of Technology, New York, NY
www.fitnyc.edu

Irving Solero has been photographing the costume collection at the Fashion Institute of Technology for nearly thirty years. He creates digital representations of each piece, showing how it was made and how it might have been worn. This photographic collection allows designers and students to easily access the collection, without touching the costumes themselves.

I WORK FOR THE MUSEUM at the Fashion Institute of Technology in New York City. Our collection started, not as a museum but rather as a study collection, when a gentleman by the name of Bob Riley saw the need to have a collection of costumes and textiles for the kids to draw inspiration from. He brought over the collection from the Brooklyn Museum when they were looking for a place for it. At the time the collection included nineteenth- and twentieth-century costumes, but over the years the directors have narrowed the collection to just twentieth-century pieces. We now have about 50,000 costume pieces, and over 300,000 textile swatches in the collection. We have an enormous number of sample books from textile mills. All sorts of samples—velvets, jacquards, damasks, silks. It runs the entire gamut to even some contemporary man-made materials.

Recently, we have been working on becoming an accredited museum, so we are on par with the Boston Museum of Fine Arts and the Metropolitan Museum. Our collection is nearly the size of the Met's, and we lend and borrow from both these museums for our exhibitions. An important part of maintaining those relationships is to be accredited by the AAM.

I CAME ON BOARD soon after the school acquired the collection. Initially, I was hired, along with a press agent, to publicize the exhibitions, but my position evolved as the school's photography needs changed over the years. Pretty early on, we realized we had a collection that was extremely important—and that we needed to take care of it. It's not enough just to have a collection, we need to document it. We are basically preserving the collection by getting photographic documentation. When researchers or designers come in to see the collection, the curators don't pull the costumes out first; they pull the images out first. Then people can thumb through them to get ideas and record the information they are seeking. There's a lot of information in the photographs. I not only take photographs of the full costumes but all of the details about how this costume was made—the parts and pieces that comprise this costume, the different sewing techniques used, how were the sequins attached, and things like that. In some of the images I try to give a sense of what the garment would have looked like when somebody wore it. I'll light it to give a sense of whether it's a day dress or an evening dress.

WE ARE WORKING our way through documenting the whole collection. We've tried to start with a representative sample of everything in the collection. For instance, we have ten Chanel suits, and so far we've

documented two or three. When we've finished doing similarly with all the other designers we'll go back and start filling in. I've got about half the collection photographed at this point.

The curator selects the piece to be photographed and carefully pulls it from the collection. Then it goes to the conservator. The conservator evaluates the piece and determines whether it can withstand being handle or photographed. If it is strong enough, the conservation department gives the green light. Then it goes to the dressers. We have specially trained costume dressers who select mannequins for it. The mannequins are coated appropriately, so there isn't any interaction between the costume and any chemicals or dyes. The dressers put the costume on the mannequin and the conservator then presents it to me in the studio.

I then go ahead and begin photographing the piece. There are a series of guidelines I follow during the session. It is important to understand that light and heat damages textiles, so I'm very careful about the kind of lights I use—UV coated lights or very cold florescent lights. I stay away from incandescent or tungsten lights. I use flash since the exposure is so limited. There is a whole set of standards and methodologies I stick to. It's a whole process—not just a matter of taking a picture.

There are usually three of us at the photography session—myself, the conservator, and the curator. The conservator is there to make sure the piece is properly cared for and handled during the session. The curator is there to communicate the important aspects of the piece and its history. I translate the information from the curator into photographic images that both document the piece and show it off in its best light.

I CAME TO THIS JOB … well, my parents wanted me to go to college and *be* something. I did what I was told and graduated from college with a psychology degree. But my head wasn't really in it. So I went back and attended photography school. After that, I landed a couple of entry-level positions and then worked as the night manager of the photo lab for a magazine. You have to understand that photography back then was a matter of film, processing, paper, prints, and slides. The photographers would be at the photo shoots all day and then bring me their film for processing at night. I did pretty well in the lab, but I really wanted to do more photography, not just processing and printing. So I started making calls looking for a new job. Somebody said FIT was starting up this collection and needed a photographer. So I applied for the job and showed them my portfolio. They liked what they saw, and I've been here nearly thirty years now.

When I started, I really knew nothing about costumes and textiles. I knew nothing about nothing! I liked to dress well—I learned that from my father. My father always said, "You have to look good." So I learned to get good suits, but I never knew anything about women's clothes. I didn't know what was front, what was back. I didn't even know what darts were! But along the way, I learned. You know what happens when you are around something, you begin to pick it up. As an employee I was allowed to take classes. I took the entire gamut of textile courses and got interested in costumes and textiles. For a while, my wife and I got into weaving. There was a period when we had a big loom and we wove a lot of pieces.

The kids here are always interesting. This is a college that kids come to because they want to be here, not because they just ended up here. They are very motivated. At the moment, I'm working with the graduate studies students who are on a master's track for conservation and curatorial. I teach them the fundamentals of photography—what to look for and how to work with a photographer. This is a teaching museum. So my work is not just documenting the collection but helping to educate the next generation of curators.

**"We're databasing our herbarium collections
and building an online virtual herbarium
that is a portal to that database."**

NÉSTOR D. PÉREZ-MOLIÈRE

Bioinformatics Manager, Imaging Coordinator
Herbarium, New York Botanical Garden, Bronx, NY
www.nybg.org
http://sciweb.nybg.org/science2/VirtualHerbarium.asp

As one of the Bioinformatics Managers at The New York Botanical Garden, Néstor Pérez-Molière is building a database of images and information based on the herbarium's collection. He organizes and structures many different forms of digital information about the collection and delivers it to scientists and the general public via the Internet.

I AM A BIOINFORMATICS MANAGER at the Herbarium at The New York Botanical Garden. That's kind of a fancy title, but I guess it would be best to start by telling you what a herbarium is. An herbarium is basically

a library of dried plants. The plants are pressed and dried in order to preserve them—like you'd put a flower in a book. When scientists collect plants for a herbarium, they also record information about where they were found and the kind of conditions they were growing in. For example, a particular specimen was collected, let's say, in the country of the United States, in the state of New York, in the county of New York City. It was on the island of Manhattan, on the topmost corner of the island next to this bridge, in a sunny area. The area was very moist and the plant was flowering during this time. All of that information becomes part of the collection. In our collection, we have 7 million plants from as early as the 1700s, from all over the world. Basically an herbarium is a whole building filled with an archive of plants.

An herbarium collection is used as the basis for botanical research, like taxonomy, systematics, ecology, etc. Scientists study how a plant community has changed through time in certain areas and compare it to information from other herbaria. Some of the herbaria in Europe have plants dating back to the 1500s. Researchers can build distribution maps for a particular species and identify biodiversity hot spots. They can look up, say, all the plants that grow in Manhattan, or all the ferns that grow in Manhattan, or all the ferns that grew in Manhattan in the 1700s. My group is assisting that research by assembling all that information into an electronic form. We're databasing our collection and building an online virtual herbarium that is a portal to that database. That is what bioinformatics management is—taking care of that database and building on it to create a more comprehensive resource. Having the information in a database helps protect the collection. Scientists can easily access the collection without having to handle the plants directly.

There are four of us here that take care of the database. My specific focus is on all the imaging aspects—I manage all the digital photography and make sure all the details are in the picture. If an image is not showing flowers or fruit—which is important to identify the species—I know that there is a little packet attached to the sheets with loose parts, and that the flower or fruits are inside the packets. I also deal a lot with file management, making sure files are named correctly and are in the right directories. That prevents a lot of errors later.

I STUDIED BOTANY at the University of Puerto Rico at Mayagüez, which is where I am from. I had always heard about The New York Botanical Garden, so I checked online soon after I graduated. There was a position available cataloging the specimens for a project focusing on eastern Brazil.

It was similar to the work I was doing at an herbarium in Puerto Rico, so I applied online. A month later I was here. It was kind of crazy how it all happened over the phone and Internet. I guess because the person who hired me knew a lot of my references. The botanical community is quite small. It was just a lucky chance—me applying at the perfect moment.

Then, after I was here maybe three years, this position opened up in image management. Since I do photography as a hobby I was a good candidate. So I applied and got the job and have been working on this for a year and a half now.

It is important to be detail oriented in this job, because I'm handling so much data day to day and looking at so many images. I have to catch a lot of these little things that can be mistakes and could cause problems further on. It's important to be detail oriented, but at the same time I have to know when to stop. I could spend the whole year trying to fix minor issues. That's not worth my time right now. We have a lot of material to get into the database. I need to focus on the big picture.

This is definitely a multitasking job. At any given time we have between three and eight projects running. Right now it's pretty busy, because we are just starting a new project—installing new equipment, training people, and establishing protocols. I have a lot of things going on at once. I work in half-hour windows of time. I start one thing and work for half an hour, then jump to another thing for half an hour, then jump to another thing. Sometimes by the end of the day, it's hard to remember what I started doing this morning.

WE ARE STARTING TO work on a lot of collaboration projects with other herbaria. We're working right now with the Royal Botanic Gardens, Kew in London and with the Missouri Botanical Garden in St. Louis. We focus on projects that relate to our strongest collections; for instance, our New World tropics collections. We have a big initiative working with all of the Latin American herbariums. My favorite one is the Flora Borinqueña project focusing on the plants of Puerto Rico. It is a small project that has gotten bigger. It's available to anyone, and it is totally free. Some of our digital archives might be a little overwhelming at first because a layperson might not understand the scientific terms. This Flora Borinqueña project is nice because it is a little more focused on a lay audience. It is very dear to me because I'm from Puerto Rico. We're collaborating with the scientists down there—a lot of them are people I went to college with, and some were my professors. It is nice to work with them and be able to help.

PUTTING ON A DISPLAY: EXHIBITING AND INTERPRETING

Once the collection has been assembled, studied, catalogued, and documented, it's time to show it to the public. But you can't just open the crates, let people peer in, and expect them to understand what's so special about it all. Someone has to pick out a few pieces, point out the interesting features, and help visitors appreciate the collection. This role can be filled in many ways by many people: docents or actors who do on-the-spot explaining; the in-house staff that arranges and displays the collection; and exhibit designers, audio-visual producers, and computer specialists, who create models, films, and activities to explain the larger concepts and put the objects in context.

All sorts of people with various skills are needed to select, interpret, identify, and display a collection. We'll hear from several:

❖ **Joan Collignon,** the docent coordinator for the Oakland Museum in California

❖ **Greg Hardison,** the museum theater coordinator at the Kentucky Historical Society, who uses his performance skills to interpret Kentucky history

- **John Spalvins,** originally a rocket scientist with NASA, who is now the head of exhibit construction at the Children's Museum of Boston

- **Gideon D'Arcangelo,** an interactive design manager at ESI Design with a background in ethnomusicology

- **Travis Gillum,** the president of LifeFormations, a firm that creates animatronic figures for museum exhibits

- **Richard Lewis,** a principal in the audio-visual production firm Chedd-Angier-Lewis in Boston

**"I must talk to 150 to 200 people a week ...
It's a whole lot of communicating."**

JOAN COLLIGNON

Docent Coordinator
Oakland Museum, Oakland, CA
www.museumca.org

Docents are an integral part of any museum program. They are the volunteers who donate a few hours a week or month to help the museums staff in whatever way needed. Joan Collignon organizes and trains the docents who run the tour programs at the Oakland Museum of California. She interacts with a lot of people every day and interjects her generosity and enthusiasm into their work with the museum's visitors.

I'M THE DOCENT COORDINATOR for the Oakland Museum of California. Our museum focuses on California's environment, history, art, and people. As a consequence, we're a huge magnet for school field trips in the area. We get about 35,000 students a year coming on school field trips—nearly half of our total visitorship. With California history part of the fourth-grade curriculum, almost every fourth-grader from the nine counties of the San Francisco Bay Area comes through here. My job is to coordinate all the volunteers who donate their time to run those tours.

I'm the liaison between the schools, the docents, and the education department of the museum. I manage the people who schedule all

those field trips. There are two employees at the docent center beside myself. We work with the schools to provide them information about the museum. We work with the teachers before a field trip so they know how to plan for it and prepare the kids. We schedule the school groups and then schedule the docents to run the tour.

We have three hundred active docents here and another hundred short-term volunteers. On a day-to-day basis, I do a lot of interacting with them—recruiting them, training them, and explaining the exhibits. We have a docent center here where they hang out. I must talk to one hundred and fifty to two hundred people a week, whether in person or by phone or by e-mail—keeping them happy, addressing their needs, and when necessary I run interference for them with the museum. It's a whole lot of communicating.

I GRADUATED COLLEGE with a degree in American History and a minor in Art History. I really wanted to work in a museum so I went to Boston University to get my graduate degree in Art History. But ultimately, I couldn't stand it—all that overanalyzing of a painting—so I abandoned that idea and left school.

I did some administrative work at a small planning firm for a while and eventually married and had children. I was raising my family—by then I had left the workforce. I did some volunteer work—the usual PTA sort of stuff and local architectural heritage preservation sort of thing. I was also active in local political campaigns—everything from ringing doorbells to designing materials. I thought it might be useful to get some training in graphic arts production, so I went to the local junior community college and got a certificate in graphics arts. It was useful basic knowledge. I used it in a lot of political campaigns purely as a volunteer as my kids were growing up.

Once my kids were in school I had an opportunity to become a staff member for a Berkeley city councilwoman, based on my administrative experience and graphic talents. I did a lot of graphics work—neighborhood flyers and things like that. A city council staff person is like an ombudsman—people call to complain about things that they want fixed. I was the middleman between the caller and city bureaucracy, and part of my job was to try to solve their problems—whether it was their garbage not being picked up or the potholes in their streets. Every two years, my boss ran for city council again, and I worked on the campaign. At the time, I was also working as a volunteer at the Oakland Museum of California giving tours to kids, teaching them about

California ecology. During that time I gained a lot of experience dealing with people—a lot of public contact, campaigning, and working with school programs. When my boss retired, I opted not to work for her successor, and I started looking for a job.

Of course as one does when one starts looking seriously for a job, I announced to everyone within earshot that I was looking for work. And luckily that fell on fertile ground here at the docent center. I was hired initially as the associate docent coordinator, and now I'm the docent coordinator.

BECAUSE I'M A DOCENT coordinator, my job is in volunteer management, and it would not have to be in a museum. It's a career that I could be doing in almost any nonprofit organization. My decision to work in a museum ties back to my original interests—what I originally wanted to do. It just took me a while to get here.

My political background taught me how to get along with people from different socio-economic and political groups, all sorts of different factions. So I'm cheery with them all; when you are managing 350 volunteers that comes in handy. This is definitely a people-oriented job. You can get some museum jobs where you never have to deal with the public, but this is *not* one of those jobs.

The graphics background gave me a niche—even in volunteer work—to be able to do something that other people couldn't. It's not a huge impressive graphics background—but the kind that can put out newsletters; I write newsletters quite well, I can edit, I handle page layout programs; I can also negotiate with artists and printers. That was enough to give me an edge over other job candidates.

People who leave the workforce to raise children sometimes feel, "What am I qualified to do?" Volunteer work is a wonderful education. Doing the volunteer organizing taught me how to work in a professional world. Most people now have a profession before they raise their children, but it's quite possible to switch gears because of what you've learned doing volunteer work. Coming to the museum I see that fully half of the people here started out as volunteers. That's how they got their foot in the door.

MANAGING A VOLUNTEER staff is different from managing any other kind of staff. You don't have the carrot and stick—you can't fire people. People will not be fired after thirty-five years as a docent, so you have to compel them to do a great job. For me it's a matter of sharing the excitement that I find. We have a current exhibition up that I am just thrilled

with—it happens to be an art exhibition. It's this sculpture and quite powerful. I try to communicate my excitement about it to the history docents and the natural sciences docents—give them clues about how to explore it and be open to it. It's been fun for me to try to communicate this to them. It's been fun to go back to the art.

"Had I known about the wonderful world of museums ... I probably would have leapt in headfirst. But I took the long route around."

GREG HARDISON

Museum Theatre Coordinator
Kentucky Historical Society, Frankfort, KY
www.history.ky.gov

Performance theater is a relatively new addition to the world of museum interpretation, although certainly not a new venue for presenting thought-provoking information to audiences. Greg Hardison draws on his performance experience and his education background to help the Kentucky Historical Society interpret their exhibits and programs.

I AM THE MUSEUM THEATRE COORDINATOR for the Kentucky Historical Society, which means I write, research, produce, and perform in short plays about Kentucky history that are staged throughout our museum. We have three sites with several exhibit spaces. The permanent exhibition in the Thomas D. Clark Center for Kentucky History covers 12,000 years of Kentucky history, from prehistory to the present. We also currently have a temporary exhibition about immigration from the frontier through the present. The Old State Capitol building has been returned to the way it was just prior to the Civil War, with two additional exhibition spaces. The Kentucky Military History Museum interprets Kentucky military history.

WE USE A VARIETY of programming to interpret these spaces and stories, but our department produces short plays that cover a wide range of topics, people, and themes—all Kentucky related. We perform them throughout the exhibit spaces. As a visitor you might meet a frontiersman

talking about his life, or you might meet Mary Todd Lincoln, or a coal miner. I perform a piece I wrote about the tobacco industry in Kentucky. It is a poem but told in the style and the chant of a tobacco auctioneer. I wanted to honor that long tradition of tobacco and agriculture in Kentucky and how it meant so much to the farmers and their families. It is heavily choreographed, like a dance. Any farmer that has ever seen the piece comes up afterward and says, "I recognize everything that you said." It is a testament to the accuracy of the piece, but more importantly, that farmer—who I might guess is not typically a theater patron—appreciated it and enjoyed it. We try to find ways to bridge those gaps and help visitors connect to our subject.

I do a lot of the performances myself, but two of our museum educators also perform, and I have a part-time contract actor who works with me three days a week, and the occasional intern. We also hire specialty performers who perform specific pieces that might run every Saturday for a month. I like to find people who can play multiple roles, so I can give them regular work. We have certain pieces that we keep in repertoire and can pull out at a moments notice. Occasionally, throughout the year we have larger productions—short ensemble pieces with three to four members in the cast. It runs the gamut.

Our theater work is an extension of our interpretive program. The group here includes the Education Manager, the Children and Adult Programs Manager, the Tour Manager, and myself. It's a creative group and the process of writing a piece is very collaborative. We start by tossing around ideas until we find one that has some meat. Then I'll research or have one of our researchers gather background material. We use a staff scholar or hire an outside scholar to check our research or to offer suggestions for other sources, and our staff editor checks that the timeline is correct and the language we use is accurate. I write some of the scripts, and sometimes we commission others. When it's ready we'll hire an actor—we'll rehearse them and costume them. Sometimes we have a costume created; sometimes we can just pull it from our stock costumes—like the overalls and work shirt we used for the coal-mining piece. However, creating a costume for an 1850s Irish shoemaker was very intensive. We looked at clothing uncovered by an archaeologist in a graveyard from the 1850s and used that as the basis for having a costumer construct the piece to our needs.

THE THEATER PROGRAM HERE started just before the museum opened, in 1999. The educators who planned our program were committed to the idea of museum theater to provide more narrative along with the factual

information. People remember information better if it is set within a context. You can take that a step further when you evoke an emotional response from visitors as part of the narrative. That's how theater fits into museums. It's that connection that you just can't manufacture on a label or in a photograph. It's about touching people on a more emotional level.

Museum theater is being used quite successfully in a lot of science museums, zoos, and aquariums—places that are very kid friendly. You might see storytellers, or puppet shows, or someone dressed up as a dinosaur, or a play about nightmares and what causes them. The Children's Museum of Indianapolis has an extensive theater program and staff. When it comes to history museums there aren't quite as many models to work from. There are certainly living-history museums and reenactments. But there's a fine line between a docent dressed up in costume simply giving you information and someone using storytelling or acting techniques to engage your imagination. I belong to an organization called the International Museum Theatre Alliance (IMTAL) that serves as a resource for museums that want to include theater techniques in their interpretive programs. I'm on the board of IMTAL. It's really helpful to have that contact with professionals in other museum theater programs.

The original theater manager at this museum came from a very theatrical background—everything from musical theater to Shakespeare. I worked with him before the museum opened to create a foundation for our program. We felt strongly that our work should always be based on primary sources. We wanted to focus on characters that were, or who represent, average people. For instance, we're not likely to do a play just about Abe Lincoln, but I've done one about his parents' wedding.

I'VE ENJOYED PERFORMING ever since I was a kid—community theater, high school drama club, amateur theater. In college, I ended up in the education department studying for an elementary education degree. But I got really frightened in college about the prospect of being in the same classroom everyday with the same students, teaching the same material. I guess I have that tendency that many artists have—moss doesn't grow under my feet. I like to be moving and constantly using the creative side of my body. Had I known about the wonderful world of museums—where the class changes everyday, where there are new exhibits to develop and new stories to tell, and 12,000 years of history to draw from—I probably would have leapt in head first. But I took the long route around.

When I was in college I started working for a family entertainment company. I learned a variety of performance skills—from storytelling techniques to performing magic and juggling and walking on stilts—all the skills that make up who I am today. Eventually I bought the company and ran it as best I could for many years. I learned about hiring and firing people, training people, finding gigs—some of the in-the-trenches kinds of skills that school doesn't really prepare you for. Finally, it became clear that I needed to get a "real job" and I took a job with a company that managed a huge indoor entertainment facility.

Then I got married. My wife's family was all in Kentucky so I said, "Let's move so we can be close to family." I came here thinking, What am I going to do? Literally within a week an ad popped up in the newspaper—they were looking for someone to fill a position advertised as half guide and half actor. I thought, "Well, I can half do that job!"

So I filled out an application. When I had the chance to audition I threw a bit of a curve. I'd been to enough cold auditions before to know that you really have to make yourself known. Most other people came in and did theatrical monologues. I designed a large book—a prop. My whole audition was about me trying to decide what I was going to do for my audition. Every time I turned a page in the book, a new situation popped up: a giant pyramid, Egypt; the book caught on fire, the burning of Atlanta; an explosion, the shot heard 'round the world, etc. I used all the magic skills I had in my bag of tricks. And ... they remembered me. The director realized he had the ability to hone me down and focus me, but I had energy and a wide range of performing skills. Together we made a pretty good combination.

ABOUT TWO YEARS AGO, we created a piece about Iwo Jima, based on an exhibit about flags in Kentucky. We looked at iconic images of flags, including the photograph of the men raising the flag at Iwo Jima. One of them is a country boy from Kentucky. So that gave us the idea to write the play. When the play opened it became very quickly one of the most popular pieces we'd ever created. Then, the movie *Flags of our Fathers* came out and we rode on the coattails of that, too. I got to perform the piece this year on the anniversary of the raising of the flag at Iwo Jima at his hometown in Fleming County, Kentucky. Many of the audience members had known him as a local boy—not as an icon. They knew him as the kid who took the cow up on the porch. At the end of this month I'll be taking it to the National Museum of the Marine Corps, in Virginia. It's a strong piece. It feels good to perform it.

**"You can't miss with water and bubbles.
You might have a mess at the end of the day,
but kids love it."**

JOHN SPALVINS

Exhibit Design Director
Boston Children's Museum, Boston, MA
www.bostonchildrensmuseum.org

John Spalvins' understated manner masks an interesting and unusual career path. After graduating from MIT as an aerospace engineer, he worked for several years designing rockets for the NASA space program. Now he works for the Children's Museum in Boston. He puts his knowledge of material properties and his creative problem-solving skills to good use designing and overseeing the construction of all the exhibits at the museum.

THE BOSTON CHILDREN'S MUSEUM has been around for quite a while—since 1913. We're one of the first children's museums in the country. In the 1960s, we were one of the pioneers in exploring hands-on learning for kids—building exhibits that kids could touch, play with, and climb on. It was a pretty revolutionary idea at the time.

Most of our activities are geared to kids up to twelve years old, though some areas are specifically for younger kids and we try to keep the parents interested, too. No child comes by himself; half of our visitors are adults. We like to build exhibits that keep kids active. We've done all kinds of things—rolling balls down raceways, navigating boats in a stream, lots of different things with bubbles. We have climbing structures. Kids love to climb and crawl through things. They're going to climb on stuff anyway, so we provide places where it's safe to do that.

We've done stuff that probably no other museum would have tried. We're not afraid to tackle some tough topics. Once we did an exhibit about death—not every museum would try that. We got a lot of positive feedback, though a few people thought we were crazy.

I'M THE EXHIBIT DESIGN DIRECTOR. I head the department that builds all the exhibits in the museum as well as everything we loan out

to other museums. I have a staff of about eight people and we figure out how to make things work and then build them. Several years ago I designed and built an exhibit called "Construction Zone." It sits in the middle of our museum. It has a big climbing structure in the center—three stories high. Around the center are construction vehicles and equipment—a couple of bobcats, a jackhammer, and so on. And a big maze of tunnels that kids can roll their cars through. It was great fun designing that.

I also keep all the exhibits fixed. Most of the time I oversee my staff as they keep things running, but if anyone is on vacation, I'm out there fixing things myself. We handle all the in-house stuff and the traveling stuff. We custom-build all the packing and shipping crates that our exhibits travel in. One of the biggest hassles is when you have an exhibit out on loan and someone calls you and says, "Hey, this isn't working—come fix it." But we can't go fix it; we have to troubleshoot it from afar. It can get pretty hectic.

I GRADUATED FROM Boston University with a degree in Aerospace Engineering. Prior to that I had worked with my father in the construction business. He always used to say, "You know, if your engineering stuff doesn't pan out, you can always work in construction." It was kind of prophetic.

After college I went to work for a private company in California that designs and builds rockets for the NASA program; it was at the tail-end of the Apollo program. In the early 1970s our office got the project to design the main engines for space shuttles. I was on the ground level, which was very exciting at the time. I'd seen a couple of rocket firings for the Apollo program and was looking forward to working on the space shuttle program. I quickly began to realize the time frame involved in developing a project of that scale. People in my office said, "Once we get this contract, it will be five to six years before we even begin to build anything and another four to five years after that before the Space Shuttles fly." I realized I had a lot of years of paperwork ahead of me.

About that time, my father became very ill, and I came back east to help him run his construction business. I did that for a while, and then one day I heard about a job opening at the Children's Museum. It seemed interesting so I decided to give it a try until things picked up in the construction business.

At that time the museum was very small—there were only two of us in the exhibit design department. I was a combination technician,

designer, and builder. We were in a small facility out in Jamaica Plains—a suburb of Boston. It was pretty laid-back—there were no real deadlines for opening exhibits. We used to close for a month every year to do the installations. One project led into the next and I stayed for a couple of years. Then the museum moved downtown and expanded. I was pretty involved in the move so I stayed several more years. New projects kept coming along—new challenges, larger exhibits, more visitors. We never do the same thing twice. It's always interesting and exciting. Now I've been here over thirty years. My job title has remained the same over that time, but the size and scale of the museum has grown. Our space is about three times larger than when I started, and we definitely don't have the luxury of closing for a month. We have to do our work while the public is in the building. Scheduling things is much more complicated.

I'M NOT A PEOPLE PERSON—that's not me. I'm a hardware person. My engineering experience has been helpful because I have a really good understanding of how materials will perform. Will they be flexible enough for what we're doing? Strong enough? Will it hold up to the wear and tear of constant use and still look good? We like to work with new and interesting materials, but I can tell pretty quickly what will hold up under what conditions. I did a lot of drafting in my engineering work, and I continue to use that in my work here. When I was designing rocket engines, all the drafting was done by hand. Now all our drafting is done on computers in AutoCAD.

Engineering trains you to think creatively—allows you to go one step beyond. Some people might get stuck figuring out how to make something work, but the minute somebody comes up with an idea, I think, "Here's a way to do it." Sometimes there's more than one way to do it.

In the construction business with my father, I learned a lot of practical knowledge about how to build things, how things work, and so on. I use many of the same techniques and basic knowledge in my work today. A lot of my experience in that field has transferred to this one.

I've been on this job for thirty-odd years and I've learned a lot about what kids like and what works. For instance, I can tell you that kids love water exhibits, and any kind of bubble play. I think we've done every kind of variation on bubble play there could possibly be. You can't miss with water and bubbles. You might have a mess at the end of the day, but kids love it.

"It all goes back to searching for the 'why.'"

GIDEON D'ARCANGELO

Interactive Design Manager
ESI Design, New York, NY
www.esidesign.com

Gideon D'Arcangelo is also an exhibit designer, but with entirely different training and expertise than John Spalvins. Gideon works in the interactive design group at ESI Design, an exhibit design firm in New York City. He and his team create exhibits for museums across the country on any number of topics, from racecars to Catholicism—his favorite being music.

ESI IS AN EXPERIENTIAL DESIGN FIRM—we design interactive experiences for public spaces. The simple answer is—we design exhibits, often for museums—but it's really more broad than that. We look at the whole arc of the visitor's experience—how they find out about the museum or place we're designing for, what expectations do they have before they arrive, how do they interact with other people, how do they use the information presented, how does the experience persist afterward, and so on.

Historically, our work has focused on hands-on, participatory public places, such as children's museums and science museums. One of the first projects for this office was for the Brooklyn Children's Museum, back in the late seventies. Today, our office is working on a big project for the new Children's Museum of Los Angeles. We have a whole roster of other museum projects we've worked on over the years—arboretums, racecar museums, music exhibits, and genealogy museums, you name it. We also have corporate clients—we design retail spaces, corporate lobbies, tradeshow exhibits, and signage. Many of the experiential design issues are the same between our corporate clients and our museum clients—how to best engage the visitor so that they get involved in the story the institution is presenting.

We have about forty-five people working on staff. I work in the interactive design group, where we dream up activities that utilize technology and media in creative ways. For example, we once created an exhibit for the Pope John Paul II Cultural Center in Washington, D.C., that simulated the ringing of church bells. A group of six visitors stand in a circle

and, when cued, pull ropes attached to the ceiling to play a tune. It was a good example of using technology to facilitate a fun interaction between people, rather than between the individual and a computer program.

MY TITLE IS INTERACTIVE Design Manager, but I actually wear several hats. As Design Manager I'm responsible for managing the work flow through my department and keeping the creative energy high. Sometimes I'll take on the role of the Project Manager for a specific job and shepherd a team of people through the creation of a concept for a given client. In that case, my job is to make sure the team designs something in direct response to the goals and aspirations of that client and that the whole project stays on schedule and on budget. A third hat I sometimes wear is that of a designer. I'll be one of the team players on a project someone else is managing and my job is to work with the other team members to come up with good ideas.

What I actually *do* is write a lot, as a way of expressing the design. Early concept work is typically conveyed as diagrams, drawings, and written documents. Other members of my team will prepare the drawings and diagrams, and then we'll pull the written materials and the drawings all together into a presentation or a report to give to the client. It's important to capture not only the design ideas but also the rationale—the why—of the design. There's a rigorous thinking process that goes into the work we do and that's expressed in the concept documents early on. So, writing is my main way of contributing to that, although when I first started here I did more of the hands-on building of prototypes.

Outside of ESI, I teach at the Interactive Technology Program at NYU. Those courses touch on some of the same issues we tackle here at ESI but in a student environment. Teaching keeps me on my toes and apprised of what's going on outside the shell of our office. I also produce a segment for American Public Media called "Listening In," on a program called *Weekend America*. I interview people of all walks of life about their relationship to music and how they use music in their day-to-day lives. I'm really interested in the ways that new technologies are changing our experience of music.

I CAME TO ESI through music. As an undergraduate at the University of Chicago, I started out with a broad liberal arts education and found my way to a degree in music. I've always been interested in the "why" of music—the role of music and the evolution of music in

our society—ethnomusicology. While I was there I produced a radio show that looked indirectly at the why of music. Each week focused on a year in history—music from that year, excerpts from books and poetry that were popular that year, advertisements, etc. It was this collage of the music and sounds.

After college, I worked as a musician in Chicago and then in New York, putting together bands, writing music, playing at experimental places like the Knitting Factory. But I needed a day job. When I heard that Alan Lomax was working in New York, I jumped at the opportunity. Alan Lomax and his father collected folk music and were creating this archive of traditional music here in the United States. He was uncovering a folk tradition that was otherwise being ignored—finding art on people's porches and in their backyards and in their fields. So I enlisted myself over at Alan's and worked there for four years. Alan had this vision and a real nose for technology and how it could be used in the service of folk music. He was always one step ahead of the technology. He got Apple Computer interested in this huge project called the *Global Jukebox*, and they provided all kinds of computer equipment and software.

So this was the environment that I walked into when I came to work for him in the early nineties. It was the dawn of the audio-visual computer. Digital video was about the size of a postage stamp, but it was very exciting stuff. I never anticipated that I'd be working with audio-visual computing. Alan helped point the way to what was the crest of a wave called digital media. Through the music door, there I was, working with digital media, which later became the foundation for exploring interactive design at ESI.

I HAD LEARNED a lot of media tools at Alan Lomax's shop. All these digital tools came across our desk, like audio editing, for example. Alan arranged for a donation of Digi-design and I learned the ropes of that. I still use that today, editing pieces for NPR. Those were the skills I put to immediate use when I first got to ESI in 1995. It was the dawn of the Internet, and the company thought we'd better have a Web site. No one here knew how to do it, so I worked with our graphic designer and we just figured it out.

What attracted me to ESI, and I think them to me, was our common interest in exploring the new medium being born—interactive media. It seemed like there was this new frontier being opened up with computers attached to our entertainment media and lots of ways to apply it in museum design.

My writing skills are pretty fundamental to the work I do here. At the University of Chicago, it was a given that every undergraduate student would develop their writing skills. It is certainly a good foundation skill in almost any field.

I've been here about twelve years now and I've learned a lot about how to manage a project. Prior to working here I had no management skills. One gift of coming to a well-organized place is the ability to develop those skills. What I'm developing now is the ability to strategize. Sometimes a project comes in that is well defined and the business relationship has been set up and you just follow it through to completion. But other times the institution doesn't have a clear picture of what they want or what they want us to do. So, you have to figure out the working relationship and navigate the ship until it becomes a well-defined project. That's harder. I'm working on learning to read an evolving situation.

I THINK THE CHALLENGE of creative work today is not just to *be* creative but to design things that enable creativity in others—to create contexts, environments, channels of communication for others to create through. The world is becoming audio-visual literate these days. Almost anyone can create their own movies and music. There is no shortage of stories. What there *is* is a shortage of ways to get at the stories and make them meaningful for a broad audience in a public environment. It all goes back to searching for the "why."

"I've learned that if you can incorporate your hobbies into your work, then you'll have a job you really love to do."

TRAVIS GILLUM

President
LifeFormations, Bowling Green, OH
www.lifeformations.com

LifeFormations creates life-like animatronic figures for museum exhibits all over the country. Travis Gillum started as a media production assistant right out of college and worked his way up to president of the company. He has successfully combined his interest in mechanics, his background in visual communication, and his innate people skills into a job he clearly loves.

I'M THE PRESIDENT OF LifeFormations. We're a design and fabrication company that creates animatronic and static figures for museums, science centers, trade shows—all kinds of venues. We started out in the trade show world, but we immediately jumped to museum work, sculpting likenesses of people and bringing history to life. I'm a partner in the company. I oversee a lot of projects that come through the door, as well as the sales and the day-to-day production that goes on in the facility. That keeps me pretty busy.

I STARTED OUT STUDYING Visual Communication Technology at Bowling Green State University. It's a program that looks at solving communication problems using photography, video, interactive media, and print-related material, all woven together. In my sophomore year I was interning at an auto supply company—they made gear shafts, transmissions, etc.—doing video production. I was interested in getting a job there because I'd always been a "gear-head," always played around with cars. My dad was in the auto business, and I liked the hands-on kind of stuff.

During my internship, my advisor came to do a site visit, and he talked with me about my work. He asked me what I was doing at the end of the summer and invited me to come take a look at his company, LifeFormations. I had no idea what *animatronic* meant, or anything about museum figures. When I went out there, I was absolutely amazed. He asked me if I could help with creating media for some marketing materials and help with upcoming installations. They had some characters that required someone with mechanical abilities. It was right up my alley, so I started working and loved it. I worked nearly full-time during the rest of my undergraduate degree.

Initially, I was a production assistant—installing characters and helping with the basic installation processes. Then I slowly started moving into project management and the people side of things—going to trade shows, working booths, talking to clients. I really enjoyed it, so I moved in that direction. Now I manage some big projects and get to travel and see neat places around the world. We just did an installation in Israel. We built it in Ohio and then sent a crew to Israel to install it.

When I got the visual communication degree, I thought my goal was to create media. But I realized that there were other things in my life that I liked doing. I liked working with my hands—tinkering with the mechanics, making things work. Those were my hobbies. I've learned that if you can incorporate your hobbies into your work, then you'll have a job you really love to do.

I love talking to people on the phone about projects and brainstorming ideas. I love working the trade shows. Communication skills and problem-solving skills are really important in what we do. It's what we always look for when we hire somebody—the ability to be a creative problem-solver and to communicate ideas to other employees and clients. I'd say that's even more important than specific artistic skills: having a good attitude and good problem-solving skills and communication skills. At some level, we can teach someone the artistic skills and the things we need done on a day-to-day basis. But the communication or problem-solving skills are tough to teach someone on the job. You can't be afraid to speak up and talk to people.

WE HAVE ANYWHERE from twenty to forty people working here, depending on the projects we have going on. We have several kinds of artists, some who are sculptors. The best ones can do a range of styles—everything from robots to likeness of historical people. It's a rare find. When we find those people we really latch on to them. Then we have people with basic art talent—they are good with a paintbrush, they can sketch, they can sculpt cartoony type characters out of foam and clay. They are our production artists—they're great all-around people. Then our lead artists are more of our more specialized sculptors. It usually takes a couple years to move to that level. We have some very specialized processes that we use and it takes a couple of years to learn them.

On the mechanical side, we have a guy that runs the fabrication department. He's been around twelve or thirteen years. He came from the world of modifying vehicles for people who are physically disabled—putting specialized mechanisms in cars to accommodate their needs. He brings a lot of experience to the table. He has several assistants that work for him who have good welding skills and metal fabrication skills.

We also have the technical side—the people who are good with computers and control system. They wire the animated characters, and they integrate that character's movements with the lighting and audio. As audiences get more and more sophisticated, the shows have to be more complex to keep their interest level.

THE BEST THING WE'VE ever done was the Abraham Lincoln Presidential Library and Museum in Springfield, Illinois. We created forty or fifty life-size characters—all custom sculpted from head to toe—everything built from scratch. It was a long process, but seeing people's reaction to it has been very rewarding; it's been a huge success for us. We

did a nice project for a Johnson Hospital in New Jersey. We created several animals that interacted with the people in the waiting room. There's a turtle that lets you play tic-tac-toe on his belly, and a giraffe that tells you your height when you stand next to him. They're all really fun—the idea was to be engaging without being scary for the younger kids.

We also do some crazy amusement park stuff. We go to the International Amusement Park Show every year. For that, we like to dream up something really off-the-wall. One year, we did a ten-foot-tall giant that sat and sang songs to kids as they walked by. He was very detailed— he had hair coming out of his ears and you could see the veins in his hands. Even for the imaginary characters, we pay a lot of attention to the details.

It's so much fun working with the team here. I really enjoy what I do— I feel like I haven't worked a day in my life.

"One of the things I like about any project is the first meeting. You find yourself at a table with a whole bunch of smart, passionate people who really love the stuff they are doing."

RICHARD LEWIS

Principal
Chedd-Angier-Lewis Production Company, Boston, MA
www.chedd-angier-lewis.com

Chedd-Angier-Lewis is a media production firm that produces audio and video material for museum exhibits. They initially specialized in science documentaries for television but have since expanded their expertise to many other subject areas. Richard Lewis has been instrumental in establishing the company's excellent reputation in the museum field.

OUR ORIGINAL COMPANY NAME was Chedd-Angier. My partners were part of the team that began the *NOVA* series—a flagship science magazine show in the late seventies. Then in the 1980s they decided to strike off on their own and formed Chedd-Angier to continue making documentary films for television. I joined the company in 1986, at which point it was already successfully making a very broad range of science documentary programs.

We first got calls from museums in 1988–89, at a time when it was becoming possible for museums to start incorporating media into their exhibit programs. Prior to that, there had been the "theater," or in some cases a weird thing you might call a multimedia slide show. Basically, some kind of very elaborate, very expensive, inflexible media show. As videodisc and early computer technologies became more accepted, people began to think about using multimedia in museums. We started getting calls from science museums. They called us because of our competence with the content. They had seen us make a film about whatever their subject might be, and they were planning a museum on a similar subject. Could we help them? And really we couldn't—we had no idea how to do those early computer things—very few people did. But of course we didn't say we didn't know how to do it. We'd say "fine" and we struggled to figure it out. Within a couple of years we had done as much, and as complex, and as good and interesting material as anyone else had.

But there was one more hurdle. We could make the technology work—and we definitely knew the science. We were using technology to explain stuff to people, but they were walking around a space with a lot of other things to look at. What we've really worked at and learned over the past ten years is how to make all the media elements work together and how to make our pieces work comprehensively with other exhibits within the architectural space. That has been the most interesting aspect of our work.

So we began very much as a science-technology group, but we were able to break out of the "science-only" category. Now we do all kinds of video, graphics, and multimedia exhibits. We went through this glorious period when we were simultaneously doing some interactive exhibits on nuclear weapons testing for the Los Alamos National Laboratory; at the same time we were working on the Pope John Paul II Cultural Center in Washington, D.C., and also Hormel's Museum of Spam. That was the point when I thought, "We're doing it all now—there is nothing we can't do." In recent years the museum business has become a more significant part of our work, so we have changed our name to Chedd-Angier-Lewis.

WHEN THINGS BEGAN, there was never any intention that we would have a group dedicated to doing museum work. I was the guy who happened to get that first museum project because I didn't have anything else to do at the time. But as time went on, it quickly became apparent that there was a niche to which we were very well suited, and I became the museum guy here. Now I'm the principal for that group.

In terms of our relationship with the museum community, I'm the person who connects us to the outside world. I'm the conduit for the company between all the people here and their various skills and the world of people who need to have media as part of their exhibits. To some extent that is a project-development task. I don't see my job as a marketing job, because I think museum folks respond very badly to salespeople. They need to see people they can actually talk to about their specific problem and get a sense of the work needed. I think of my work as being around when people call and working with them to figure out what they need. Of course, there is bidding and putting bid packages together for those kinds of projects, and overseeing the work actually being done. There are some pet projects in which I have a creative role as a writer/producer—though time rarely allows it. I do general management and supervision of the museum group and make sure that all our projects are moving forward in the way they are supposed to be. I work closely with the principals at the museums to be sure they can see that everything is going in a good direction.

I ATTENDED OXFORD for my undergraduate degree. I studied Anglo-Saxon and Middle English literature. If you know English college curricula, you'll know it's very narrow—there was no science, no math, no foreign language—there's what you are studying and that's it. It's great— I'm a great believer in that narrow, but deep field of study. But when I came away with my bachelor's degree, it wasn't immediately clear what I was going to do with it. I took a year off and then applied to a couple of universities in the United States that had programs in communications. To my surprise and delight, the University of Pennsylvania accepted me and gave me a teaching job as well. I graduated with a master's degree in communications from the Annenberg School.

I was interested in getting jobs in film to see what I could do in media, so I moved to New York—and got some horrible jobs. The first was as a production assistant for an after-school special. The story was about a kid in wartime, who'd moved up from the South and wanted to recreate his vegetable garden on his rooftop. My job was to move the dirt to the roof of the building from the street where the truck had dumped it. I look back on that job fondly—a solid day's work—but I knew there would be better things ahead.

For a while I worked with a guy who made documentary films for the Olympics. When I had the chance to join Chedd-Angier, I started here as a junior producer. Then serendipitously, this museum work popped up. I was

here for the first museum job that came in, and I was around as we built up more and more museum clients. As word of mouth spread about the kind of work we could do, our clients told other people, "Talk to Richard Lewis." So after three or four years we had a museum practice.

I thought my degree in Anglo-Saxon literature would be completely useless once I started working here. But we were trying for a job and the subject came up about my academic background. I had made a joke about being able to talk about evolutionary biology given my background in Anglo-Saxon literature. At the end of the presentation, the deputy director of the museum slipped me this line of obscure Anglo-Saxon poetry; it was somewhat of a test. Fortunately it was a line I knew and could identify correctly. We got the job—I think as result of that. That was the first time in thirty years that I was glad I had that Anglo-Saxon degree.

OVERWHELMINGLY, I'D SAY the skills that are most useful in my work are "people skills." For a while, I think we got some jobs simply because we could work with people that no one else could deal with. I actually derive a lot of satisfaction from being able to work with a wide range of folks. We're all in the same boat. The challenge is to find a way to have everyone paddle in the same directions together. It's very satisfying work if you can make it happen.

One of the things I like about any project is the first meeting. You find yourself at a table with a whole bunch of smart, passionate people who really love the stuff they are doing. In almost every case they are fascinating, complex, interesting people. Over the course of the project, you're going to work with them and find out about them. That discovery is a continual delight—the best part of the job. You can't fake it; you have to love doing it.

There is one common characteristic of all the clients we work with. For them, they are undertaking a "once in a lifetime" project. They want to create an exhibit that will tell the story of the subject that they love most dearly—a topic they are passionate about. That is the point we intersect with them. So we have to step up to their level, respect their passion and encourage it. We have to channel that passion and give it back to them. We have to have everyone on our team as pumped up about their subject as the client certainly is.

THE GROUP WE HAVE here is about as diverse a group as you'll find—producers, writers, editors, graphics designers—all of them creative in one field or another. They come from all over the place in terms of

backgrounds. But there are some qualities and skills that are prerequisites. Emerging from the soup of backgrounds there are two to three things that people need to have wherever they are coming from.

Our strategy is that the technical things that we do are not all that incredibly difficult—we can teach people the technical skills they need. But what is difficult is to find are people who can write—that's the one absolute prerequisite. They have to be able to communicate their ideas in writing—to their coworkers, to the client, to the project files. It is absolutely essential.

Another thing we look for are people who have that little bit of spark—who come across as enthusiastic the first time you see them. One of the delights of what we do is to zip all over the place in terms of the content we deal with. The idea is that anything that comes to us is inherently interesting. So we want people who have that intellectual curiosity and who are ready to explore unexpected topics and take delight in them. That quality more than anything else is what brings me to make someone a part of our team.

eight

ENGAGING IN CONVERSATION: EDUCATION, OUTREACH, AND VISITORS' SERVICES

Once the exhibits are ready to view, the next task is to reach out to the public, encouraging them to come to the museum. Advertising and promotion are an initial step. Informative and enticing programs, usually developed by educators and specialists good at communicating with the public, also help to attract visitors. Once visitors arrive, employees in visitor's services are needed to welcome them, answer questions, and provide an opportunity to buy tickets. Afterward, museums often conduct periodic visitor evaluations to be sure that the public enjoyed and understood the programs and exhibits.

Museums also offer their facilities for community-based activities: festivals, gala events, or celebrations. Through this multi-tiered effort of reaching out, listening to visitors, and serving their needs, museums maintain a two-way conversation with their community. Generating this level of interaction with visitors employs many different people, including folks like:

❖ **Jennifer Rothman,** who works in the education department of the New York Botanical Garden

❖ **Alisa Martin,** who manages the marketing and visitor's services department at the Brooklyn Museum in New York

❖ **Will Gillham,** the director of publications at the Amon Carter Museum in Texas

❖ **Randi Korn,** the founder of a consulting firm that provides visitor evaluation studies for museums

❖ **Jennifer Williford,** the special events planner at the Brooklyn Museum

"Working in museums offers you a lot of perks. Big companies have financial perks, but museums and gardens and zoos have life-experience perks."

JENNIFER ROTHMAN

Associate Vice President for Children's and Public Education
The New York Botanical Garden, Bronx, NY
www.nybg.org

Jennifer Rothman works in an unusual setting—a 250-acre botanical garden located in the middle of New York City. Among the many "perks" of her job are walking through a fifty-acre stand of old growth forest at lunchtime. She draws on her education background as she helps interpret the forest and many other aspects of the garden for the thousands of people who visit each year.

I'M THE ASSOCIATE VICE PRESIDENT for Children's and Public Education at The New York Botanical Garden. What I do is oversee the organization of programs for the public and for school groups—tours, lectures, classes, concerts, audio tours, home gardening demonstrations, anything that adds value to the visitor's experience when they come to the garden. During our orchid show, for instance, we'll have orchid demonstrations each weekend—how to photograph them, how to get them to re-bloom, how to pot and divide orchids. It's one of the busiest exhibitions for our public education department.

I have many people who work with me in my department. On a typical day, we'll be doing everything from scheduling performers and teachers who will present programs, to pulling together brochures and marketing pieces, to going out on the grounds and figuring out where people get confused and putting up signs to help direct them. Our department is also

involved in exhibit planning. Whenever there is a new exhibit, we're thinking about how to bridge the gap between the scientists and horticulturists and the general public. We do that through programming and interpretation.

A lot of our work is just getting people through the door. We want to encourage people who aren't science minded or horticulturally minded to visit the garden—and hopefully turn them into regular visitors. Sometimes our programs might be concerts or visual arts programs that you might not associate with a garden. But people are interested and it's a way of introducing them to the rest of what we do here.

I WENT TO COLLEGE in Maine and studied Environmental Science and Biology. I planned to be a marine biologist—move to Key West and study coral reefs. When I graduated, I called the aquarium where I lived to see what kind of jobs were around. The only ones available were in the education department, so I started teaching there. Then I moved to San Francisco and started teaching at the aquarium out there. At some point I realized I wanted to get an advanced degree. I knew I wanted to continue my career in education but didn't want to work in a school system. So I looked at environmental education programs and soon came upon the museum studies programs—there are a couple of good ones in the San Francisco area. I realized museums are a great place to educate people in a very informal setting—more so than in the school system—you get to work with all different ages of people.

I worked for two years at a children's museum in Palo Alto before I moved back to New York. My interest was always toward science, so most of the places I applied to were science oriented; the Botanical Garden was a good fit. I've had several positions here, working both in education—with school groups and the general public—and in our marketing department, which was eye-opening. I now think about the programs in a much broader way. I see them as not only helping the mission of the garden—educating visitors about plants and nature—but as helping with the overall success of the garden so that mission can be accomplished. Sometimes my programs aren't necessarily educational, they're just entertaining. It's challenging to reach people who don't necessarily think of the garden as a place for them. The idea is to turn them from non-garden-goers to garden-goers.

I WORK WITH a lot of different groups—the scientists and horticulturalists, the public, and different departments here at the garden. I'm sort of

the liaison between the groups, and I have to be able to see the garden through a lot of different people's eyes—from many perspectives. There's a lot of balancing of different opinions. And being organized is a huge component. I always have a lot of projects going on at once. I'm one of those people who just likes to put order to things. It is also helpful to have a mind for numbers, since much of my work involves budgeting for programs.

One of the things I see working in public programs and children's education at a garden is that it's good to have a science background. While it is not necessary, my science background helps. I can speak with the scientists and horticulturalists in enough detail so they know I know what I'm talking about. That helps build their trust. If I don't have their full support, I'm not going to have any programs. They're not going to let me do a program that they don't trust I can pull off appropriately.

WORKING IN A MUSEUM offers you a lot of perks. Big companies have financial perks, but museums and gardens and zoos have life-experience perks. I think it's especially true of science-related museums.

When I was working at the children's museum we had a staff of four to five people. Part of the building included a small zoo. When the zookeeper was on vacation, we all became the zookeepers. I would let the geese out in the morning, someone got to take the baby bobcat home when it was too young to be alone. When I was at the aquarium in San Francisco, employees were able to help the aquarists feed the sharks. You would never get the opportunity to do things like that otherwise.

Here at the garden, we have a vanilla orchid that only blooms once a year, and even then only a couple of hours at a time. Last time it bloomed, someone called me—"You have to go see the vanilla orchid"—so I got to see it in bloom.

The New York Botanical Garden is huge—about two hundred and fifty acres—and we have a fifty-acre forest in the middle of it. It's one of the last remaining uncut stands of forest that used to cover New York City. I go for walks in the forest and really feel like I'm miles and miles away. One of the draws of working at the garden for me was knowing that I could be so near nature. I'm looking out my window right now and there is a hawk perched in a nearby tree. It's a really amazing setting, right in the middle of New York City.

**"Marketing and museums have not traditionally
gone hand in hand. Museums have, at times, been
resistant to the idea of marketing themselves."**

ALISA MARTIN

Marketing and Visitor Services Manager
Brooklyn Museum, Brooklyn, NY
www.brooklynmuseum.org

In recent years, museums have become very visitor-oriented, placing a strong emphasis on their marketing efforts and their visitor's services programs. Alisa Martin oversees a department at the Brooklyn Museum that combines both. She coordinates the branding efforts of the museum and handles the daily logistics of ticketing and scheduling. She comes to her job with a degree in industrial organizational psychology and fifteen years' experience in the financial services field.

I WORK AT THE BROOKLYN MUSEUM in the marketing and visitor's services department. Our department covers two areas. One is the visitor's services component. That includes staffing the front desk, making sure we have brochures and other information available, keeping track of attendance statistics for each exhibition, taking care of special staffing or ticketing needs for big exhibits. The other is the marketing component. Several years ago, there was a desire to have a full-fledged marketing department. Marketing and museums haven't traditionally gone hand in hand. Museums have, at times, been resistant to the idea of marketing themselves. So this museum functioned for a very long time without a marketing department. Of course, a lot of marketing functions were going on around the museum—direct-marketing campaigns in membership, merchandising in the shop, advertising campaigns with an outside agency—but all these functions weren't coordinated. They weren't coming from a central department. So the museum was thinking about having a separate and distinct marketing department.

After 9/11 the idea that the museum might have the funds to support a marketing director and department died. But the desire was still there. I was asked if I would head a combined department—marketing and visitor's services. I was crazy enough to say yes.

I'M FIRST AND FOREMOST a manager of people—a mix of back-office staff who schedule tours and school groups and the front-desk staff who take tickets and greet visitors. There are a lot of tasks related to being a manager anywhere—coaching, transmitting information, making sure people are trained properly. That sort of thing.

I also spend time being an influencer. In a certain way, marketing goes on in all departments of the museum by people who don't all report to me. So in order to get people to do what needs to be done from an overall organizational perspective, they need to understand the bigger strategic picture. Sometimes that's a meeting, sometimes that's sitting down over lunch. Sometimes that's an e-mail that is worded just so.

Our department generates the results information for the museum—the number of audio tours we sold or the attendance figures at an exhibition. There is always some report needed—to the board, to staff, or to my manager. We are the warehouse for all that attendance and revenue information and I'm often asked for it unexpectedly at meetings. So I have to be well versed in the numbers and what they mean.

MY INITIAL PROFESSIONAL PATH was psychology—a bachelor's degree in psychology and a graduate school degree in industrial organizational psychology.

My first employer was Met Life. I was in a program that was preparing me to be a general manager so they moved me around quite a bit—first with an internal consulting group, next in marketing, and after that, in the human resources and corporate quality departments doing research, planning, and process improvement. I was there for over ten years. My last two years were spent as part of a new venture. We partnered with a publishing company to produce a magazine for policyholders. Eventually, the corporate marketing department, of which we were a part, was disbanded, and I was downsized out of a position.

Next I went to American Express as a marketing manager. After about two years, that area was disbanded, and I again found myself looking for work. But there was a big difference between this downsize and the first one. The first time I was terrified, but the second time I decided this was not the end of the world and I should take some time to assess my options. Museums always seemed interesting, but for a long time I told myself that I couldn't work in a museum because I hadn't taken the right courses in school—no art history, whatsoever.

When I went to the out-placement classes one of the things they emphasized was when you are looking for a job you should take every opportunity that passes your way and turn it into a job-hunting opportunity. Sure enough, soon after that I met a friend of a friend at a social gathering. She had moved from the corporate world to the nonprofit world. She was head of a local development corporation, and she wanted someone to do a survey of artists in the community. So that was the project I did for them. While doing that I was exposed to a lot of people in the Brooklyn art community, and I really enjoyed it. I remembered back several years earlier when a friend had asked me if I talked to my five-year-old daughter about what I did all day. I couldn't imagine what she was talking about— I worked in financial services at the time. But I found when I worked on this project, every night I came home gushing—telling my daughter about my day, whether she understood it or not. I'd talk a mile a minute. I was so excited about what I was doing, it was clear to me this was a world I liked. Even though I'm not an artist, I was bringing value to the art community.

When I finished the project, the woman I worked for asked me if there was anyone I'd like to be introduced to, and I told her that the Brooklyn Museum had always struck me as a cool place to work. She got me an introduction and I came in for an informational interview. At that point we weren't talking about a particular job—it was just for me to get an understanding of the needs of the institution. The woman I spoke to suggested several areas where I might be a good fit and talked about the direction those departments were headed. Visitor's services sounded interesting. So then I went through a more formal interview process and eventually got the job.

ONE OF THE THINGS I learned throughout my career was the ability to manage and influence people that did not directly report to me. So when I came here, I was very accustomed to getting people to do what I needed them to do. For instance, recently the museum developed a new logo and we needed feedback from different people. My job was to keep the various constituencies in mind. Sometimes our director would get excited about the design being really, really out there. I'd point out that there were scholarly colleagues and conservative audiences whose buy-in we also needed. While recognizing his desire to end up with a cutting-edge design (which we did!), I helped the group come to consensus. To be able to persuade and encourage—that skill set is important in whatever field you're in.

**"And of course there's the Web site—the bear that is
never satiated ... "**

WILL GILLHAM

Director of Publications
Amon Carter Museum, Fort Worth, Texas
www.cartermuseum.org

*Will Gillham speaks enthusiastically about his ever-expanding role at the Amon
Carter Museum. He is the Director of the Publications Department, which
publishes all the catalogues, annual reports, and newsletters that the museum
produces. The latest addition to his "to-do list" is to keep the museum's Web site
up to date.*

AMON G. CARTER SR. (1879–1955) was an oilman and newspaper pub-
lisher in North Texas during the first half of the twentieth century. He
collected art of the American West, particularly the works of Frederic
Remington and Charles M. Russell. His will stipulated that a museum be
established to house his collection of four hundred works of art and nearly
four thousand books. This museum, which was designed by Philip Johnson,
opened in 1961. The first director considered art a discipline in which
works are created on a "succession of frontiers," and this mantra informed
the museum's early collecting activity. We began collecting photographs in
the 1960s, for example. In addition to its paintings, sculpture, and works on
paper, the museum now holds one of the great collections of American pho-
tography in the country. A really fine collection of American art lives here.

I'M THE DIRECTOR OF PUBLICATIONS, and I currently supervise a
department of five: an editor, graphic designer, Webmaster, assistant, and
work-study student. Virtually all the text the museum generates comes
through this department: the biannual magazine, annual report, newslet-
ter, the exhibition catalogues and didactics, electronic correspondence
with our constituents. We edit it, design it, get it produced. A good bit
of it we write as well. We publish anywhere from one to half a dozen
books each year, and we're responsible for generating all the ephemera,
too—brochures, press releases, invitations, and so on. And of course
there's the Web site—the bear that is never satiated—we're charged with

keeping that organic publication current. We're also knee-deep now in producing electronic publications.

I'm presently the "brand champion" at the museum. Branding has become a trend issue among nonprofits of late, and for very good reason. Museums must work hard in their respective communities to make themselves known and compete for the potential visitor's time and money. I work closely with our public relations department to manage our "public face" so that when someone sees an ad in the paper, for example, it looks like the Amon Carter Museum.

When I started here in 1995, I was hired as the publications manager. I was a department of one. I performed all the jobs my staff does now, though on a smaller scale. But the museum was watching the horizon—five to ten years out, and I was asked to develop a long-range plan for building the publications department. There are now six of us, and we are able to publish more and keep pace with the aggressive goals of the museum, though frankly the Web site activity is demanding more and more of our resources, a development that is not going to slow down.

I STUDIED ENGLISH in college. For a while I vacillated between studying English or studying classical guitar. Two promising moneymaker careers, right? The English degree was a good base for what I have ended up doing. When I graduated I moved to New York City, where I began temping. Mostly I was assigned jobs in humanities-related fields, and as I began to spend more time in publishing houses it began to awaken in me this interest to pursue full-time employment along those lines. I eventually took a position at a publishing house in lower Manhattan; I started out as an editorial assistant and ended up an assistant editor. I ushered books through all stages of production—acquisition, line editing, proofreading, generating jacket and market copy, and presenting list titles to the sales force. I really loved it, but after about three years I became disenchanted with the industry's focus on a book "earning out" as being the measure of both its and the editor's performance. To my mind, this was the beginning of the demise of the small work of literary fiction. I left and began freelancing. I enjoyed that for a while, but anyone who's done this knows the downsides to the freelance life—like the lack of a steady paycheck or benefits, or being able to socialize with the rest of the world. When you freelance in the trade publication world, especially in New York, you are always under a tight deadline. After about four years of that, family matters necessitated a return to Fort Worth, Texas, where I trolled for freelance positions in

the cultural district there. When I contacted the Carter, they asked me if I was interested in full-time employment. Turns out I was.

There's an added dimension to the work I do here that I didn't have the opportunity to do before. In the literary fiction area of trade publishing, I was producing books that were straight black ink on white paper. Fine art publishing assumes the added challenge of reproducing works of art in four-color reproduction and doing it as richly and beautifully and truthfully as possible. The materials I print now may provide the only opportunity a reader ever has to appreciate a particular work of art, so my charge is to make it as accurate and accessible as possible. I also really enjoy the challenge of finding just the right words to accompany an image in order to help the reader see it, that wedding of an image and the words that speak to it.

I'D SAY THERE WERE a number of skills and experiences that helped me get this job and do it well. The English degree was a good start, and the experience in trade publication, of course, was a foot in the door. But most important, I've always enjoyed working with words. I'm enamored with how words sound, and what they mean lined up next to each other. That passion is probably the strongest asset I bring to this job.

I also have a good eye for how content should look on the page. I have no formal training in graphic design, but I've been a photographer since I was a kid and am an exhibited artist. I've tried my hand at two- and three-dimensional art. I've exhibited art, and I've curated shows, and these experiences have been very helpful in my career.

Honing the management skills needed for this job was, and probably still is, the biggest challenge for me. I do possess some innate management skills, but I've learned a lot on the job, of course. Certainly the freelance work was good for me in this way. To be anywhere near successful as a freelancer, you have to hone good self-management skills. You must be able to manage your own time effectively and be very disciplined about meeting your deadlines. Of course, the transition to a nine-to-five job requires a fundamental change in the way you work. You go from the quiet of working in your home every day to having people stop in your office every half hour, or every five minutes. My time is broken up into much smaller segments—running to this meeting, dealing with that curator, meeting with this printer, whatever. Managing my time, let alone that of the people I supervise and work with, is a much bigger challenge.

RIGHT NOW, I'M IN the middle of printing our members' magazine, pulling together the annual report, and I've got six books coming out next year. I went live with our new institutional Web site last summer, and I have a grant-driven Web site to launch by this fall. As I said earlier, the Web site is a demanding, dynamic monster. And it's only going to become more demanding.

A year ago we uploaded our first major electronic publishing project: Texas Bird's-Eye Views. We have these large, wonderfully detailed but very delicate maps in our collection—lithographs on paper. They are very fragile and rarely go on view. So we scanned them and used the freeware Zoomify to make them available as never before on our site. They were perfect candidates for this type of publishing. This project proved an exciting new direction for us and a harbinger of things to come. We're now creating podcasts and vodcasts, managing a blog, and are in the process of systematically making our entire collection available online. It's a busy and exciting time to be in this business.

"I love helping clients see the value of the visitor's voice, and the visitor's way of experiencing their museum."

RANDI KORN

Founding Director
Randi Korn & Associates, Inc., Alexandria, VA
www.randikorn.com

Visitor evaluations are one of the ways that museums assess how visitors understand and what visitors think about their exhibits, programs, and services. Randi Korn heads a team of specialists who help museums ask questions of their visitors in order to hear what they have to say. Randi's innate curiosity about the world and how people learn is one of the building blocks upon which her firm is built.

WE ARE A FULL-SERVE museum evaluation company. Museums call us for lots of different reasons, but much of our work focuses on exhibition and program evaluation, although we are trying to push museums to think evaluatively about their whole organization. We also do basic audience research, which means we try and help museums understand their public

so they can serve it better. A lot of times museums don't know what they want to know about their visitors, but someone has a feeling that they need to know something. We might receive a call asking us to do a survey or focus group. We help them take a step back and think about what they want to know about their audience, and then we can identify the particular method of data collection most suitable for collecting the information they need.

Sometimes just knowing where practitioners are in their development process will help us understand what they need. For instance, a front-end evaluation is done during the planning stage. Once the idea for an exhibition is solidified and the exhibition team is all on the same page—they've developed their objectives for their exhibition and they have outlined their interpretive strategy—then we do a front-end evaluation to help them understand how the public thinks about the ideas in the exhibition. A front-end evaluation helps staff understand how the public thinks about their ideas so they can determine *how* to best communicate them before the exhibition is built.

Formative evaluation is like pilot-testing your ideas. If you are evaluating a program, you might do a dry run, or if you are assessing an interactive exhibit, you might build a prototype and test it. This will identify operational or functional problems in need of attention before the programs or exhibits are ready for the general public. We may do several rounds of formative evaluation to make sure everything is working the way the team intends. There's also remedial evaluation, which is a later stage of formative troubleshooting before the summative evaluation.

Summative evaluation is done when things are up and running, to determine whether you've achieved what you set out to achieve. This ties back to the front-end evaluation. There are very strong links between the project planning and summative evaluation at the end. In planning you identify your goals and objectives, and during evaluation you measure whether you have achieved them.

THE CYCLE OF PROJECTS IS different for every client. Typically, we'll start with the objectives of the study—what do they want to achieve. We like to have an on-site meeting with the client, especially if we are evaluating an exhibition, as context is important. Then we write a proposal that describes the scope of work—defining the goals of the study, the types of instruments, and the cost of the project. Once the proposal is accepted, we design the evaluation plan and identify the data collection tools. After

receiving approval of the plan, we begin crafting the instruments and questions. There's usually some back-and-forth as we make sure that we understood what was being communicated at the initial meeting. Then a project takes on a life of its own. If we are conducting a visitor survey, we often train and hire data collectors to administer a survey, so we don't have to live at the museum while the survey is being administered. When the data comes in, we analyze it and write a report for the client. If it is a one-season survey, the whole process takes about three to four months. If we're working on a long-term project, either for an exhibition or a program, doing a front-end, formative, and summative evaluation, the entire process can take three to four years.

MY ROUTE TO THIS career is not the route a young person today would take. I was trained as a graphic designer and I use my design education all the time, because what I was really trained to do was to ask questions: "Is this the best communication strategy?" "Is this the right medium for the message?" To me, that is what an evaluator does—we use inquiry in our work with our clients to help them achieve clarity; we ask questions of ourselves to make sure we are in fact asking the right questions of visitors; we ask questions of visitors continuously; and we ask questions about the data we collect. So inquiry is what I always use and that is the training I received as a designer.

My first job was at the Philadelphia Museum of Art. I was part of a community project where I was charged with documenting the "life cycle" of the Jewish community in Philadelphia and designing an exhibition to celebrate the group's life cycle. I instantaneously became very curious about the people in the museum and whether they were receiving the messages I was trying to communicate. That really started my interest. After that I worked at several museums. At the time—in the late seventies—there was some formal evaluation work going on in the field, but there certainly wasn't anywhere you could go to school and learn this stuff. So, I read a lot. I received a master's degree, creating my own course of study, and worked with someone who had done evaluation work at the Natural History Museum in London. I did what I could to piece together some kind of formal education to get me to where I wanted to go. Today, you could enroll in a psychology program and focus on how people learn in an informal learning environment—you could get a degree in educational research, educational psychology, or informal learning. That would be the contemporary path.

THE PRIMARY SKILL ONE needs to have in this field is curiosity. It's an absolute necessity. Of course, having research skills, qualitative and quantitative, is also absolutely necessary. The great thing about this work is we are exposed to lots of different topics because of all the subjects that museums cover. You have to be curious about everything and have the ability to ask questions. You have to be able to help your clients identify the essence of an exhibition or of a program. For instance, when a museum's planning team is debating the exhibition's themes, they have to narrow it down to one core nugget. The exhibition can't be about everything—there has to be one core idea. If the program exhibition sounds uninspiring, I know that the planners haven't yet identified that core thing they want to communicate in the exhibition—their passion—so we ask questions until they find it. The best exhibitions are when you can feel the passion of the people who put it together, and that's how you can best reach your audience.

When I hire people on my staff, I first look for someone who has at least some museum experience. I really feel that museums are unique in the nonprofit sector. They are both educational, but not wholly educational. They are part of a leisure experience, yet in an educational way. Someone who hasn't worked in museums or isn't an avid museum visitor just isn't going to get museums. Then I look at someone's research skills. With a senior-level person, they have to have done qualitative and quantitative research. They have to have a command of the English language, so they can ask good questions and write up the data clearly. Writing is a really important skill.

The other thing I look for—and this is hard—I look for a good human being; I want people to be nice people. We are a small office and everyone just has to be nice and respectful of everyone else around them, no matter what job they have in the office. Having respect for one's coworkers just makes for a good work environment.

I LOVE ATTENDING THE initial meetings with a client, especially if it is a big project. There are all these scholars sitting around the table and I get to sit around the table, too, and learn from them. I get to learn new things about topics that I probably wouldn't have had an opportunity to learn about. That part I really love. I love helping clients see the value of the visitor's voice and the visitor's way of experiencing their museum. I believe that museums have unique value in society, and we use evaluation to help museums measure and communicate that value.

"You've got a deadline approaching and you think you're looking at a light at the end of the tunnel. ... but that's not a light—it's a truck, barreling at you at incredible speed!"

JENNIFER WILLIFORD

Special Events Manager
Brooklyn Museum, Brooklyn, NY
www.brooklynmuseum.org

Jennifer Williford keeps a hectic schedule and calm persona. As Special Events Manager, she coordinates all the members' events, openings, weddings, and fund-raising events held at the Brooklyn Museum, a role integral to the financial health of the museum. Jennifer was headed to a law degree before she changed gears and moved into event planning.

I WORK AT the Brooklyn Museum. In a nutshell, I am responsible for orchestrating the fund-raising events that the museum holds. That includes two annual fund-raising events, as well as the membership events, special exhibitions, openings, and trustee and donor cultivation events. We also run a rental program where we rent out space for corporate and social events and weddings. I oversee all of those events—about sixty to sixty-five events throughout the year, mostly September through June.

More specifically, what I do depends on the event. Our fund-raising events are a bigger scale. They take more work and a longer time to plan for—usually about six months. For those events, you have to solicit someone to chair the event—to be the volunteer leadership to help fund-raise. I'll work with them to figure out what the theme is going to be, the date of the event, the invitation copy and design, and so on. I'm responsible for overseeing the production of the invitation and getting it out in the mail, taking all the RSVPs, and writing the acknowledgement letters.

We have an exclusive caterer that we work with—that makes life easier. I tell them what I want. I coordinate all the details of bringing them in and getting them set up. I'll get chairs and tables set up, floral arrangements ordered, entertainment booked, any special lighting needs or sound equipment set up ... whatever is necessary to put that event on.

The membership events and art council events are not quite as involved. They have a shorter time frame. Someone else sends out the invitations. I make sure the doors are open, the AV is set, the caterer is ready to go. I attend all the events and make sure everything is running smoothly—people are being checked in, the bathrooms are clean and working. It's unbelievable the number of details.

Some days it's overwhelming. You've got a deadline approaching and you think you're looking at a light at the end of the tunnel ... but that's not a light—it's a truck, barreling at you at incredible speed! Most days it's very rewarding. It's a job with very tangible results. People walk into a space that is beautifully designed and they're clearly impressed. I get that immediate gratification.

I STARTED AS a pre-med student and then decided that was not for me. I needed to declare a major, so I chose political science with a minor in history. I decided that I was either going to go to law school or get my master's in public policy. So I first worked as a paralegal in a law firm. After about six months of that I decided that I was definitely not going to go to law school. But I didn't know what I wanted to do.

I always loved to coordinate and organize events and parties. I helped my sister plan her wedding. This is the typical story you'll hear from almost everyone who's changed careers to go into event planning—they helped someone plan a wedding or a baby shower. I decided I really enjoyed this kind of work. My sister knew the former events manager at the Brooklyn Museum, so when he left his assistant was promoted and they had an opening for the entry-level position. So I started there and worked my way up. I've been here about four and a half years. I fell into the job.

For several years I had worked on the big fund-raising gala as someone else's assistant. Then came the first year I ran the gala by myself. I was so nervous. My coworkers thought I was crazy. I was so set on deadlines and lists—doing things perfectly. The event came off incredibly well. It was a huge success. Several people told me it was probably one of the best balls we'd had. I was so relieved—it was the first time in about a month that I slept through the night without waking up scribbling notes and reminders to myself. It made me feel more confident, particularly because everyone had been watching so closely.

THIS JOB REALLY SUITS my personality. I tend to be very organized. I'm deadline-driven and addicted to lists. You have to pay attention to a lot of

deadlines. If you plan out an event and work backwards, it's very easy to tick off the things to do when you know when to do them. So I find that is one of the primary skills.

It also requires a certain level of diplomacy because you are working with *so* many different people. I work with my staff, the director, trustees, the vendors, the chairs and cochairs, and lots of brides. There are so many people I come into contact with. It's important to manage those relationships, particularly when you depend on those people to get your job done. So much of my job is directing someone else to do something, so that I can do the next two steps.

There is a development function to this job—it's not just planning parties. It's knowing how to write a good solicitation letter that someone will read and say "I want to give $50, or $500, or $50,000 to support this cause." Some of my most useful skills are my clerical skills, which I learned working with my mom in her office—running reports in Excel, word processing. We do a lot of letter writing. Those are my daily used skills.

And ... crisis management. I may not always be the calmest person, but I can make a decision. I know what needs to happen. That's definitely a necessity, because you have to deal with all kinds of situations—the caterer is short of food, or linens didn't come in. You have to be able to pull it together and say—you do this, you do that, and I'll take care of this—disperse the troops to get the job done. Because at the end of the day, it's all about getting the job done. All the little fires you put out, most guests don't see that. Maybe in my mind there are things that didn't go quite right, but the guests didn't see them. In their mind it was a great event. That is what you want in the end.

nine

RUNNING A TIGHT SHIP: ADMINISTRATION AND SUPPORT

Any organization needs myriad administrative and support staff to keep things running smoothly; museums are no exception. These positions are numerous and varied—from the director, who keeps all the departments working toward a common goal, to the security officers who keep the place safe. The grant writer and the museum shop manager both collaborate to keep the museum financially afloat, while the superintendent and facilities management staff keeps the building and grounds well maintained. The human resources staff keeps the jobs filled with qualified people, while the accounting department makes sure they all get paid. Sometimes in a small museum several job titles are condensed into one position, such that one person wears several hats.

We'll talk with a few people who hold administrative jobs in museums:

❖ **Brian Kelsey,** the director of a small maritime museum, who brings a strong business and finance background to his job

❖ **Catherine A. Daly,** director of the American Family Immigration Center at Ellis Island, who comes to her job from a background in education and social services

❖ **Jose Fussa,** the operations manager at Wave Hill, a cultural site in the Bronx, who has an extensive background in museum security

❖ **Georgia Blue,** who oversees the retail shop and café at the Anchorage Museum in Alaska

❖ **Phoebe Kent,** the director of research and writing in the development department at Colonial Williamsburg

"The question really is 'What don't I do?'"

BRIAN KELSEY

Executive Director
Door County Maritime Museum and Lighthouse Preservation Society
Sturgeon Bay, WI
www.dcmm.org

When Brian Kelsey left his last job as Vice President of Marketing for an international corporation, he took a huge step up to director of a small maritime museum in Wisconsin. In that one step his responsibilities expanded tenfold. Now he is simply responsible for everything.

I'M THE EXECUTIVE DIRECTOR of the Door County Maritime Museum and Lighthouse Preservation Society. Door County is located on the "thumb" of Wisconsin. It is a long peninsula and series of islands that jut out into Lake Michigan. The Great Lakes are part of a network of rivers and lakes that connect the Midwest to the East Coast, and Door County has played a significant role in the country's maritime history.

The museum is located in three separate facilities. Sturgeon Bay is our year-round facility and has exhibits on the shipbuilding industry in the Great Lakes area, as well as a number of other exhibits. We have two more locations that are open seasonally. One is the Cana Island Lighthouse and the other is the Museum at Gills Rock. There are about seven full-time staff covering all three locations, plus a number of part-time and seasonal staff. We host a variety of events throughout the year including the Door County Lighthouse Walk, the Classic and Wooded Boat Show, and a speaker and concert series.

WHAT DO I DO? The question really is "What don't I do?" Being the executive director of a small- to mid-size museum means you really have to be a Jack-of-all-Trades. I have primary fiscal responsibility for the

institution. I'm effectively the CFO, so I'm the one doing the budgeting and keeping an eye on the numbers. I'm also in charge of marketing and all of the public relations for the museums. I do a lot of coordination for our special events—arrange for the speakers and find corporate sponsors, that sort of thing. I also speak at fund-raising events promoting the museum and our programs. In a museum of this size, we all get a chance to do a little of everything, even working at the front desk. I like being able to interact directly with our visitors, seeing how they enjoyed their visit at the museum.

One of the things I am *not* is the curator. When I hired our current curator I was adamant that we hire someone with professional curatorial training, specifically because I don't have a museum degree. I come from the business world, not from the museum world. I think it is important to have that balance on your staff. With my financial and marketing background I can run our museum from an operational perspective, but I need someone with the vision for the exhibits.

I do review the plans for upcoming exhibits, and I encourage our curator not to interpret our mission too tightly. Our mission is to preserve the local maritime history and the maritime history of the Great Lakes. We try to develop programs that will be interesting to a lot of people and still tie back to that mission. For instance, this summer we will have an exhibit on pirates—high seas piracy, Great Lakes piracy, and modern piracy. It's the Great Lakes component that ties it back to our mission. It should be a lot of fun.

I WAS BORN AND RAISED here in Sturgeon Bay, and like many young people who grow up in a small town, when I was eighteen I couldn't wait to get away. I went to college in Milwaukee. I started out in accounting but quickly switched to journalism and public relations.

After college, I went overseas and worked in Scotland for a year. Then I came back to the United States and worked for a marketing company in Minneapolis for about eight years. I was managing hi-tech accounts, like Microsoft, planning their marketing events all over the country. Then, I moved back to Europe and worked in quick succession for a several Internet-based companies as director or VP of marketing. It was a very typical hi-tech career path, moving quickly from one company to the next, each time getting better jobs with more responsibility. My last company was bought out, and all the senior staff were downsized.

So I took a few months' break and came home—briefly. My father had just passed away. It was a good time for me to re-group and consider what I wanted to do next. While I was home, I heard that the museum was looking for an executive director and I was intrigued. Maritime history has been a part of our family for several generations—my family had owned a large yacht builders here in Sturgeon Bay for many years. I was interested in the preservation of the maritime history of our area. But I had to ask myself some serious questions—Could I take a four-times salary cut? Could I move back and make my life here? And I discovered that the answers were "yes."

GOING FROM A FOR-PROFIT, very corporate, international environment, to working at a not-for profit organization in small town was a big transition. In my last job, I had a $2 million marketing budget. Now I have a $700,000 operating budget. But, ultimately, the biggest change for me is that here I have full-blown responsibility for everything. Not just a department or an event. Everything. It's a big step up.

A lot of the business skills that I'd acquired in previous jobs have come together for me in this position—the financial and budgeting experience, the public relations and marketing experience, the people management experience, and the historical knowledge have all been a big part of my success here. This job brought it all together for me.

One of the interesting things that has happened since I've been here is that I was asked to be on the board of directors for the Association of Midwest Museums. The president asked me to be the secretary of the board, and I said, "I'm not from the museum field. I have a business degree." And he said, "You are what is happening in the museum world. So welcome to the board." It's been really enjoyable meeting and working with the individuals in this field, but the best part is being accepted. To come from a whole different perspective and to be welcomed into this field as I have has been great.

So my advice to high school graduates is "You never know where a career is going to lead you or how you will use your degree. The important piece is to stay open to new experiences." When students say they don't know what they want to be, I say "Good!" Don't have a preconceived notion of what you want to be. Don't be afraid to change your major. And don't be afraid to switch jobs. All those experiences will serve you well.

I GET SO MUCH JOY out of this job. I can really see when we're making a difference, much more so than when I was working in corporate A merica or corporate Europe. I love seeing that "aha" moment when a child or adult discovers something new. For me, the most rewarding thing is having that close interaction with our visitors.

I also like the diversity of the work. It takes all of the skills that I had been taught during my years in the business world and lets me use them to save a part of history that as a child was very important to me. I like finding that balance in our institution between the curatorial vision and the business grounding. It creates a push-pull in our conversations that ultimately helps us grow. I think it is a good model for building a museum staff, and the more that museums embrace the idea of including people who come out of the business world, the better off museums will be.

"I get to hear the stories of the everyday people that came and contributed to the building of this country. Every single human being who made that trip had a story. And now someone is looking for it and them."

CATHERINE A. DALY

Director, The American Family Immigration History Center
The Statue of Liberty, Ellis Island Foundation, Inc., New York, NY
www.ellisisland.org

The American Family Immigration History Center is an education and research center located on Ellis Island, right next to the Statue of Liberty in New York Harbor. Ellis Island was an immigration processing station during the peak years of U.S. immigration. The records for those immigrants—22 million names—are available online and at computer stations at the American Family Immigration History Center. Catherine A. Daly is the Director of the Center.

I WORK AT the American Family Immigration History Center. Visitors come to our center to trace their ancestors who arrived in America through the Port of New York between 1892 and 1924. The main document they seek is a copy of the ship's manifest—the ledger that was filled out by the ship's crew as passengers boarded the boats in their countries of origin. We have a database of the names of people who came through between 1892

and 1924. The database has links to pictures of the appropriate manifest pages, which has a great deal of information about the passenger—name, age, marital status, how much money they had, and where they were headed. It shows who else was on the ship; this is a way to find names of other family members who were traveling at the same time.

Finding information about a particular immigrant is not always easy. Because these were handwritten records for the most part, there were significant errors that were introduced as part of the transcription—A's and O's looked alike; F's and S's looked alike—which sometimes resulted in names being changed. There were also cultural tendencies that affected how a name might be entered. For instance, Italian women, even if they were married, by cultural practice traveled under their maiden name rather than their husband's name. Many second- and third-generation Americans are not aware of that and may be looking for their grandmothers or great-grandmothers under the wrong name. It takes a bit of sleuthing. We work with visitors to locate their ancestors and help them work backwards as they develop their family tree.

As director, I oversee the staff and volunteers who work here. We have four full-time staff and, from the outset, two employment agencies that provide part-time staff for us in the busy seasons. One of the agencies is an international agency and the other is an agency for trained librarians. We've a lot of luck with both, but the young people from the international agency tend to want to move on to more corporate jobs, whereas the librarians see this as historical research and more geared toward their experiences and training so they remain with us for a long time.

My focus is training my staff to provide a good service to the visitors who come here. The notion of customer service is important to instill in a workforce; it is key. That service commitment has to be demonstrated, shaped, and modeled. Hopefully, my staff sees what it means to the visitors that come here. On my part, its important to appreciate the strengths different workers bring, as well as their level of comfort at various points in their interaction with our visitors. Many of our visitors will experience an emotional moment during their search here. They are connecting to people that are gone, or who had a difficult passage to America, or were fleeing persecution. Finding those names raises deep emotions and it is not unusual to have people break down and cry. Everyone has to find their own comfort level first, with people's display of emotions. Sometimes that means stepping back and letting a colleague help.

MY BACKGROUND IS IN education. I have a bachelor's degree in Elementary Education and an M.S. in Education from Yeshiva University. When I was in college I joined a missionary organization called Maryknoll, and after completing my B.A. I worked in East Africa for about five and a half years—in Tanzania and Kenya. I was primarily involved in primary teacher training; working with young people, some who had very limited educational backgrounds. Maybe the students were the only children in their family who had the opportunity to get schooling beyond, say, the third grade. That was a wonderful life experience—living and being taught myself in another culture. I enjoyed East Africa and her peoples greatly. I did consulting work for the Joseph P. Kennedy Foundation in Tanzania and Kenya after my Maryknoll years.

When I came back to this country I became very involved with special needs populations—severely impaired and multiple handicapped people. I ran a school that was interdepartmental and multidimensional in terms of the way we approached education for this population. My work with special needs populations and the Gay Men's Health Crisis in New York City led me to service in the field of AIDS. I became an ombudswoman at the GMHC. At that time, the AIDS crisis was rampant in New York City, and the GMHC was the lead agency in the country directing their efforts towards this crisis. I worked with all kinds of health and social service agencies throughout the city; it was very demanding. I engaged with every sector of society—from hospitals, to people's employers, to nursing homes, to funeral homes. Wherever someone was diagnosed and needed assistance, we'd be available to help. I'd get a call on a Friday afternoon—a client was being discharged from the hospital; they had no home to go to; there were no services in place. You had to really go into action and tap into the health department and all the regulatory divisions to prevent this and get appropriate discharge plans in place.

It was very challenging and one could see change over time; after seven years there was a point where I felt it was time to move on. I worked for a while training health care workers in the health and hospital system throughout the city—training nurses, doctors, and orderlies how to treat patients. There was a hue and cry in the industry about lack of proper care. The hospitals were invested in getting people better trained to hear the patients, hear the families, treat people with respect and dignity.

During that time I saw this particular job advertised for the director of the American Family Immigration History Center. I'm a first-generation American—the child of two immigrants to this country. I thought, What a great privilege it would be to work at Ellis Island. I had that feeling that I would do very well in this job, so I pursued it. It was a long pursuit; there were certain parts of my background that didn't quite fit; for instance, I wasn't highly trained in technology. But they really needed somebody who would come out to Ellis Island and deliver good services to people and deal with customers from the whole world—someone who could work with staff and be able to run a center and oversee the facility. It was very competitive and in the end I was chosen—to my great delight.

I HAVE A LOT OF TRANSITIONAL skills that came with me to this job—people training, good listening skills, cultural awareness—and language skills. Occasionally I get someone in who speaks Kiswahili; they are usually pleased and surprised when I greet them in their own language.

I think that my sound educational background is the single most important asset I bring. Being trained as an educator and having worked with adults and children and a wide spectrum of people gives me the ability to be adaptive and explain things to most anyone. Not all of our staff have been a part of an Ellis Island experience. However, they come in with different experiences and from many other nationalities. My experience of living in another culture was a wonderful preparation for this job because I know what it is like to be dependent on others.

IT IS SUCH A PRIVILEGE and an honor to meet and work with all the people who come in here. They share so many stories—some are heartbreaking, others are so heartwarming. Many of them have some element of coincidence. I can't tell you how often someone will discover that the date of their ancestor's arrival turns out to be a date already significant in the life history of that family—if I had a penny for every time that happens—the birth of a child or grandchild, the date of a wedding, sometimes it is even that very day they have come to Ellis Island. It's so unbelievable.

You often hear the stories of the immigrants who became famous, but I get to hear the stories of the everyday people that came and contributed to the building of this country. Every single human being who made that trip had a story. And now someone is looking for it and them.

> "Museums have expensive assets just like banks.
> But banks don't hang their million dollars on the
> wall and let people view it. Museums put their
> irreplaceable treasures and artifacts on the wall
> for everyone to see."

JOSE FUSSA

Operations Manager
Wave Hill, Bronx, NY
www.wavehill.org

Jose Fussa worked for many years in museum security, protecting museums against vandalism, theft, and terrorism. He recently made a career move that significantly expands his areas of expertise. He is now the operations manager at Wave Hill, a cultural site in the Bronx.

I WORK AT WAVE HILL, which is a twenty-eight-acre cultural institution at the north end of the Bronx. We have gardens, greenhouses, and woodlands, and we provide environmental programs for school groups and for the public. We have lots of concerts, lectures, and workshops that serve about 100,000 visitors a year. We also have a lot of people who come here for private functions, like weddings.

I'm the Operations Manager for Visitor Services. Because we are a small cultural center, visitor services covers a number of departments—security, corporate conferences, private functions, general council, etc. Basically I work with a lot of the other staff people making sure their programming goes off without a hitch. I coordinate all the different things going on in a given day to make sure the programs run smoothly. I meet with people, get as much information as I can about their program—when it is, where they want it held—and I make sure there are no conflicts with other programs or events. I make sure the security staff is on hand, that the table and chairs are set up, that any sound or PA systems are set up. Everything like that.

We are not in a high security-threat area, so the daily security issues are not extensive, but that's my background, so I'm interested in making sure we have all our security policies in place. One of the things I'm working on is evaluating what kind of training our guards need and getting them that training. I work with our security manager to assess the needs and risks of the institution. I regularly meet with security people

at other museums in the area to keep tabs on what's going on. I've been here about four months. In that time, we've only had one dignitary visit who needed a security detail. They came in a day or two ahead of time. We went over the route, entrance and exit points, the emergency egress. They wanted a room with a phone line out, in case of emergency. That kind of thing.

Security is just one of the areas that reports to me. I've other areas of responsibilities too. One of the reasons that I took this job is that it offered me an opportunity to branch out and broaden my area of expertise. Most of the other areas of responsibility are newer to me, and I'm just learning them.

I STARTED OUT as a security guard in the diamond district in New York City. I was about eighteen at the time. A couple of years later, I was offered a position at the Guggenheim Museum. The Guggenheim had been under renovation, so they had laid off all their security people. They were re-hiring and had mostly hired a lot of people with art history backgrounds. I came in with a security background so I moved into a supervisory position.

From there, I went to the Brooklyn Museum as a security coordinator— I covered the night shift and evening events. I stayed there a couple of years and then found a position as an assistant manager at the American Museum of Natural History. The AMNH is a big museum in a big city— they have a lot of security issues to deal with. That's where my career took the biggest jump and I learned the most. I started there about the same time they hired a new director of security. He had been a deputy police commissioner for the New York City police department. He came in with a lot of new ideas. Because I was new, I didn't have any old alliances or preconceptions and I was able to really run with the direction he was taking the department. In turn, he really groomed and developed me. I got a lot of training there—how to identify explosive devices, how they are built and disguised, how to check the undercarriages of vehicles, security detail for presidential visits, the whole gamut. I was there seven years and moved up to senior operations manager. By that time, I had about 180 people reporting to me.

But I realized I was hitting my ceiling there. In the security field, to move up you need to be a retired top-level law enforcement officer—police, FBI, whatever. I was lucky to have gotten as far as I had without having any of that background. As senior operations manager, I was the number-three guy. But I knew I was getting a lower salary than if I was a retired cop doing the same job. I realized I wasn't going to go much higher in the

security field and I needed to start expanding myself. I had worked with a lot of other departments at the museum pretty closely—development, events, and conferences, so I knew how they worked. I decided to find a smaller institution and find a position with broader responsibilities. So now I'm at Wave Hill as the operations manager.

THE SECURITY FIELD IS changing a lot these days—it's a field that's really growing. It used to be that if you were a cop with permit to carry a gun, you could direct a security department, which basically meant hiring the guys to stand in the halls. Now the trend is not just manning a security force but bringing value to the company and protecting the assets. There are all kinds of specialty areas—forensic accounting, security fraud, IT security, and so on.

Security is much more complicated these days. For one thing, the types of things you are guarding the institution against are much more complex—bombs, anthrax, pedophiles, you wouldn't believe the number of issues—especially in a large institution. There is a lot of strategic planning and prevention involved. In one institution where I worked, we had evidence that a particular piece of art was going to be targeted for vandalism. So we had the curators put the piece behind glass. In that case, when we're doing our job well, our work is virtually invisible to the public. We prevent problems before they happen.

Depending on which areas you want to go into, there are all kinds of training programs and certificates you can get. John Jay College is working on expanding their curriculum because the expectations in these positions are so much higher. The American Society for Industrial Security (ASIS) has a series of certificate courses. They are optional—none of them are mandatory—but institutions will look for them on your résumé.

You have to look at the experience you have, your education, and your interests and make some choices. Years ago, when I was at the Brooklyn Museum, I started to go back to school and take security-management courses. Then it dawned on me, I was already in security management. I was wasting my time with those courses, so a shifted gears. I went into business administration instead. That gave me a much broader foundation for later career moves.

SECURITY AT A MUSEUM is entirely different than dealing with security at any other kind of institution. Museums have expensive assets just like banks. But banks don't hang their million dollars on the wall and let

people view it. Museums put their irreplaceable treasures and artifacts on the wall for everyone to see. It's the responsibility of security to safeguard that and at the same time allow the museum to fulfill its purpose of educating the public. That's where the challenges come in.

If you're going to work in a museum, you've got to love working with people—even in the security and operations fields. There are a few behind-the-scenes tasks, especially in my job, but I always work with the public. They might not be aware of the work I do, but I interact with them every day.

"I oversee the management of the museum shop and the café. I've been here over eighteen years and I really do have the perfect job."

GEORGIA BLUE

Enterprise Director
Anchorage Museum at Rasmuson Center, Anchorage, AK
www.anchoragemuseum.org

The Anchorage Museum is one of the largest museums in the Pacific Northwest, with a collection that encompasses the art and history of Alaska and the circumpolar north. They recently received a generous donation for the bricks and mortar of an expanded museum, which is under construction and will open in 2009/2010. Georgia Blue heads the retail components of the museum—the shop and the café.

MY TITLE IS a little different—I'm the Enterprise Director at the Anchorage Museum. I oversee the management of the museum shop, the café, but no spaceship! I've been here over eighteen years, and I really do have the perfect job. When I first started managing the shop, I did every single thing possible—buying for a wide array of departments, managing thirty volunteers, the shipping, displays, cleaning, you name it. We have a strong Alaskan native arts department, so I bought from all the artists. My love is contemporary crafts so I purchased a lot of contemporary crafts and jewelry. Today, even though we have more staff, I still retain the jewelry and contemporary crafts departments. At times the shop itself has been a million-dollar business. It averages about $900,000 in revenues each year.

Early on, I established a mission for the shop that works in conjunction with the museum's mission. All the items we sell in the shop complement the museum's exhibits, their collections, and their programming. Part of the mandate of any museum shop is to stay within the guidelines of UBIT—Unrelated Business Income Tax. That means we focus on selling merchandise that is related to the mission. Let's say, for example, that I liked porcelain figurines from France—if it doesn't relate to our collections or our exhibits, then I should not have them in the store. I'm lucky because our museum's mission is very broad, especially when it comes to working with contemporary artists. We have lots of original art in the museum store and people say it is one of the best museum stores they have visited.

For the café, I oversee the contract, but I'm not in the day-to-day business of the café or their catering. I manage the communications and logistics between the contractor and the museum. In our new museum we'll be getting a whole new shop and café and catering kitchen. I'm excited because we had the time to plan and evaluate the needs of this enterprise and its impact on the actual museum.

The other big component of my work is to develop and direct several craft events every year that are held here at the museum. These events strongly influence the artists in the community, and they show the museum's support of their work. And vice versa, the artists support the museum by paying a percentage on their sales. We showcase all kinds of artwork plus books from small publishers. We have a fun *Masters of Mud* event highlighting clay art-ists in Alaska, and a *Summer Art Potpourri* where sixty artists are selected to be in the museum for sixty days. As these events have grown, they take up more and more of my time, so I've gotten away from some of the daily management of the shop. It's been fun to watch all of this grow.

A STRONG INFLUENCE IN my life at the museum has been a fifty-year-old-plus national organization called the Museum Store Association. I was on the board in the mid-nineties, and I have to say it is one of the most dynamic and progressive organizations I have been involved with. It's a great resource and opportunity for keeping in touch with what is happening in the rest of the museum nonprofit retail world. Our mem-bers include people working in all types of museum venues—not just art and history museums—science museums, zoos, historic houses, botanical gardens, libraries, too. The MSA provides workshops at their annual con-ference and a trade show of vendors knowledgeable about working with nonprofit retail entities. They also publish a quarterly magazine discussing

various topics—cultural tourism is a big one at the moment—and advertising many museum stores' products. They have a huge database and compile information on national trends that none of us could do on our own. They provide you with significant and meaningful information to do your job well.

One new area that has been added to my job description is overseeing the calendar for some very public areas in the museum. We rent out these spaces for meetings, weddings, and receptions both large and small. This has been a new area of learning and its impact on the museum is both financial and physical. It has meant hours of philosophical discussions. Policies have been reworked, developed, and distributed. Here the devil is in the details and it's been interesting to work with many departments in the museum and then translating this to the general public.

I CAME UP TO ANCHORAGE from Seattle with an art history degree from the University of Washington. It was pipeline days and jobs were plentiful. I moved quickly into the arts community. I worked for the Alaska State Council on the Arts, and for a while I ran a wonderful contemporary art gallery that dealt with Alaskan native and non-native artists. When I took this job, I just had a baby and the hours and the wage were a plus. I foolishly thought that a part-time job meant I would be working part-time. After six months I became full-time. Everything just grew once they hired someone to really pay attention to the business.

When I came to this job, I had experience in retail, having managed a couple of art galleries, but I questioned this move because I'd been working in the fine arts and I didn't quite know what it would be like to run a shop per se. I also wondered if I would like the commercial aspect of art as opposed to the fine arts. It's been fabulous. I've watched artists grow and in some instances helped to make things happen for them. Part of what has worked so well was that the museum director not only believed in me but believed in the importance of a retail enterprise. We had the same aspirations for the museum store. She wanted—not a tourist shop—but a really nice store and that's what I wanted.

When I received my art history degree, everyone said, "OK, what are you going to do with *that* degree?" But I have found it to be very useful in my work here, working with all the artists that I do. It also gives you a broader picture of life, art, history. Museum stores are seen as an extension of a museum's education department, but more and more they are being placed in the financial sector of organization charts. I started to

think that having an accounting degree was the important part, but now I don't really think that this is critical. Having some level of financial background is definitely important because you have to understand how to put together financial information and to be able to communicate with museum management. In my role, it is just as important to be able to buy the finest quality of craftsmanship or to be discerning on developing new stationery or apparel. In a sense, you have to embrace both sides of your brain in this business along with staying up to date on new technology. A lot of young people come into this field from the retail book business and they have the business sense and also the artistic sensibility.

The other aspect that is important in my job is to be able to get along with a wide variety of people. I work with many different people—artists, vendors, volunteers, museum visitors—including other museum retail managers. Years ago our museum had a joint exhibit with a museum in Washington. I was sent there to see the exhibit and the shop manager gave me a first-class tour, which included lunch and a trip to her vendors. She shared her inventory and ideas with me. Recently, the exhibit *T Rex Named Sue* came to our museum and then it went to a peer's museum. I streamlined a list of inventory items and vendors and sent it off to her. Where else to you find people going to that next level to make your job easier? It just has to happen once and then you operate differently in your world. That is one of the delightful things about this business—the sharing of knowledge among colleagues at other museums.

" ... keep the proposals to one to two pages. That's hard to do when you're trying to be convincing."

PHOEBE KENT

Director, Development Research and Writing
Colonial Williamsburg Foundation, Williamsburg, VA
www.cwf.org

The development department of any nonprofit institution is responsible for soliciting the gifts that keep that institution financially healthy. Phoebe Kent directs the research and writing staff at Colonial Williamsburg's development department. She and her team write the proposals that convince major donors to contribute to the Foundation, and to do this well, she needs to know a little bit about most everything that is going on at Williamsburg.

I WORK AT the Colonial Williamsburg Foundation. It's the largest living history museum in the United States. It's a 301-acre restoration of eighteenth-century Williamsburg, once the capital of the Colony of Virginia. Our mission is to preserve as much as we can of the colonial capital, and in that setting present, educate, and inspire visitors about the importance of our shared American history—how the ideas that became the basis for our democratic republic were voiced here by any number of people, including Thomas Jefferson, Patrick Henry, and others less well known. In the last few years, our role has been to educate for citizenship purposes. The best way to be a fully participating informed citizen is to know that this country is an experiment in self-government. It requires the active participation and reinterpretation of the founding principles and the Constitution by each successive generation.

I WORK IN DEVELOPMENT—specifically fund-raising—as a writer/ researcher. Within the Development Department, I am the Director of Research and Writing. We have two full-time researchers and three full-time writers, including myself and a support person. We are responsible for doing extensive research of donors and prospective donors. We research their backgrounds and interests (using information in the public domain) so we can identify them to leadership and development colleagues at upcoming events or tailor proposals to their specific interests.

On the writing side of it, we write proposals—both formal and informal. Formal proposals include federal grants, which can fund projects all over the foundation. That means not just in the historic area where 500–600 costumed interpreters interact with visitors. Colonial Williamsburg also includes a very scholarly research area, with historians and archaeologists who are experts in colonial America. We also have a bevy of curators and conservators who work in our conservation labs and museums. They preserve and interpret maps, prints, textiles, furniture, painting, archaeological objects, the whole range. The range of their skills and their expertise is just phenomenal. In short, we seek grants to support the work of the whole foundation.

The kind of proposal writing I prefer is working with a major gift officer or the president to fashion a proposal for a particular donor who has a specific area of interest. Maybe it's supporting an historic trade—we have about thirty separate eighteenth-century trades that are practiced here. Maybe someone is interested in coverlets and quilts or something else. I'll write a proposal asking for a specific amount of money that will help

advance the institution and can be a legacy for the donor. Those are fun to do because they are much more informal. I particularly like it because it gets me out to diverse areas of the foundation looking for projects that need funding, and I learn a lot.

Another area of responsibility for research and writing is stewardship reports. We periodically report to donors in some detail about how well we have used their money. This is a very necessary step in development, in terms of cultivating somebody to be interested in making subsequent gifts.

I CAME TO WILLIAMSBURG as a trailing spouse. I lived most of my adult married life in the Boston area raising our kids. I was an English history major, then got an education degree and taught for a while. I was out of the workforce for a significant period of time while my children were young. Midlife, when my youngest child was eight, I went through a graduate program called Women in Politics and Government. Part of that program included an internship in the Massachusetts Executive Office of Economic Affairs. The woman I interned with ended up being the director of a program called the Massachusetts Centers of Excellence Corporation, where I worked as her executive assistant. We promoted with grant funds a variety of high technology companies—biotechnology, photovoltaics, marine science, polymer science, and applied technology. I knew nothing about high-technology firms. I didn't know what polymer science was. It was a great learning experience that I really loved.

When my husband's job brought us to Williamsburg, I looked for work in this area where there are two major employers, Colonial Williamsburg and the College of William and Mary. I applied in a flurry for jobs that I was in some cases overqualified for. I applied for this position as a writer, because I had done so much writing in my previous position. It seemed like a perfect fit. I've been here ten years now.

MY WRITING AND EDITING SKILLS are helpful for our work. In addition to my writing responsibilities, I'm informally the editor of documents leaving our office. I guess … once an English teacher, always an English teacher.

There are a lot of life skills that come along that prove to be valuable in the world of development. For instance, I like to understand things— to a fault—sometimes it can slow down the whole writing process while I try to get my arms around everything before starting. But once I really

understand it, the process goes much faster. And I do find a great deal of satisfaction by learning things along the way.

This is very much a collaborative position within the development department. I work closely with all major gift officers and the planned giving staff. I like interacting with all of them and participating in strategy discussions. If I know the strategy for a donor, that helps me in terms of shaping the proposal. I enjoy being the conduit for information back and forth.

WHEN YOU ARE IN THE world of fund-raising, sometimes the number of words you write bears no relation to what somebody ends up giving. Sometimes the longest, most carefully crafted proposals are not nearly as effective as the cumulative experience that someone has had with an institution. One of our most generous donors, who started out by giving a $25 gift way back when, became closer and closer to the institution and its leadership; despite the fact that he lived on the West Coast, he visited Colonial Williamsburg often. The president thought we ought to ask this individual for a major gift—about $5 million. We worked on crafting three options. I wrote one, and my two colleagues each wrote one. The president asked us not to overwhelm the donor with paper—keep the proposals to one to two pages. That's hard to do when you're trying to be convincing.

The three proposals went off with a cover letter from the president along with a video put together by the Colonial Williamsburg's educational outreach department. The donor and his wife called and said, "We've read all the proposals and we can't choose, so we've decided we'll fund all three." So five to six pages of proposal netted $15 million. That doesn't happen all that often.

ten

LOOKING TO THE FUTURE: LONG-RANGE PLANNING

There is yet another sphere of museum work to explore; beyond gathering, maintaining, and exhibiting collections; beyond educating and reaching out to the public; beyond the daily administration and care of the institution. There are people who plan for the long-term growth of a museum, who see to the governance of the institution, and who look to the health of the industry itself. These people keep their eye on the future of their museum and of the museum field.

Periodically in the lifespan of a museum, the staff or board will undertake a major expansion. Before they begin, they want to know that the project is a viable one—that when all the work is done, more people will come. They want to know what the project will cost, in both up-front and ongoing costs, and how long will it take to raise the money. They'll need someone to design a new building, a new wing, or renovate the existing one. Most of these tasks are needed infrequently—maybe only once in the life of a museum—and so are well suited for outside consultants who have worked with many other museums doing similar projects.

In addition, there are a handful of people at any museum who supply the vision and lay the groundwork for growth. A carefully selected board of trustees keeps the museum integrally connected to the community they serve. These dedicated individuals are responsible for the governance of their museum.

The entire museum profession is supported by a network of organizations and associations dedicated to serving a particular segment of the museum field. These groups provide forums for information exchange and career guidance to practitioners in the field, and leadership to the industry as a whole.

We'll hear from people who provide expertise and long-range planning to museums, helping them achieve their goals:

- ❖ **Marcy Goodwin,** president of M. Goodwin Associates, Inc., who develops strategic plans and feasibility studies for museums

- ❖ **Jim Hackney,** a managing partner at a consulting firm in Atlanta that specializes in helping museums raise funds for large capital campaigns

- ❖ **Mike Shakespear,** an architect and engineer specializes in designing aquariums around the country

- ❖ **Maureen King,** who serves as the chairman of the board at the Mingei International Museum in San Diego

- ❖ **Greg Stevens,** who works for the American Association of Museums organizing seminars and workshops for current and aspiring museum professionals

> **"I listen, I mediate, I ask questions, I probe for underlying answers. And, I apply good rule-of-thumb judgment based on having worked with so many museums."**

MARCY GOODWIN

President
M. Goodwin Associates, Inc., Pasadena, CA
www.mgoodwinassoc.com

Marcy Goodwin is the President of M. Goodwin Associates, Inc. She works with museums starting very early in the conceptualization of the project, helping them plan for a major expansion or new building. She has a solid understanding for how museums work, an innate understanding of how people communicate, and a contagious enthusiasm for pure design.

WHEN A MUSEUM is planning a major renovation, they need help to figure out what work needs to be done, who needs to be involved, and how the parts fit together—they need a strategic plan. The museum staff or the board may never have done this kind of planning, since it's not something they do on a regular basis. As a result, it's good to bring in someone who can anticipate the next steps and start the project off on the right foot. What I do is help people look realistically at their current museum and then to help them envision the future museum; I allow them to imagine the future. And then I help make it real. I am the bridge between this imagination and the reality.

I start by working with the museum's staff and board to help them articulate the purpose of the museum, the project and the goals. This is a very important step because sometimes the board wants to head in one direction and the staff has different aspirations. I help them gain consensus. You have to get everyone on the same page from the beginning. But I can't just tell them their goals—I can't make these goals up for them. The goals have to come from the people at the museum. I listen, I mediate, I ask questions, I probe for underlying answers. And, I apply good rule-of-thumb judgment based upon my previous work with so many museums. I work with the director, the board of trustees, politicians, and the big donors. I also work a lot with the day-to-day staff. Both sides—supporters and staff—have to feel their voice is being heard. And if they do, they will feel ownership of the project. They will pitch in either with time, money, or support. They will spread good PR through word-of-mouth.

Another step in planning a new museum is developing what is called the program document. This is a report defining all of the uses of the spaces. Its goal is to make sure you have the right types of spaces in the right sizes and proximity to be able to do all the things you hope to do at the new museum. For instance, if you want to have a temporary gallery with changing exhibits, you need to have room or rooms of a certain size, and with close proximity to the front entry and to a loading dock. If you hope to attract a lot of school groups, there are specific space needs—a bus drop-off area, separate classrooms where kids can stash their stuff or eat their lunch, and so on. I work on the conceptualization of the spaces, the building overall, the functional aspects of how it will be used, and the follow-through of the design from the concept to the implementation. It's important to organize the team to be a good client and to be aware of their needs.

WHEN I STARTED OUT, I was an art student. I studied design. I love design. My belief is that the entire world is design. The toothbrush, the

cell phone, the car, the way I set the table. It's all design. Everything. When I graduated from college, I thought I was going to teach on the college level, but a lot of other young people graduated with the same degree and the same idea at the same time. There was an oversupply, and so I had a lot of competition.

I worked my way up through a series of interesting jobs. I taught design and color theory. I was a museum educator. I had a wonderful opportunity to work in the office of Charles and Ray Eames as the project manager in charge of developing the "Inventions" exhibit for the opening of the IBM Exhibition Center in New York. That job was really magical. It was like being in an amazing prep school for designers. I got to meet and work with all kinds of people including the greatest designers of the mid to late twentieth century. And Charles had the same belief that I had: "Everything is design." I was in charge of planning the exhibits, working with the content and physical layout, sizing the spaces, determining the sequence of the spaces, and working with the circulation and flow. We worked out calculations for the space capacity. It's a whole sensibility of use, to figure out how many square feet per person and how many square feet for the exhibit, what is the maximum amount of stuff you can put into the room? At what point do you drive people away because the room is too crowded and uncomfortable?

Right after that I got in on the ground floor of planning a new museum, the Museum of Contemporary Art in Los Angeles. I was the building project manager, coordinating between the board of trustees, the director, the administrative staff, the architect, and the design team. A few years afterward I opened my own firm, and we've been very successful. I really enjoy what I do. I love helping people imagine their future, to dream their dreams, and then I help them to make it real.

ONE OF THE SKILLS THAT is important in what I do is to have an understanding of how people use and react to the space around them and how people move in and through spaces. This helps me make recommendations about how the building's spaces can be arranged to make visitors feel most comfortable, the staff most productive, and the community fully included.

Good communication skills are another important factor—not only in presenting the information but also in facilitating others to communicate well. Part of this, of course, is being a good listener. I have to listen to what is being said but also to what is *not* being said and I have to extrapolate this information from the group dynamics. It's important to hear the "metamessages," or overarching themes, not just the words.

It's essential to understand the group's psychology. One feature of my work is that my client is almost always a group of people. They are usually not of one mind in their opinions or the way they speak. Groups make decisions in very different ways than individuals, and they look to me to help steer them through the decision-making process. In addition, the process of institutional change can be very scary. If the institution has to do things differently in order to grow, the group sometimes freezes up because they're unsure of what lies ahead. People need to be reassured along the way.

Good teaching skills are essential. I'm frequently up in front of people making presentations all day. All the qualities that make up a good teacher— understanding how people think and learn, the ability to convey the feeling of excitement and discovery even when the work is hard, and the ability to keep the group on track—are skills that are important in this kind of work.

And of course, good management skills are the basis for everything. There are a lot of details to manage and a lot of people to coordinate and organize. There is always an avalanche of information coming at you. Every piece of it is important to someone on your client's team. You have to keep track of all of it and inspire confidence in your client team that you're on top of it all.

"It's a real delight and outright fun to work with so many people who all have such charitable intent towards the universe."

JAMES HACKNEY, JR.

Managing Partner
Alexander, Haas, Martin & Partners, Atlanta, GA
www.ahmp.com

After graduating from divinity school, Jim Hackney worked at several colleges in the student services and alumni programs departments. His first experience in the museum field was as director. He now specializes in development and fund-raising for nonprofit institutions and thoroughly enjoys his work helping museums set and achieve their funding goals.

ALEXANDER, HAAS, MARTIN & PARTNERS is a fund-raising consulting firm. We work with nonprofit organizations to help them plan and

implement their fund-raising campaigns. The firm works with all kinds of nonprofit organizations—colleges, universities, schools—and now we also specialize in museums. We're strategists more than anything. We help our clients figure out where they are going, what they want to do, and how they want to develop the resources to implement their mission. We look for the best ways to connect a museum or organization with its community and to the people that have the financial resources to support its goal.

Usually, a museum will come to us with an idea for a major new initiative that the director or board want to undertake—a new wing, a new building, a new collection. We'll work with them anywhere from eighteen months to four years. We start by first evaluating whether the museum's board, staff, and community are all in agreement and supportive of the idea. We need to be sure that the board is geared up for the leadership role they will need to undertake. If need be, we'll help restructure the board and bring in new blood. We check in with the staff to be sure they are ready to embrace the change and that the community feels that this idea will serve their needs. We'll look at the institution's by-laws. We'll conduct studies to understand the level of financial support the museum can expect from its community. We spend a lot of time listening and working with the staff and key board leadership to really hear them articulate what they want that museum to be, and then we help them figure out how to get there. Once we are ready to enter a campaign, we will help the museum develop specific strategies for individual campaign solicitation.

MY TITLE IS MANAGING PARTNER. I joined the firm more than eleven years ago. At that time, we didn't have a strong focus on the museum world even though we had done successful work with museums. I could see this was an opportunity for us. There were no other fund-raising firms working specifically in the museum field. So about five years ago, we expanded our marketing base to specifically include museums. Just recently, we became the consultant to the American Association of Museums.

I have the best job that anybody could have, because I get to work with all different types of museums—art museums, history museums, science museums, zoos, botanical gardens, and so on. One day I may be working with AAM in Washington, then the next day with an art museum in Jacksonville, Florida, and the next day in Texas or New Mexico. I travel all over the United States and take on a lot of different roles. It might be

working with staff and board members—doing basic training on how to ask somebody for a gift or sitting down with a potential donor to find out what interests them about the organization. It might be working with the board and senior management to be sure they have a clearly articulated mission, helping them to be honest with themselves about what they can reasonably achieve. Oftentimes I'm the reality check.

There are about thirty people working in our office, four to five of us who specialize in museum work. We work as a team so that we can draw on each other's expertise. That way, our clients get the benefit of our pooled knowledge and resources. For me, being a consultant is a better fit with my own skill sets and personality because I like the diversity and I get to meet people from all over the country. It's a real delight and outright fun to work with so many people who all have such charitable intent towards the universe.

I GREW UP IN a very small town in North Carolina and never saw an oil painting until I was in the fifth grade. From then on I was fascinated by art. In college, I majored in humanities with a concentration in art history. I thought about furthering my education in art history but decided instead to go to Yale Divinity School and earned a master's in art in religion. My plan at that point was to work in college administration.

After Yale, I worked in student services at several colleges and then became the Director of Alumni Programs and then Director of Development at Wofford College in North Carolina. As I traveled the country to meet alumni, I always made time to squeeze in a local museum or art gallery. I also discovered I really liked fund-raising a lot. I thought—why not combine the two? So my next position was as the Director of Development and Marketing at the Mint Museum in Charlotte, North Carolina. Six weeks later the director resigned and I was named Acting Director of the museum and spent the next eighteen months really trying to learn as much as I could about museums. This was my first job at a museum, and suddenly I was the director! It was hard work, but we increased attendance, and went from raising $700,000 annually to raising $4 million annually. Finally, a new director was hired. I was thrilled because I really wanted to be able to learn from someone with experience. I stayed on at the Mint for the next couple of years and focused on fund-raising.

In my fifth year I became president of the Art Museum Development Association and traveled the country meeting people and visiting museums. That experience helped me decide to become a consultant working

with a variety of museums. I had been contacted by AHM&P, the firm I work for now. So I called them, and they said, "When can you start?"

WHILE EARNING MY UNDERGRADUATE degree, I was in an experimental humanities program that required us to take no more than three classes in any single department, which really forced us to diversify and learn a little bit about everything. That perspective on learning has been very valuable in my job. I'm able to pull from a broad base of knowledge and connect it with all different types of museums. I'm just as fascinated in an art museum as I am in a history center.

My focus in divinity school was in community organizing and counseling—specifically, looking at how organizations can be society change agents. That really is the core of my work today. I'm not an ordained minister, but I did study counseling. I use that all the time to know how to talk to different people—to listen to different people to make sure we get all the input we can.

In many ways museums today are sort of what cathedrals used to be in Europe back in the Middle Ages. Where else can you go in a town besides the local art museum to learn about different cultures? It's everybody's common ground.

I'VE BEEN WORKING on a project for several years with the Art Museum of Western Virginia. They're located in Roanoke, nestled in the Blue Ridge Mountains. The museum serves the forty counties in western Virginia and has been around about fifty years. They have gallery space that is really too small for what they need, but they also have a board with incredible leadership skills and vision.

Initially they called us to help raise funds to renovate a building. We worked with them for about six months and gave them some assignments. And sure enough, about eighteen months later they called back and said, "We've done that. Now what?" Their board has been instrumental in pushing and prodding their team to do the hard work necessary to figure out what they really wanted to be. In 2008, they will open a new $55 million spectacular contemporary building that will serve the whole western part of the state. They are a wonderful client because they are so dedicated to what they are doing. Some of these people could live anywhere in the world that they want, but they choose to live in western Virginia and serve the community there. It's an extraordinary and inspirational project.

**"I love to make things ... A good whiff
of sawdust—that's my therapy."**

MIKE SHAKESPEAR

Architect, Engineer, Designer
Thinc Design, New York, NY
www.thincdesign.com

*With a background in both architecture and engineering, and an eye for theatrical
effect, Mike Shakespear is uniquely qualified to design aquariums. He oversees
large projects from conception to completion, catering to the needs of the fish and
animals that will live there and to the visitors that come to see them.*

I WORK FOR an exhibit design firm. We design museums of all kinds,
including traditional museums, natural history museums, science muse-
ums, as well as a number of aquarium projects. My background is in both
architecture and engineering, which makes me well suited for our aquar-
ium projects. I function as the lead designer on several of them. One of
the challenges for a typical architect, especially on an aquarium project,
is that you are at the mercy of the engineers. If you don't understand the
engineering, you can't really guide the project and shape it. These big
tanks are difficult. Designing an aquarium is more than just creating an
environment for a colony of living fish; it's more than a big water reten-
tion vessel. You have to be able to visualize the whole thing in three
dimensions and turn it around in your head. You have to have a sense of
theatricality—decide where to cut an opening for the greatest effect. You
create an opening to allow people to see in—just as you do in a stage set.
But on the other side you have, not actors, but other divas—sharks that
can't handle magnetic fields, saltwater fish that need saltwater, freshwater
fish that need freshwater, different temperature needs for every inhabit-
ant. You have to figure out how to bring food to them and how to treat
the water. You have to figure out how to cater to all their needs; otherwise,
they die.

WHEN I WAS SIX, I came from Buenos Aires with my family. My parents
were both engineers—my mother was a civil engineer and my dad was a
car engineer. Figuring out how things worked and making things was what

my whole childhood was about. My mom used to call to me "Miki, me lo arreglas" which translates into "Mickey, can you fix it for me." I loved to pull apart things to fix them.

When I went to college, there was no doubt about it—I was going to be a car engineer. I went into mechanical engineering at MIT. But when I graduated in 1974, there was an oil shortage, and the auto industry was not doing well. For a number of reasons, the car industry in Detroit was not a good plan for me. Instead I went to New Hampshire with my room-mate to help build a cabin. It turned out quite well and I fell in love with the idea of architecture. So I went from wanting to design mechanical giz-mos to thinking that what I really liked best was building. So I applied for an architecture program at Berkeley and got my master's degree there.

Berkeley was an eclectic place—I felt right at home. I graduated, got my license, and met my wife—she's an architect too. We opened an office together and did a lot of residential and commercial design work. Then we got a job with the Monterey Bay Aquarium designing the education build-ing. It was the biggest project we had done and it was our opening to aquar-ium work. There is something marvelous about designing a tank for an aquarium when the end product is to bring joy and knowledge to everyone. After that, we went to South Carolina to be the owner's representative for the South Carolina Aquarium. We thought that project would take a year. It was "nearly done" when we moved there. We thought we would come right back to San Francisco after a year with that experience in our pocket and build on it. How little we knew! It was an eight-year stint. By the end of eight years, we decided instead to move to the New York area and I got a job at Thinc Design. I had worked with the owner before on the Mystic Aquarium and I liked how he pushed the edge on every project.

AT THINC, WE WORK on lots of different kinds of museums, but I tend to specialize in aquariums. I'm the person who meets with the client, steers the design, makes sure all the pieces get done, and juggles all the bud-geting and scheduling. I also do a lot of back-and-forth communication between all the players on the project, making sure everyone is on the same page.

As a manager, one has to be omnivorous when it comes to under-standing the vocabularies and needs of the various players, so the abil-ity to listen and communicate is critical—translating the nitty-gritty of the contractor's issues to the owner or to the design team. It takes a lot of patience, but I can usually get to the root of things that are objective.

If you are talking about technical realities of time, schedule, budget, physical natural limitation, things living or dying, lights being on or off, I can handle it. I love working with structural engineers, mechanical engineers. I know plumbing and lights and the physicality of a building pretty intuitively. I'm good at mediating different opinions into a solution.

As a lead designer on an architectural project, I'm always walking that fine line between design and management. In my role as a designer, I have opinions, utilize theories of color, theories of form, theories of space, and make design judgments. But when designing a large architectural project, you never function as a sole designer. You are working with a team. There will be multiple entities and you have to do a balancing act. Design by committee never works, but design by inspired project director can work. It's a very fine line.

I LOVE TO MAKE THINGS. I enjoy it when a project finally gets built and you see the results of all that work. Sometimes when I get frustrated with all the paperwork, I'll head to the model shop in my office or the wood shop in my garage and make something. I can make almost anything. A good whiff of sawdust—that's my therapy.

" … leadership in its true form is a gift. I am humbled by leaders who have gone before."

MAUREEN KING

Chairman of the Board
Mingei International Museum, San Diego, CA
www.mingei.org

Maureen King chairs the board of trustees at the Mingei International Museum in San Diego. All of the board members, including Maureen, volunteer a significant amount of their time to attend monthly meetings, organize events, and oversee and support the work of the museum. An effective and well-run board, such as Mingei's, is only possible with the clear leadership and persuasive skills of a talented chairperson.

THE WORD "MINGEI" MEANS "art of the people" in Japanese. Our museum's collection includes folk art and crafts from around the world— pieces that are made for daily use but are also beautiful. We really believe

that art speaks for itself, and that when people see the art, it will speak directly to them. We do a minimal amount of labeling and interpretation so as not to intrude on that interaction.

I'm the Chairman of the Board of Trustees. The board's role is to set policies for the museum and oversee the fiscal health of the museum. Within that fiscal role, traditional responsibilities include not only setting and reviewing budgets but also raising the money or causing the money to be raised to meet that budget. With the advent of the Sarbanes-Oxley Act in 2002, which established standards of board responsibility and accountability, boards have become, by obligation rather than by choice, the overseers of the day-to-day operations of the museum. Although I've always held the theory that board members need to take a "fingers in, but hands off" attitude—in other words, work through the director—now we really have to watch what happens much more closely than we ever did before. We are responsible—very, very responsible.

Mingei's board has just come through a tremendous transition. Up until a couple of years ago, for twenty-seven years, we were a founder-led museum—a situation where the founder was the director and really did everything. The board was very much a "rubber stamp" board, which can be typical of museums of small to medium size. The founder, Martha Longenecker, was, and still is, a tremendously influential woman. This museum was her idea—it was her passion—and it was pretty much an autonomous situation. She had the vision and made the whole thing work. That changed when she stepped down as a director. We did a national search and hired a new director. As a result of this change the board really became intimately involved with the workings of the institution. We required much more accountability on the part of the director, not because we didn't trust him, but because we knew we were moving to a whole new paradigm—going from the leadership of one person to a shared leadership of staff and board. That's where we are today and it is working beautifully. The museum is in really good shape.

Where we are now is a much more typical role for trustees—we not only have fiscal and policy responsibility, but we really need to know what is going on at the museum on a month-to-month basis. And believe you me, every member of our board looks at those financial statements, they look at that exhibition schedule, and they look at the development reports *very* thoroughly, every month. Historically, on this or other boards, it might have been possible for a board member to attend a meeting just three or four times a year. Not any more, and I think you will see that less and less, not only in the museum world, but in the entire nonprofit world.

THERE ARE CURRENTLY FIFTEEN members on our board. Normally we like to have about eighteen—our maximum is twenty. That is a nice size, a very workable board. We have normal board rotations where people can serve two three-year terms then have to rotate off the board for a year. Our most important criteria for bringing on new board members is that they have a real interest in the museum. Yes, fund-raising skills and connections are important, but if we don't have people who are passionate about the organization, it doesn't work nearly as well. We look for people that are able to be our emissaries in the community, so we try for a balanced board—in terms of men and women, in terms of professions, a variety of ages, and ethnic diversity. Underlying all these criteria is still the basics—board members have to be passionate about what we do.

I CAME TO THIS POSITION not exactly in the traditional way. I'm on several boards in San Diego, but I've been a part of Mingei International for twenty-six years. I came to it when I was young; my children were in grammar school. I was at the point in my life when I was ready to get back into the world of the gainfully employed. After casting around for work, I had a call from someone on Mingei's development board who had just read my résumé. He thought I'd be a good fit as the Development Director, so I interviewed and got the job. After about three years, I was hired away by MEND (Mothers Embracing Nuclear Disarmament), so I went off and worked there and ultimately ran that organization for several years. But I always maintained my connections with Mingei.

When I came back, the museum was raising money for a new museum facility in Balboa Park. I was the consultant on the capital campaign, then I was asked to join the board. That led to becoming vice chairman of the board and chairing the search committee for the new director, and ultimately rotating into the chairmanship. So, it was not a way that I've come to any of the other boards of which I am a part.

SINCE WORKING WITH this museum, I've learned to look at museums and art in a whole different way. I've learned to enjoy art by "looking" and "seeing" much more than I ever did before. This museum has had an enormous influence on my life and on my family. When I first came to work for the museum I was a development department of one. As such, our children were pressed into service to pass hors d'oeuvres at the first donor appreciation dinner we held at the museum, and they continued to

do that over the course of the years. One of our daughters, who is now an adult and the chairman of Mingei's young people's group, recently spoke at a Director's Circle event about how the children and grandchildren of the trustees are ready and able to be involved in the museum. I thought it was really so funny that things have come full circle. The influences of this museum have really transcended the generations in my home. Our grandchildren call it Mody's museum.

SKILL IN PUBLIC SPEAKING is one of the most important things to have as chairman of a board. Organization skills and people skills are good to have, but public speaking is way up there. I've been behind a podium for most of my volunteer and professional life and it has served me well, especially as chairman of the board. The other thing you have to have as a trustee—in any area of the nonprofit world in which you are working—is a sense of humor. Honest and truly, I have been on some boards that are deadly, just deadly. And nobody wants to go to those meetings. Even with the most serious of topics, moments of levity can help achieve a sense of balance. People are doing this on a volunteer basis. You don't want them to dread going to board meetings. The ability to bring humor to the meeting is critical.

And leadership. Conventional wisdom will tell you that leaders can be trained. My view is that wonderful managers can be trained, but leadership in its true form is a gift. I am humbled by leaders who have gone before—especially the women leaders. I am inspired by the work they have done in my own San Diego community and on a national level. If leadership is a skill you have, then by golly you better use it.

"Caminante, no hay camino; se hace camino al andar." (Walker there is no path; you make the path by walking.)—Antonio Machado, nineteenth-century Spanish poet

GREG STEVENS

Assistant Director for Professional Education
American Association of Museums, Washington, DC
www.aam-us.org

The American Association of Museums (AAM) is a national nonprofit organization serving the museum community and its professionals. AAM represents institutions across the country of all types and sizes—everything from art museums, history museums, and science centers to children's museums, historical sites and historic houses, zoos, arboretums, and aquariums. The organization provides innumerable services to the museum field, including a nationwide accreditation program, guidelines for professional ethics, and professional development programs. Greg Stevens is the Assistant Director for Professional Education at AAM, and a faculty member in the Museum Education Program at George Washington University. A recent addition to the AAM staff, Greg is responsible for developing and overseeing professional education seminars, workshops, and symposia across the country.

AAM'S MISSION IS "to enhance the value of museums to their communities through leadership, advocacy and service." The work of the meetings and professional education department, and my work in particular, is helping museum practitioners be better at their jobs, so they can help their institutions better serve their audiences—I like to describe it as "inreach" and "outreach." Museums reach their audiences and communities more successfully when the people who work in and for museums are empowered to think creatively, communicate effectively, and strategize collectively. This means our professional development programs address everything from skills building in specific content areas to effective communication across departments, across cultures, and across generations.

Part of what gives AAM its identity is our annual meeting. This is a week-long conference and a major component of what we focus on in our department and throughout the organization. We try to stimulate an exchange of ideas among professionals from different types of institutions and from outside the museum profession. Thousands of people participate in the meeting every year—as attendees, presenters, keynote speakers, thought leaders, and exhibitors. It's really field driven, meaning the content for nearly all the sessions and workshops comes from the field of practitioners who share their knowledge, expertise, and valuable time. We supplement that with other programs and professional development opportunities, like the Career Café, where we provide résumé-writing workshops, mentoring roundtables, public speaking workshops, and other offerings.

Our goal with the annual meeting, as with all our professional education programs, is to provide educational content—meaning folks come to learn something new. But we also know that many, many people come to be renewed and refreshed and to engage with their colleagues— colleagues they've known for years and years or brand-new colleagues. It's that idea of connecting and relationship-building that makes the museum field so dynamic.

I CAME TO AAM by way of museum education, by way of arts education, by way of theater design, by way of acting. I started off as a kid wanting to be an actor—in high school I was president of the drama club. Then in college I got into theater design, dropped out for a while, then landed a design job at this quirky visual and performing arts elementary school in San Diego, where I discovered my innate skills as a teacher, collaborator, and leader. I really flourished there, though when I arrived my "plan" was to go in, design the show, and move on. I had no intention of having my career take that path. I ended up staying eleven years, developing the entire visual arts program, and working with hundreds of wonderful young people over the course of my tenure. It was a tremendously creative part of my life. I guess it's safe to say many of the important things I know about education and theater (and life) I got from this school.

In the midst of that eleven-year run, I went back to school, got my B.A., then turned around and came to D.C. to study museum education. I came to my museum career at thirty-nine—fresh out of college, and fresh out of elementary school, so to speak. After graduating from the George Washington University, I worked at several museums and for a regional museum association, all the while trying to define myself as a museum professional. Then one day, I had an epiphany: I realized that when I'd come to the museum world, I thought I had to leave my theater experience behind—I thought those skills weren't transferable. But, everything I had learned and was passionate about I'd learned through theater—how to envision wonderful things that never existed before; how to plan and collaborate with all kinds of people and all kinds of resources; how to pay attention to detail while keeping an eye on the big picture, and the importance of having a goal. That idea of "you've got the costumes, I've got the barn; the show opens Friday at eight and you've got to be ready!" is a powerful motivator. It was a huge eye-opener for me to see how all that previous experience was relevant to my life outside of the theater world. It has changed my whole perspective on my work and who I am becoming as a museum professional.

One of the things I love about my work is creating new program ideas and being able to connect with people from all different fields, working with them to develop themes, identify great presenters, and put all the pieces together for our programs. Sometimes those programs are workshops or seminars where people meet in person with colleagues and mentors; other times they are forums for leaders in the field to discuss issues relevant to a particular area of interest. We are experimenting with some new e-learning delivery platforms, which have interesting potential, especially for museums with limited financial resources. It is all in the service of helping museums help their staff help their visitors.

A friend of mine once told me my greatest skill is "connecting the dots." I have to say, it's also my greatest passion—connecting ideas, connecting people, connecting projects—it all suits me terrifically. And, in true theater style, the show—whatever the "show" might be—"opens on Friday night at eight, so everything has to be ready!" I love it!

ONE OF MY FAVORITE QUOTES is from Antonio Machado, the marvelous nineteenth-century Spanish poet: "Caminante, no hay camino; se hace camino al andar" ("Walker there is no path; you make the path by walking"). I used to think that all professional people had some magical straight-as-an-arrow path that they followed to get them where they are. I'm learning that's not quite the case for everybody. You have to find your own path—asking for help and seeking the resources you need along the way. There are very few predefined career paths and, in fact, the most interesting ones meander a bit—they let you find your own passion and vision.

At its core, that is the work my colleagues and I do. We help museum professionals and aspiring museum professionals find their path, their vision, their passion. We work to establish meaningful, long-term relationships with these people at all stages in their careers—the folks who work in museums, as well as the people who work for museums, including consultants and service providers. Museum people are tremendously generous, thoughtful, giving people. They really care about their colleagues and they are passionate about what they do. We help them connect with each other and the resources they need to effectively reach out to their visitors and serve their communities.

PART III
GETTING A JOB

*The fervor of your hunt will be
directly proportional to how much
you care about what you are
hunting for.*
 —RICHARD BOLLES[39]

In his acclaimed book *What Color Is Your Parachute?*, Richard Bolles describes two types of job searches. The first is the "traditional" search: you look for a job very similar to the one you have now, but perhaps with better pay or better working conditions. It may be the next step up a career ladder in a field you like, or it may be a lateral move to a similar job at a company you like better.

The second type of job search is the "life-changing" job search, wherein you look for a job in a different field or line of work, leveraging your skills and accomplishments into a new career. This "life-changing" model is the harder of the two but usually the more rewarding. It requires more thinking and self-evaluation. It may involve going back to school or learning some new skills on the job. You'll need a certain amount of self-confidence to explain to a prospective employer how you'll bring value to his or her company. Some "talking your way into a job" (convincing people that you are the best candidate) may be required.

Whichever your approach, *start early*. Start your job search long before you are ready to change jobs. You may need to fine-tune your aspirations, qualifications, and résumé in order to find the job that suits you. You may discover, once you start interviewing, that the kind of job you thought you wanted isn't really all that interesting. You'll need time to circle back and redefine what you want to do. Plan ahead. Give yourself time. Don't wait until you are frustrated in your current position before making your career move.

A life-changing career change typically involves three steps:

❖ finding your direction

❖ getting your foot in the door

❖ landing the job

eleven

FINDING YOUR
DIRECTION

The secret of getting ahead is getting started.

—MARK TWAIN

Finding a new career requires self-evaluation and a lot of research. You'll need to find out what kinds of jobs exist in the field you're interested in and what's required to land those jobs. But first things first ...

FIGURE OUT WHAT YOU WANT TO DO

The first step in finding a new job is to figure out what kind of job you want. What do you want to be? This step is often the hardest. It's easy to get stuck thinking about what you *don't* want to do or what you don't like about your current job. To succeed in a job search you need to think more positively. What would you like to be doing in six months? Five years? Ten years? When you imagine yourself in a new career, what do you do everyday? With whom do you work, and where? How much money do you make? And which of these answers is most important to you in defining where you want to head?

Write down your thoughts. Initially you may not know the answers, but do the best you can. Find someone to brainstorm with; bounce some ideas around. Think about things that you love to do and how they might

translate into a job. The more passionate you are about your job goals, the more avidly you'll pursue them. The resounding theme echoed by many of the people interviewed in this book is that they love what they do. So it's worth the time to figure out where you want to head and what you're excited about doing.

If you really don't know what you want to do, move on to the next steps. But plan to keep coming back to this step periodically. The more clearly you articulate your ideal job to yourself, the more likely you'll attain it.

DEFINE WHAT YOU'RE GOOD AT

The next challenge is to identify what you're good at. What are the skills and talents you currently have that might come in useful in your new career? In order to play to your strengths, you need to know what your strengths are and be able to communicate them to potential future employers. Think about these in two categories—your transferable skills and your personality traits—and make a list of each.

First, your transferable skills. Think about things that you have accomplished at work or in your volunteer activities. Have you managed a department? Are you responsible for preparing written correspondence? Have you initiated a new program, policy, or department? Are you the "idea" person? Do you prepare financial statements or projections? Have you launched a Web site? Jot down all your work-related accomplishments in as general terms as possible.

Now, think about your personality traits and how they apply to your work accomplishments. Are you good at details? Are you more of a big-picture person? Do you work well under tight deadlines? Are you patient with people? Are you enthusiastic and able to convey that excitement to others? Write down all the traits that seem pertinent. Don't be modest. Sometimes it's helpful to brainstorm with a friend. Both of these lists will be useful when you begin to put your résumé together.

While you are at it, make a list of specific problems or challenges you've encountered in a work situation and examples of how you have used your skills and talents to solve or prevent the problem. This list will come in handy when you're preparing for a job interview.

DO SOME EXPLORATORY RESEARCH

Now you need to get a feel for the job market and a sense of what quali-fications you'll need to be competitive. The simplest approach is to poke around on the Internet. You'll find a lot of resources available on the

Internet but no central clearinghouse. So you just have to wade through them all. At this point, all you need to do is dabble and get a sense of what's out there. Later, you'll do a more thorough search.

The American Association of Museums (AAM) is a good starting point. Its Web site (*www.aam-us.org*) includes a job-posting center. Search its current listings based on the state you live in or by the type of job you're looking for, or both. The AAM also has six regional affiliates serving specific parts of the United States, and most states have their own associations. There are many museum associations that cater to particular types of museums such as the Association of Science and Technology Centers (ASTC) or the Association of African American Museums (AAAM.) Find several Web sites relevant to the part of the country you live in or your interest area, and check out the "Careers" or "Job Listings" sections in each one. For more ideas, look through the Resources section at the end of this book.

Plan to do a lot of poking around. There's a lot out there. Whenever you find a job listing, read through it to get an idea of the qualifications expected and the salary offered. Bookmark the Web sites that have the most relevant job listings, so you can find them later. The Internet is an amazing resource, but you'll need to do your homework and stay organized.

READ BOOKS AND BACKGROUND MATERIALS

Find reference books that will give you an overview of the specific field you're interested in. Many of the associations listed at the back of this book publish books and periodicals about the museum field. Many have newsletters you can subscribe to for a minimal cost. Get an understanding of what kind of educational background is expected in your area of interest and what skill sets are required.

NETWORK WITH YOUR FRIENDS AND ACQUAINTANCES

Word-of-mouth is really one of the best ways to find a new job, so get the word out there. Tell everyone you know that you're looking to make a career change. Prepare a two-second "sound bite" about yourself. Make sure that everyone is aware that you're looking and what you're looking for. Ask them if they know anyone who works in the museum field; you'd be surprised how many contacts you have, directly or indirectly. Once you locate a few people, ask if you can spend some time with them learning about their work. Go out for coffee. Take them to lunch. Talk on the

phone. Even fifteen to twenty minutes is helpful. Find out what they do, where they work, and if their museum or firm is hiring. Ask them how they got their job. Try to get a behind-the-scenes tour of a museum or of a company that provides services to museums. By and large, people in the museum world are excited about what they do and happy to share their experiences and insights. Most people will be delighted that you've asked.

SCHEDULE EXPLORATORY INTERVIEWS

Once you've found some specific museums or companies that look interesting, call and ask to come in for an exploratory interview, either with their human resources department or with any personal contacts you have there. Even if there are no current vacancies, many places are willing to meet with prospective employees on an exploratory basis and keep résumés on file for a few months. This will help you gain a sense of what they are looking for. Find out how their departments are organized, who works in them, and the qualifications they look for in new hires. Find out future aspirations the company or museum might have in terms of long-term growth—perhaps they're interested in starting a marketing department or launching a new Web site. Listen carefully and think about how your skills might be of service to them. Be prepared to talk about your qualifications and what you're interested in doing. See if the person you're meeting with can suggest ways you'd best fit into their institution.

Exploratory interviews are somewhat less formal than job interviews, but you should go in prepared. Be professionally dressed. Take a copy of your résumé (see Step 2). An exploratory interview will give you a sense of how close you are to being able to start your job search in earnest or whether you need to gain more experience or education. It will also give you a chance to practice your interviewing skills.

TAKE STOCK

Before you go any further on your job search, step back and see where you are. Based on your aspirations, your self-evaluation, and your exploratory research of the job market, take a moment to think about what else you need to do to prepare for a successful job search.

Most job postings will list the minimum level of education required and/or the skills required to be a successful candidate for the job. Are you close to meeting the requirements, or are you missing key skill sets, experience, or educational degrees? If your exploratory research has turned up

the uncomfortable fact that your background experience is not sufficient to land the job you want, it's time to do some homework. Consider one or more of the following:

❖ *Go back to school.* This may be as simple as taking an eight-week course or as involved as getting an advanced degree. See what's available at your local community college, at your local museum, or through online education programs.

❖ *Get more experience at your current job.* See if you can fill in the missing pieces by gaining more experience at your current job. Ask to get in-house training on a specific computer package or other technical skills. See if there are other projects happening in your office that you can help with or if you can expand your responsibilities on a current project. Is there software you can learn to further support the work of your company? Be creative in finding ways to broaden your skills and experience base.

❖ *Volunteer.* Try volunteering at your local museum. This will give you a good behind-the-scenes look at what it's like to work in a museum and the types of jobs available. The experience will help you confirm that you're headed in the right career direction or help you adjust your bearings if you want to change course. It's also a good way to get your foot in the door for future job possibilities. Volunteering shows your commitment to the museum community and reflects well on you during a job interview. Another volunteering option is to offer your time to a nonprofit, community, or cultural organization. These institutions are always looking for willing volunteers and offer great opportunities for you to learn new skills or fine-tune existing ones. For instance, most organizations periodically host a fundraising dinner or press event, which are almost always understaffed. They often are looking for a willing pair of hands; in exchange, you gain an opportunity to hone your "planning," "initiating," or "coordinating" skills. Be sure to include your volunteer experiences on your résumé.

❖ *Consider an intermediary career step.* Sometimes the gap between your current experience and your ideal museum job is just too big for one step. In this case, think about an intermediate career. For instance, if you're working as a stockbroker on Wall Street, you won't be able to step directly into a job as the education director

for an art museum. You first may want to find a job in the development office or strategic planning department of the museum. Once there, familiarize yourself with the museum's collection and their education department and volunteer to help with some of their special events. Find out what further education you'll need to be able to take on a leadership role in that department, and then set about getting it. In a few years you'll be much more eligible for the position you want.

Knowing the direction in which you want to head will help you immensely in the next steps of your job search. Of course, you'll want to keep your options open for unexpected or unusual opportunities. But having a clear direction at the outset is the best way to avoid wasting time and energy in your job search.

twelve

GETTING YOUR FOOT IN THE DOOR

Goals determine what you're going to be.
—JULIUS ERVING, "DR. J"

Now that you have a direction, you'll want to contact prospective employers and introduce yourself as a qualified candidate—in fact, as the best candidate. First, you'll need a résumé and some specific job listings in hand.

PUT YOUR RÉSUMÉ TOGETHER

Typically when you apply for a job, your first communication with a prospective employer involves sending in your résumé. Your résumé is a brief synopsis of who you are and what you can do. It is a summary of your education, skills, work experience, and other accomplishments. Preparing a good résumé usually takes time and effort. Expect to go through many drafts before it is ready to send out.

If you've never prepared a résumé or if it has been many years since you've updated it, find a book or Web site where you can see some examples. Even better, if you have access to a career counseling department, make an appointment. There's an art to résumé writing, and a good résumé is your best foot in the door.

In general, your résumé should include:

❖ your name and contact information

❖ your objective(s) for your new job

❖ your work experience—including a description of your responsibilities

❖ your education—including the colleges or schools you attended and degrees you attained

❖ other experiences or volunteer work that may be pertinent to communicating your skills

Before you start writing your résumé, make a list of all the jobs you've had and all the volunteer activities you've participated in, including dates of employment and contact information. Find the lists you made in Step 1 of your transferable skills and personality traits. Then take a look at other résumés to see how they are organized. Typically there are two approaches. Some résumés list work experience in reverse chronological order, with the most recent jobs listed first. This format is useful if you've worked primarily in one field or area of study. It can be used to show your progression and increased responsibility as you've moved from one job to the next. Other résumés list work experience by category, such as "Teaching Experience" or "Lighting Design Experience." This is useful if you have had several dissimilar jobs or if you want to highlight internships or volunteer positions. It helps the reader focus on the types of things you're good at rather than your specific employment history. Take a look at a dozen or more sample résumés. Concentrate on ones that are *not* in a field you're familiar with to see how they communicate the person's skills and potential and see what works best for you.

Now start drafting your own "career changing" résumé. Lead off with your name and contact information and one sentence or phrase about what you're looking for in a career. Then list all your paid and unpaid work experience and your dates of employment. For each job you've had, briefly describe the work you did and your responsibilities and/or initiatives. Use action verbs, like *administered, coordinated, created, resolved, oversaw*, or whatever applies to your situation. As you write, refer to your list of transferable skills. Help a future employer understand your skill set and strengths within the context of your job. Simply listing your job title is not enough; you must communicate the qualities that you personally brought to the job.

At the end of your résumé, include information about your education and years of graduation. List any applicable volunteer activities you've participated in and, as appropriate, hobbies, extracurricular activities, or associations you belong to if they pertain to the kind of job you're looking for. You'll definitely want to list any specific skills, such as computer software, you are proficient at, or foreign languages you speak—anything that might give you an advantage over other job applicants. If you are applying for an academic position, list any awards, publications, or research projects you've worked on.

Once you've got all the information down, it's time to shape and edit your résumé. Cut out the information that seems irrelevant. A résumé should be no longer than two pages, and one page is perfectly acceptable. It's better to be clear and to the point than exhaustive and meandering. Have someone review your résumé—if possible, someone who is *not* familiar with your current field of expertise. Get their honest feedback. Your résumé should succinctly communicate the kind of job you're looking for and your qualifications for it. The reader should be able to immediately see your strengths and the benefits you would bring to a new position in their museum or firm. A good résumé does not have to give every detail of your work life, but it should give enough information to make a potential employer want to call you in for an interview.

THE KITCHEN SINK RÉSUMÉ

In some instances, you may need to construct several résumés, or even tailor your résumé each time you send it out. Perhaps you have a long list of publications that are interesting to some employers but not to others. Maybe you are pursuing several career directions at once and each résumé focuses on different skills and interests. Whatever the reason, if you need to have more than one version of your résumé, you should first construct your "kitchen sink" résumé.

A kitchen sink résumé is simply a master résumé. It has all your information about everything you've done all in one document. It's probably *not* a document that you'll ever send out—it will be too long—but it is the one you'll draw from as you construct individualized versions of your résumé. It is the place where you will make any updates as they become necessary—awards you've won, projects completed, and so on. Then when you are applying for a particular job, you'll draw information from this master version to construct the résumé that best fits that job listing.

FIND JOB LISTINGS

Now you need to find museums or firms that have job vacancies. Most companies or institutions with a job vacancy will post a job listing where it can be found easily by people looking for that type of job. Sometimes the listing is a very short blurb in the classified section of your local newspaper, giving very little information other than the title of the position and where to send your résumé. Sometimes the listing is a long explanation of the duties and qualifications for the job posted on a Web site, with links to all the associated forms you'll need to fill out.

In general, you'll find that the Internet is your best resource for up-to-date and relatively information-rich job listings. Go back to all that exploratory research you did in Step 1. Identify the Web sites that were most useful and check them again (and again, and again; new postings will come up daily). Check the AAM Web site and your regional museum association's Web site. Check the Web sites of any professional associations that relate to what you're looking for. Do a search for "museum jobs" or "museum careers." You'll likely turn up several commercial Web sites that specialize in museum jobs, including Globalmuseum.org and Museumjobs.com. Check *Monster.com*. Check *Craigslist.org*. Check any general job search Web sites to see if they post any museum-related jobs. Does your local newspaper have its classifieds posted online? Check the Web sites of professional journals. Sometimes colleges with museum studies programs will post information on where to find current job listings. Look everywhere you can possibly think of. For the first few days, wading through all this information will be tedious. But once you're up to speed, you'll only have to look at the most recent posting, and you'll recognize the ones you've seen already. Plan to schedule a block of time every day to keep up with this research.

On a daily or weekly basis keep an eye on the classified sections of your local newspapers. These listings usually will be shorter and offer less information about what the museum or company is looking for, but they might offer the name of a Web site or company you can look up. If you haven't done so already, you might want to subscribe to a couple of professional journals in your area of interest; they often publish articles about upcoming events, which can give you ideas of where to look for jobs. They may also run advertisements from companies pitching their services to the museum community. These companies may be a good source of jobs. These journals can be expensive, though, so be judicious about how many you sign up for. Don't forget to take a trip to your local library or to

the resource center of your local college. Librarians are incredibly helpful people. See what resources they can point you toward. Keep your word-of mouth network active. Make sure that everyone you know knows that you're actively looking for work. Be specific about what you're looking for, so they can easily convey that information to someone else. Check in with your contacts periodically; let them know you're still in the job market. Talk to people who have recently found new jobs and pick their brains about how they did it and what resources were most helpful.

Finding job listings is the most time-consuming part of looking for a job. You need to do it every day. Set yourself a schedule and a checklist of places to look and people to talk to. Some need to be checked daily, others once a week, others once a month. It gets easier the more you do it. Stay focused. If you find you are consistently hitting dead-ends, think creatively about how to widen your search. Most importantly, stay optimistic. Optimism is your most important tool. Making a career change can take a long time; don't get discouraged.

WRITE A COVER LETTER

When you find a job you want to pursue, the next step is to express your interest in the position and introduce yourself as the best possible candidate. The most common approach is to send in your résumé with a cover letter. A résumé should *always* be accompanied by a cover letter. Your cover letter should respond specifically to the qualifications mentioned in the job listing and indicate your experience in those areas. So read through the job description carefully. Look for information about the requirements of the job and instructions on where or how to submit your résumé.

A cover letter should be typed in business letter format. It should include the date and the name and address of the business or institution and should be addressed to the person referred to in the job listing. If the job listing does not include a name, then address your cover letter to the Human Resources Department, or To Whom It May Concern.

The first paragraph of your cover letter should reference the position you are applying for and where you heard about it. For instance, "I am writing in response to your job posting for a bookkeeper listed in the *Chicago Tribune* on March 18, 2008." This way, the person receiving your letter, who may be screening applicants for several positions, will route your letter and résumé to the correct department.

Next, say a little bit about yourself and what you currently do. Describe your experience and level of responsibility. Give one or two examples

of specific projects or tasks that you've participated in, being careful to pick examples that showcase the skills requested in the job listing. For example, if the job listing asks that candidates be "detail-oriented," pick a situation or task that illustrates your attention to detail.

As a closing for the letter, say something complimentary about the museum or company you are applying to and how very pleased you would be to work for them. Indicate the best way to contact you and list your phone number and e-mail address after your signature. A cover letter does not need to be long—usually a single-page letter is sufficient. Remember that the person reading the letter will have lots of application letters on his or her desk. Your best chance of capturing his or her attention is to be clear, to the point, and personable.

Before finalizing and signing the letter, reread it and check for spelling, grammatical, or punctuation errors. The worst thing you can do is to send a letter with errors in it. If possible, have a friend proofread it for you.

FILL OUT ANY APPROPRIATE APPLICATION FORMS

Some jobs, especially government jobs, require that you fill out and send specific application forms along with your cover letter and résumé. Some want your résumé to be formatted in a particular way or to include particular information. The requirements are usually minor, but you need to read the fine print so that your résumé is not rejected on a technicality. The job posting will usually tell you if special formatting is necessary and will point you to a Web site where you can find the appropriate forms.

SEND IN YOUR RÉSUMÉ

Now, print out the final copy of your cover letter and sign it. Attach your résumé and any application forms. Address it to the appropriate person and send it via mail or e-mail, according to the instructions in the job listing. Be sure to keep on file a copy of all the materials you've sent in response to each job listing. Several weeks may go by before you hear back from this employer; in the meantime, you should apply for several other positions. The cover letter for each one should be unique, so you'll want to keep good records of what you send to whom and when.

HEARING BACK

Some employers will respond within a week or so of receiving your résumé. More frequently, several weeks may pass. Often, employers must wait until a specific deadline passes before they close the application process and start

reviewing the résumés they've received. There may be a lot of applicants for the job, so they will winnow the pile down to a few top candidates. If you are in that list of select few, you'll be contacted about the next step in the process. More frequently, however, you may never hear back. Maybe you didn't have the qualifications they were looking for, or they had a better candidate, or they filled the position from within the institution. Frequently, institutions are so inundated with applications that they can't or don't take the time to respond to applicants they don't select. So don't pin your hopes on one job application. Move on and keep on sending out lots of résumés.

thirteen

LANDING THE JOB

Appearances matter. They shouldn't, but they do.
So tuck in your shirt.

— FRANKLIN ROBINSON[40]

When you hear back from a company or institution, that's usually a good sign. It means your cover letter and résumé have been received positively and the employer wants to find out more about you. You will probably be asked to come in for one or more interviews. You'll need to do a little more work to be properly prepared.

DO YOUR HOMEWORK

Before you go to any interview, do some research on the firm or institution you'll be visiting. Most places have Web sites that can give you some basic information about themselves. How big are they? How long have they been around? What is their reputation? What programs do they run? Find out whatever you can so you don't ask questions during the interview that you easily could have answered for yourself ahead of time.

Do a search on the person with whom you'll be interviewing. Often you can find out how long he or she has been there, what special projects he or she has been involved in, or any recent publications. Go in to the interview knowing as much as you can find out about him or her.

PHONE INTERVIEW

Sometimes the first step is a phone interview. This is a way for companies to screen applicants before they come in, which saves both you and them time and money. Keep in mind that during this interview you may not be speaking with the person who will make the hiring decisions. You may speak with a recruiter or human resources person who will later relay your information back to whomever will make the hiring decision. So keep your information clear and concise. Your area of expertise may not be the interviewer's area of expertise. He or she will take notes on what you say, but any nuances may be lost in translation.

As with any job interview, be sure to schedule this call at a time when you are not pressed for time. Find a time when you aren't likely to be interrupted or distracted for a good thirty or forty minutes. Take the call in a quiet place where you can focus exclusively on the conversation.

Usually the interviewer will ask:

❖ *What do you do and what is your level of responsibility?* You may have included this information in your cover letter and résumé, but be prepared to talk through it again, giving specific examples.

❖ *What challenges or obstacles have you encountered on the job?* This is a tricky question, so be prepared for it. Go back and look at the notes you made at the end of Step 1. The interviewer is looking to see if you can solve problems that inevitably come up on the job. So your answer to this question should focus on how you solved a problem creatively or prevented it from occurring.

❖ *Why are you leaving your current position?* Make sure you have a positive response to this question: you want to expand your level of responsibility, say, or you're interested in pursuing a museum-related career. Under no circumstances should you describe personality conflicts or other problems as a reason for leaving your current position.

❖ *What are your salary requirements?* If the salary range was not included in the job listing, you'll have to do some homework. Find out what comparable positions are paying by looking at similar job postings in your part of the country. Figure out a salary figure that is high enough to be of interest to you even if the price comes down a bit in later negotiations. But don't pick a number that will price you out of their consideration.

You should also be prepared with your own set of questions. This phone call is an opportunity for you to find out as much as you can about the museum and the position you're applying for. Think up some questions ahead of time that will help you evaluate whether this job is a good fit for you. How big is the department you'll be working in? What are they looking to have you do? Is there a lot of travel involved? And so on.

At the end of the conversation, find out when you're likely to hear back from the interviewer. She or he will need a little time to speak to other candidates and confer with colleagues before making a decision about who they'd like to have come in. It is reasonable to expect that no matter what their decision is, they will get back to you with a response one way or the other. Hopefully the next step will be to have you come in for an interview.

PREPARE FOR A SUCCESSFUL INTERVIEW

When you get a call asking you to come in for an interview, you can do a couple of things right away to improve your odds of success. First, schedule the interview at a time that is convenient for you; make sure you'll be able to easily arrive on time without feeling pressured or rushed. (Don't try to squeeze it into your lunch hour.) Second, leave yourself enough time so that if the interview is going well and runs late, it won't be a problem.

Before your interview, find out the name of the person you'll be meeting with and his or her position in the organization, so you know whom to ask for when you arrive. And just before you go in, call ahead to confirm your appointment. Sometimes schedules get mixed up or people get double-booked. By confirming your interview a day or so ahead of time, you prevent a wasted trip and give the impression of being organized and proactive.

Dress for success. Even if the job only requires casual dress, show your interest and respect by dressing in business attire for the interview. You will rarely lose a job by overdressing for it. When a firm was hiring for a custodial position, they interviewed several qualified candidates, but one candidate stood out from the others because he came to the interview in a suit. He got the job.

Bring copies of your résumé. You may meet with several people during your interview, and they may not have received a copy of your résumé, or they may not have it with them. Be prepared with several extras on hand.

THE INTERVIEW

Be on time! Do not be late under any circumstances. If you are a few minutes early, so much the better. You can spend a few minutes in the reception area gathering initial impressions about your potential future place of employment. If you are forty-five minutes early, take a look around the museum or go have a cup of tea to kill some time. Arrive at your interview five to ten minutes ahead of schedule.

Confidently introduce yourself to each person you meet. Have a firm handshake. Express genuine pleasure in meeting them. Then, let the interviewers or staff lead the discussion. (If you need to, ask leading questions to get them talking first.) They likely will start by telling you about the organization and the position they are looking to fill. This initial description will give you background information about the job but will also give you a sense of the pace and tone of the interview. If your responses are similarly paced, you'll generally make a good impression.

Within a few minutes they should turn the conversation over to you. Talk about your current position, the things you do well, and what you like about working there. Be positive. Give specific examples of projects you've worked on recently, research you've done, or initiatives you've taken. Also talk about why you want this new job. Be sure to frame leaving your old job in a positive context. During the interview, the people you are meeting with may ask follow-up questions. Study their manner to determine if they want short answers or detailed responses. See if you can discern who is the decision maker in the group. Be as relaxed as possible. When you are unsure, it's okay to pause and consider a question before answering. Answer questions fully and give examples but don't dominate the conversation. Make sure the interview is a conversation, not a monologue.

Ask questions that will give the interviewers a chance to tell you about the job. This is a good time to ask some specific questions about your potential responsibilities, your future colleagues, or what your typical assignments might be. Although the primary purpose of the interview is for the museum or firm to evaluate you, it's also an opportunity for you to evaluate the job and the environment.

React positively to the descriptions of the work and work environment. During the interview, use body language that conveys attentiveness and enthusiasm—even if it becomes clear early on that this is not a job you want. Use this opportunity to practice your interviewing skills.

Nod, smile, or give other nonverbal feedback to the interviewers when they are speaking. Take your cues from the people you're meeting with for the pace, tone, and length of your answers. A lot is communicated nonverbally, so be aware of how you present yourself.

Before you leave, find out when you will hear back from them and what the next steps are. The staff may be interviewing other candidates, but they should be able to tell you when they expect to complete the process and if there will be any follow-up interviews. Make sure you have the names and titles of everyone you met during this interview. Ask for correct spellings if you need to or get their business cards. Thank them and express your pleasure at having met them. When you get home, send a thank you letter to everyone you met. Again, express your pleasure at having had the opportunity to meet with them and your enthusiasm about the job.

WAITING TO HEAR BACK

If you don't hear back right away, don't be discouraged. Although professional courtesy calls for an interviewer to follow up in the time frame indicated, don't take it as a personal affront if this doesn't happen. Often the hiring process is convoluted and may be delayed for reasons having nothing to do with you. If they said they would reach you in a week, give it two weeks and place a follow-up call yourself. Explain that you're just making sure they have all the information they need from you and ask how the decision-making process is coming along. You probably won't get any concrete information, but you've expressed your continued interest in the position. After that, don't place any more follow-up calls. If you don't receive a call back, the people in charge of hiring are most likely mired in internal politics and further follow-up calls will only annoy them. At this point all you can do is wait it out and move on to the next job application.

It's safe to say that you will not get every job you interview for. There are usually lots of candidates applying for a job, and you will likely receive more rejection letters than job offers. But don't get discouraged, and don't let it affect your positive attitude at your next interview.

When you least expect it, you may get a call asking you to come in for a follow-up interview.

THE FOLLOW-UP INTERVIEW

When you are called back for a follow-up interview, you are usually one of a handful of candidates under consideration, or maybe the only candidate. Follow the same rules as during the first interview—be prompt,

know whom you will be meeting, dress for success, etc. At this interview, be prepared with more in-depth questions that you'd like to ask. There may be one or more follow-up interviews depending on the hierarchy of the organization. Each interview will get progressively more detailed about the job expectations and terms of employment. Be sure you discuss salary, benefits, and any other job requirements.

Bring a list of references: two to three people you've worked for or with, who can give a positive recommendation of your work. These need not be people at your current job, if you don't want to advertise your job search at your current place of employment. They can be people at previous jobs or people who have left your current place of employment before you. Contact each one of your references ahead of time to ask permission and let them know that your prospective employer may be calling.

THE JOB OFFER

Congratulations! Your hard work has paid off. You've been offered the job. If you haven't done so already, make sure you know all the details of the offer—salary, hours, vacation time, benefits, and starting date. If any of these are open for negotiation, now is the time to do it. As a final step, your new employer should send you a job offer in writing with all the agreed-upon terms. Wait until you receive this letter before quitting your current job. Depending on your level of seniority, it is appropriate to give two to three weeks notice before leaving. Then celebrate—treat yourself, take a vacation, or go out to a nice dinner. If there were people who were particularly helpful during your job search—in reviewing your résumé, giving recommendations, or giving encouragement—send them a card or treat them to lunch. They'll be happy to know of your success.

STARTING YOUR NEW JOB

Starting a new job can be stressful. There will be lots you don't know and a lot of things to learn—fast. Your new colleagues will have high expectations of you, and if the position has been vacant for a while, there may be a backlog of work that they think you'll magically catch up on. The continued support of your family and friends will be important in the first weeks and months of your new job. Pay careful attention to how things are done in your new job. Listen and learn, but also go in with ideas and recommendations for how you think things could be done. Pave the way for yourself to make a significant impact in your new career.

PART IV
RESOURCES

*We museum people hold the material
of others in our hands.*
—Elaine Heumann Gurian[41]

W hen you are ready to start your career search in earnest, you'll want to draw on a variety of resources to assist you. Become familiar with museum associations related to your area of interest that provide information, guidance, and most of all job listings for positions in the museum field. Find information and examples to guide you in putting together your résumé. Most of all, find a friend or career support group with whom you can meet and talk on a regular basis. They can help define your goals, identify your talents, and provide a sounding board as you transition into the museum field.

This section provides a sampling of resources that may be helpful in your search for a museum career. Most are Web site listings, which will serve as a starting point for your research. They are grouped into:

❖ Professional Associations

◆ National and International

◆ State and Regional

❖ Museum Studies Programs

❖ Museum Job Search Resources

❖ Résumé Writing Resources

❖ Suggested Books

Appendix A

PROFESSIONAL ASSOCIATIONS

Numerous organizations and associations cater to the museum industry. Many of them hold conferences and produce publications, which are excellent sources of further information.

National and International Associations

Academy of Certified Archivists
www.certifiedarchivists.org

Advisory Council on Historic Preservation
www.achp.gov

American Anthropological Association
www.aaanet.org

American Arts Alliance
www.americanartsalliance.org/americanartsalliance

American Association for the Advancement of Science
www.aaas.org

American Public Garden Association
American Association of Botanical Gardens & Arboreta
www.aabga.org

American Association for Museum Volunteers
www.ansp.org/hosted/aamv

American Association of Museums
www.aam-us.org

American Association for State and Local History
www.aaslh.org

American Craft Council
www.craftcouncil.org

American Historical Association
www.historians.org

American Institute of Architects
www.aia.org

American Institute of Conservation of Historic and Artistic Works
http://aic.stanford.edu

American Library Association
www.ala.org

American Association of Landscape Architects
www.asla.org

American Cultural Resources Association
www.acra-crm.org

American Federation of Arts
www.afaweb.org

American Folklife Center
www.loc.gov/folklife

American Historical Association
www.historians.org

American Society for Industrial Security
www.asisonline.org

American Zoo & Aquarium Association
www.aza.org

Americans for the Arts
www.artsusa.org

Archaeological Institute of America
www.archaeological.org

Arts International
www.artsinternational.org

Association of African American Museums
www.blackmuseums.org

Association of Art Museum Directors
www.aamd.org

Association of Art Museum Curators
www.artcurators.org

Association of Children's Museums
www.childrensmuseums.org

Association of College and University Museums and Galleries
www.acumg.org

Association for Living, History, Farm & Agricultural Museums
www.alhfam.org

Association of Railway Museums
www.railwaymuseums.org

Association of Science and Technology Centers
www.astc.org

Association of Science Museum Directors
www.asmd.org

Council of American Jewish Museums
www2.jewishculture.org/cultural_services/museums/cajm

Council of American Maritime Museums
www.councilofamericanmaritimemuseums.org

Council for Museum Anthropology
http://unparallel.com/cma

Heritage Preservation: The National Institute for Preservation
www.heritagepreservation.org

International Association of Museum Facility Administrators
www.iamfa.org

International Council on Monuments & Sites
www.international.icomos.org

International Council of Museums
www.icom.museum

The International Committee for Museum Security
www.museum-security.org

The Institute of Museum and Library Services
www.imls.gov

International Museum Theater Alliance
www.imtal.org

International Planetarium Society
www.ips-planetarium.org

International Special Events Society
www.ises.com

Museum Computer Network
www.mcn.edu

Museum Education Roundtable
www.mer-online.org

Museum Security Network
www.museum-security.org

Museum Store Association
www.museumdistrict.com

Museum Trustee Association
www.mta-hq.org

National Archives and Records Administration
www.archives.gov

National Assembly of State Arts Agencies
www.nasaa-arts.org

National Association for Interpretation
www.interpnet.com

National Register of Historic Places
www.nps.gov/nr

National Trust for Historic Preservation
www.nationaltrust.org

National Assembly of State Art Agencies
www.nasaa-arts.org

National Endowment for the Arts
http://arts.endow.gov

New Interfaces for Musical Expression
www.nime.org

Oral History Association
http://alpha.dickinson.edu/oha

Small Museum Association
www.smallmuseum.org

Society for American Archaeology
www.saa.org

Society for American Archivists
www.archivists.org

Society of American Historians
www.historians.org

Society of Architectural Historians
www.sah.org

Society for the Preservation of Natural History Collections
www.spnhc.org

Visitor Studies Association
www.visitorstudies.org

State and Regional Associations

There are six regional museum associations in the United States; each holds its own conferences and posts regional job listings on its Web site. In addition, most states have a statewide museum association, again with job postings and related links that provide further information about local resources.

Association of Midwest Museums
www.midwestmuseums.org
(Illinois, Indiana, Iowa, Michigan, Minnesota, Missouri, Ohio, and Wisconsin)

Mid-Atlantic Association of Museums
www.midatlanticmuseums.org
(Delaware, Maryland, New Jersey, New York, Pennsylvania, and Washington, D.C.)

The Mountain-Plains Museums Association
www.mountplainsmuseums.org
(Colorado, Kansas, Montana, Nebraska, New Mexico, North Dakota, Oklahoma, South Dakota, Texas, and Wyoming)

New England Museum Association
www.nemanet.org
(Connecticut, Maine, Massachusetts, New Hampshire, Rhode Island, Vermont)

Southeastern Museums Conference
www.semcdirect.net
(Alabama, Arkansas, Florida, Georgia, Kentucky, Louisiana, Mississippi, North Carolina, South Carolina, Tennessee, Virginia, and West Virginia, and Puerto Rico and the Virgin Islands)

Western Museums Association
www.westmuse.org
(Alaska, Arizona, California, Hawaii, Idaho, Nevada, Oregon, Washington)

Alabama Museums Association
www.alabamamuseums.org

Museums Alaska
www.museumsalaska.org

Museums Association of Arizona
www.azmuseums.org

Central Arizona Museum Association
www.azcama.com

Arkansas Museums Association
www.armusa.org

California Association of Museums
www.calmuseums.org

Colorado-Wyoming Association of Museums
www.cwamit.org

Delaware Museum Association
www.delawaremuseums.org

Florida Association of Museums
www.flamuseums.org

Georgia Association of Museums & Galleries
www.gamg.org

Hawaii Museums Association
www.hawaiimuseums.org

Illinois Association of Museums
www.illinoismuseums.org

Association of Indiana Museums
www.indianamuseums.org

Iowa Museum Association
www.iowamuseums.org

Kansas Museum Association
www.ksmuseums.org

Kentucky Association of Museums
www.kymuseums.org

Louisiana Association of Museums
www.louisianamuseums.org

Maine Archives & Museums
www.mainemuseums.org

Maryland Association of History Museums
www.mahm.org

Massachusetts Museums
www.masshome.com/museums.html

Michigan Museums Association
www.michiganmuseums.org

Minnesota Association of Museums
www.minnesotamuseums.org

Mississippi Museums Association
www.missmuseum.org

Missouri Museums Association
P.O. Box 12, Savannah, MO 64485

Museums Association of Montana
www.montanamuseums.org

Nebraska Museums Association
www.nebraskamuseums.org

Nevada Association of Museums
www.nevadamuseums.org

New Jersey Association of Museums
1 Riverside Drive, Camden, NJ 08103

New Mexico Association of Museums
www.nmmuseums.org

New York State Museums
www.nysmuseums.org

Museum Association of New York
www.manyonline.org

North Carolina Museums Council
www.ncmuseums.org

Museums in North Dakota
www.state.nd.us/hist/mind.htm

Ohio Museums Association
www.ohiomuseums.org

Oklahoma Museums Association
www.okmuseums.org

Oregon Museums Association
www.oregon-museums.org

Pennsylvania Federation of Museums and Historical Organizations
www.pamuseums.org

South Carolina Federation of Museums
www.southcarolinamuseums.org

Association of South Dakota Museums
www.sdmuseums.org

Tennessee Association of Museums
www.tnmuseums.org

Texas Association of Museums
www.io.com/~tam

Utah Museums Association
www.utahmuseums.org

Virginia Association of Museums
www.vamuseums.org

Washington Museums Association
www.washingtonstatemuseums.org

West Virginia Association of Museums
www.museumsofwv.org

Wisconsin Federation of Museums
www.wisconsinmuseums.org

Appendix B

MUSEUM STUDIES PROGRAMS

In the event that you'd like to get further education in the museum field, many colleges and institutions across the United States offer museum studies courses. Some are individual courses in a specific field; others are degree programs with undergraduate or graduate certification. The following Web sites provide links to them.

The Smithsonian Institute
http://museumstudies.si.edu

Graduate schools with museum studies programs
www.gradschools.com/programs/museum_studies.html

The Museum Employment Resource Center
www.museum-employment.com/deeglis.html

The Global Museum
www.globalmuseum.org

Click on the Museum Studies link and then the part of the world in which you would like to study.

Appendix C

MUSEUM JOB SEARCH RESOURCES

Listed below are Web sites with museum job listings that get updated on a regular basis; be sure to check them frequently. In addition to these, you may also want to go back through Appendix A to find listings specific to your area of interest.

American Association of Museums
http://museumcareers.aam-us.org/search.cfm

Association of Children's Museums
www.childrensmuseums.org/programs/employment.htm

Association of Science and Technology Centers
www.astc.org/profdev/jobs/jobs.htm

Association of Zoos and Aquariums
www.aza.org/JobListings

International Association of Museum Facility Administrators
www.iamfa.org/jobs.asp

Global Museums
www.globalmuseum.org
Click on the Museum Jobs link.

Museum Employment Resource Center
www.museum-employment.com

MuseumJobs.com
www.museumjobs.com

Museum Resource Board
www.museumwork.com/jobs.html

Preservenet
www.preservenet.cornell.edu/employ.html

National Park Service
http://home.nps.gov/applications/digest/usajobs.cfm

Smithsonian Institute
www.si.edu/ohr/museum.htm

The following are links to listings of many of the museums in the United States. Find your local museums and see if they have job postings.

Museumlink's Museum of Museums
www.museumlink.com/states.htm

Museums USA
www.museumsusa.org

Appendix D

RÉSUMÉ RESOURCES

The following are Web sites and books that may be helpful in putting together your résumé. If you have access to a career counseling center at a local university, or an out-placement center, take full advantage of the guidance they can provide.

JobWeb
www.jobweb.com/Resumes_Interviews/default.htm

The Riley Guide: Résumés and Cover Letters
www.rileyguide.com/eresume.html

University of Minnesota: Office of Human Resources
www1.umn.edu/ohr/careerdev/resources/resume

The Wall Street Journal
www.careerjournal.com/jobhunting/resumes

What Color Is Your Parachute? **Web Site**
www.jobhuntersbible.com

You can also find professional résumé-writing assistance through these organizations:

Professional Association of Résumé Writers and Career Coaches
www.parw.com/home.html

National Résumé Writer's Association
www.nrwa.com

There are numerous books available with information on preparing and sending a résumé. Here are just a few:

What Color Is Your Parachute? A Practical Manual for Job-Hunters and Career Changers
by Richard Bolles

Dynamic Cover Letters: How to Write the Letter That Gets You the Job
by Katharine Hansen and Randall S. Hansen, Ph.D.

The Complete Idiot's Guide to the Perfect Resume
by Susan Ireland

The New Perfect Resume
by Tom Jackson and Ellen Jackson

Appendix E

SUGGESTED BOOKS AND RESOURCES

You'll find many books and articles about museums; a few recommended ones are listed below. Several publishing companies cater specifically to the museum field and provide extensive listings of museum-related books.

Books

Museums in Motion: An Introduction to the History and Functions of Museums
by Edward P. Alexander

Introduction to Museum Work
by G. Ellis Burcaw

Opportunities in Museum Careers
by Blythe Camenson

Careers in Museums: A Variety of Vocations
by Sara Dubberly

Museums: A Place to Work Planning Museum Careers
by Jane R. Glaser, with Artemis A. Zeneto

Museum Job Descriptions and Organizational Charts
by Mary Lister

Graduate Training in Museum Studies: What Students Need to Know
by Marjorie Schwarzer

The Lotus and the Pool: How to Create Your Own Career
by Hilda Lee Dail

Publishers

American Association of Museums
www.aam-us.org/pubs/index.cfm

AltaMira Press
www.altamirapress.com

Left Coast Press
www.lcoastpress.com

American Association for State and Local History
www.aaslh.org

Ten Speed Press
www.tenspeed.com

NOTES

Acknowledgments

1. Ford W. Bell, "The Inclusive Trustee," *Museum News*, November/December 2007, 79.

Introduction

2. Elaine Heumann Gurian, "The Family in the Museum," *Museum News*, September/October 2004, 70.

3. American Association of Museums, "Museum FAQ." *www.aamus.org/aboutmuseums/abc.cfm*, accessed November 17, 2007.

Part I

4. David Carr, "What I Saw in the Museum," *Museum News*, September/October 2004, 41.

5. American Association of Museums, "Code of Ethics for Museums." *www.aamus.org/museumresources/ethics/coe.cfm*, accessed November 17, 2007.

Chapter 1

6. Albert Ten Eyck Gardner, "Museum in Motion," Metropolitan Museum of Art, *Bulletin* 24 (Summer 1965), 21.
 Edward P. Alexander, *Museums in Motion: An Introduction to the History and Functions of Museums* (Walnut Creek, CA: AltaMira Press, 1996), 14.

7. Edward P. Alexander, *Museums in Motion: An Introduction to the History and Functions of Museums* (Walnut Creek, CA: AltaMira Press, 1996), 6–7.

8. *Encyclopedia of World Art: Volume X* (London: McGraw-Hill, 1965), 379.

9. *The New Encyclopedia Britannica: Volume 24* (Encyclopedia Britannica, 2002), 481.

10. *Encyclopedia of World Art: Volume X* (London: McGraw-Hill, 1965), 380.

11. *Encyclopedia of World Art: Volume X* (London: McGraw-Hill, 1965), 381.

12. Patrick Mauries, *Cabinets of Curiosities* (London: Thames and Hudson, 2002), 148.

13. Jane R. Glaser with Artemis A. Zenetou, *Museums: A Place to Work Planning Museum Careers* (New York: Routledge, 1996), 11.

14. *Encyclopedia of World Art: Volume X* (London: McGraw-Hill, 1965), 390.

15. *The New Encyclopedia Britannica: Volume 24* (Encyclopedia Britannica, 2002), 483.

16. Edward P. Alexander, *Museums in Motion: An Introduction to the History and Functions of Museums* (Walnut Creek, CA: AltaMira Press, 1996), 47.

17. Herbert and Marjorie Katz, *Museums, USA: A History and Guide* (New York: Doubleday, 1965), 3.

18. Jane R. Glaser with Artemis A. Zenetou, *Museums: A Place to Work Planning Museum Careers* (New York: Routledge, 1996), 13.

19. Jane R. Glaser with Artemis A. Zenetou, *Museums: A Place to Work Planning Museum Careers* (New York: Routledge, 1996), 16–17.

20. Jane R. Glaser with Artemis A. Zenetou, *Museums: A Place to Work Planning Museum Careers* (New York: Routledge, 1996), 88.

21. Marjorie Schwarzer, *Riches, Rivals & Radicals: 100 Years of Museums in America* (Washington, D.C.: American Association of Museums, 2006), 9.

22. Marjorie Schwarzer, *Riches, Rivals & Radicals: 100 Years of Museums in America* (Washington, D.C.: American Association of Museums, 2006), 81.

23. Marjorie Schwarzer, *Riches, Rivals & Radicals: 100 Years of Museums in America* (Washington, D.C.: American Association of Museums, 2006), 87–89.

24. Jane R. Glaser with Artemis A. Zenetou, *Museums: A Place to Work Planning Museum Careers* (New York: Routledge, 1996), 19.

25. Marjorie Schwarzer, *Riches, Rivals & Radicals: 100 Years of Museums in America* (Washington, D.C.: American Association of Museums, 2006), 36.

26. Marjorie Schwarzer *Riches, Rivals & Radicals: 100 Years of Museums in America* (Washington, D.C.: American Association of Museums, 2006), 139.

27. Marjorie Schwarzer, *Riches, Rivals & Radicals: 100 Years of Museums in America* (Washington, D.C.: American Association of Museums, 2006), 149–150.

28. Marjorie Schwarzer, *Riches, Rivals & Radicals: 100 Years of Museums in America* (Washington, D.C.: American Association of Museums, 2006), 147.

29. Marjorie Schwarzer, *Riches, Rivals & Radicals: 100 Years of Museums in America* (Washington, D.C.: American Association of Museums, 2006), 46.

30. Marjorie Schwarzer, *Riches, Rivals & Radicals: 100 Years of Museums in America* (Washington, D.C.: American Association of Museums, 2006), 22.

31. Marjorie Schwarzer, *Riches, Rivals & Radicals: 100 Years of Museums in America* (Washington, D.C.: American Association of Museums, 2006), 51.

32. Marjorie Schwarzer, *Riches, Rivals & Radicals: 100 Years of Museums in America* (Washington, D.C.: American Association of Museums, 2006), 210.

Chapter 2

33. Edward Able, "The Imagination Soars," *Museum News*, July/August 2003, 71.

34. Edward P. Alexandar, *Museums in Motion: An Introduction to the History and Functions of Museums* (Walnut Creek, CA: AltaMira Press, 1996), 9–12.

35. Robert R. Archibald, *The New Town Square: Museums and Communities in Transition* (Walnut Creek, CA: AltaMira Press, 2004), 17.

Chapter 3

36. Jane R. Glaser with Artemis A. Zenetou, *Museums: A Place to Work Planning Museum Careers* (New York: Routledge, 1996), 14.

Chapter 4

37. Marjorie Schwarzer, *Riches, Rivals & Radicals: 100 Years of Museums in America* (Washington, D.C.: American Association of Museums, 2006), 2.

Part II

38. Marjorie Schwarzer, *Riches, Rivals & Radicals: 100 Years of Museums in America* (Washington, D.C.: American Association of Museums, 2006), 80.

Part III

39. Richard Bolles, *What Color Is Your Parachute?: A Practical Manual for Job-Hunters and Career Changers* (Berkeley, CA: Ten Speed Press, 2004), 158.

Chapter 13

40. Franklin Robinson, "Advice to a New Director," *Museum News*, March/April 2004, 35.

Part IV

41. Elaine Heumann Gurian, "A Song Made Visible," Museum News, September/October 2004, 71.

BIBLIOGRAPHY

Alexander, Edward P. *Museums in Motion: An Introduction to the History and Functions of Museums* (Walnut Creek, CA: AltaMira Press, 1996).

_____. *Mermaids, Mummies, Mastodons: The Emergence of the American Museum* (Washington, D.C.: American Association of Museums, 1992).

_____. *The Museum in America: Innovators and Pioneers* (Walnut Creek, CA: AltaMira Press with American Association for State and Local History, 1997).

American Academy of Arts and Sciences. *Daedalus* (Cambridge, MA: American Academy of Arts and Sciences, Summer 1999).

American Association of Museums. *Museums for a New Century* (Washington, D.C.: American Association of Museums, 1984).

Anderson, Gail, ed. *Reinventing the Museum: Historical and Contemporary Perspectivess on the Paradigm Shift* (CA: AltaMira Press, 2004).

Archibald, Robert R. *The New Town Square: Museums and Communities in Transition* (Walnut Creek, CA: AltaMira Press, 2004).

Bolles, Richard. What Color Is Your Parachute?: A Practical Manual for Job-Hunters and Career Changers (Berkeley, CA: Ten Speed Press, 2008).

Burcaw, G. Ellis. Introduction to Museum Work (Walnut Creek, CA: AltaMira Press, 1997).

Camenson, Blythe. *Opportunities in Museum Careers* (New York: McGraw-Hill, 2007).

Case, Mary, ed. *Registrars on Record: Essays on Museum Collections Management* (Washington, D.C.: American Association of Museums, 1988).

Daedalus (Cambridge, MA: American Academy of Arts and Sciences, Summer 1999).

Diamond, Judy. Practical Evaluation Guide: Tools for Museums and Other Informal Educational Settings (Walnut Creek, CA: AltaMira Press, 1999).

Dubberly, Sara. *Careers in Museums: A Variety of Vocations* (Washington, D.C.: American Association of Museums, 2001).

Glaser, Jane R. with Artemis A. Zenetou. *Museums: A Place to Work Planning Museum Careers* (New York: Routledge, 1996).

Grinell, Sheila. *A New Place for Learning Science: Starting and Running a Science Center* (Association of Science-Technology Centers, 1992).

Gurvis, Sandra. *The Cockroach Hall of Fame and 101 Other Off-the-Wall Museums* (New York: Carol Publishing Group, 1994).

Hellman, Geoffrey T. *The Smithsonian: Octopus on the Mall* (New York: J.B. Lippincott Company, 1966).

Lister, Mary and Roxana Adams. *Museum Job Descriptions and Organizational Charts* (Washington, D.C.: American Association of Museums, 1999).

Mauries, Patrick. *Cabinets of Curiosities* (London: Thames and Hudson, 2002).

Museums for a New Century (Washington, D.C.: American Association of Museums, 1984).

Peniston, William, ed. *The New Museum: Selected Writings of John Cotton Dana* (Washington, D.C.: American Association of Museums with the Newark Museum, 1999).

Piper, David. *The Treasures of Oxford* (New York: Paddington Press, 1977).

Rubin, Saul. *Offbeat Museums: The Collections and Curators of America's Most Unusual Museums* (Santa Monica, CA: Santa Monica Press, 1997).

Schwarzer, Marjorie. *Riches, Rivals & Radicals: 100 Years of Museums in America* (Washington, D.C.: American Association of Museums, 2006).

_____. *Graduate Training in Museum Studies: What Students Need to Know* (Washington, D.C.: American Association of Museums, 2001).

Weschler, Lawrence. *Mr. Wilson's Cabinet of Wonders* (New York: Pantheon Books, 1995).

INDEX

ABOUT THE AUTHOR

*"Each individual brings a unique perspective to their
museum work, just as visitors bring their individual
perspectives to the museums they come to see."*

Jan Burdick has worked in the museum design field in New York City
for nearly twenty years. She began her career with dual degrees in dance
and computer studies at the State University of New York at Brockport.
Intrigued by the technical elements of the performance world and the
creative aspects of software design, she worked as a stage manager for
theater and dance companies, taught computer courses at several colleges,
and freelanced as a software designer for educational publishing companies
in and around New York.

In 1989 she joined ESI Design, an exhibit design firm, and worked for
eighteen years as a project manager helping museums to develop interactive
exhibits and educational programs. Her broad range of interests found a
welcome haven in the museum field. Collaborating closely with museum
staff, she helped to interpret a wide array of topics—immigration history,
minor-league baseball, ice-cream manufacturing, symphonic music—for
museum visitors. Inspired by the unusual career paths traversed by many
of her colleagues and clients, she began collecting interviews and stories
for *Creative Careers in Museums*.

Jan continues her passion for performance by dancing with Half Moon
Sword, an all-women's English Sword Dance group, teaching and touring
in the U.S. and abroad.

She currently works for an architectural firm as a project manager for
educational clients. *Creative Careers in Museums* is her first book.

Books from Allworth Press

Allworth Press is an imprint of Allworth Communications, Inc. Selected titles are listed below.

Creative Careers in Photography
by *Michal Heron* (6 × 9, 272 pages, paperback, $19.95)

The Business of Being an Artist, Third Edition
by *Daniel Grant* (6 × 9, 354 pages, paperback, $19.95)

Caring for Your Art: A Guide for Artists, Collectors, Galleries and Art Institutions, Third Edition
by *Jill Snyder* (6 × 9, 256 pages, paperback, $19.95)

Fine Art Publicity: The Complete Guide for Galleries and Artists, Second Edition
by *Susan Abbott* (6 × 9, 192 pages, paperback, $19.95)

The Quotable Artist
by *Peggy Hadden* (7 1/2 × 7 1/2, 224 pages, paperback, $16.95)

Selling Art without Galleries: Toward Making a Living from Your Art
by *Daniel Grant* (6 × 9, 256 pages, paperback, $19.95)

Guide to Getting Arts Grants
by *Ellen Liberatori* (6 × 9, 272 pages, paperback, $19.95)

The Artist's Guide to Public Art: How to Find and Win Commissions
by *Lynn Basa* (6 × 9, 256 pages, paperback, $19.95)

The Artist-Gallery Partnership: A Practical Guide to Consigning Art, Third Edition
by *Tad Crawford and Susan Melton* (6 × 9, 216 pages, paperback, $19.95)

Artists Communities: A Directory of Residences that Offer Time and Space for Creativity
by *the Alliance of Artists Communities* (6 × 9, 336 pages, paperback, $24.95)

Business and Legal Forms for Fine Artists, Revised Edition
by *Tad Crawford* (8 1/2 × 11, 144 pages, paperback, includes CD-ROM, $19.95)

Legal Guide for the Visual Artist, Fourth Edition
by *Tad Crawford* (8 1/2 × 11, 256 pages, paperback, $19.95)

The Artist's Complete Health and Safety Guide, Third Edition
by *Monona Rossol* (6 × 9, 416 pages, paperback, $24.95)

To request a free catalog or order books by credit card, call 1-800-491-2808. To see our complete catalog on the World Wide Web, or to order online for a 20 percent discount, you can find us at ***www.allworth.com.***